Uncovering the History of Children's Drawing and Art

Uncovering the History of Children's Drawing and Art

~

Donna Darling Kelly

Publications in Creativity Research
Joan Smutney, Series Editor

Westport, Connecticut
London

Library of Congress Cataloging-in-Publication Data

Kelly, Donna Darling, 1947–
 Uncovering the history of children's drawing and art / Donna Darling Kelly.
 p. cm.—(Publications in creativity research)
 Includes bibliographical references and index.
 ISBN 1–56750–674–7 (alk. paper)
 1. Children's art—Themes, motives. 2. Child artists—Psychology. 3. Creation (Literary,
 artistic, etc.) I. Title. II. Series.
 N352.K425 2004
 704'.083—dc22 2003059686

British Library Cataloguing in Publication Data is available.

Library of Congress Catalog Card Number: 2003059686
ISBN: 1–56750–674–7

First published in 2004

Praeger Publishers, 88 Post Road West, Westport, CT 06881
An imprint of Greenwood Publishing Group, Inc.
www.praeger.com

Printed in the United States of America

The paper used in this book complies with the
Permanent Paper Standard issued by the National
Information Standards Organization (Z39.48–1984).

10 9 8 7 6 5 4 3 2 1

Copyright Acknowledgments

The author and publisher gratefully acknowledge permission for use of the following material:

Excerpts from Rudolf Arnheim, *Art and Visual Perception: A Psychology of the Creative Eye. The New Version.* Berkeley: University of California Press, 1974. Permission granted by the Regents of the University of California and the University of California Press.

Illustration 9.1 and excerpts from W. Viola, *Child Art.* London: University of London Press, 1944.

Excerpts from S. Macdonald, *The History and Philosophy of Art Education.* London: University of London Press, 1970.

Every reasonable effort has been made to trace the owners of copyright materials in this book, but in some instances this has proven impossible. The author and publisher will be glad to receive information leading to more complete acknowledgments in subsequent printings of the book, and in the meantime extend their apologies for any omissions.

This book is for John, who has been my inspiration.
It is dedicated to Quinn and Colin,
whose "child art" initiated these may questions.
(I thank God for them all.)

CONTENTS

1

INTRODUCTION

The universal appeal of visual and decorative art by young children is appreciated not only for its innocent charm and fascination, but also for its enduring, enigmatic nature for adults who attempt to appreciate or analyze it. How do we explain or attribute aesthetic meaning using the artistic vocabulary of adults to the seemingly uninhibited flowing and graceful strokes of a three- or four-year-old? When we compare these preschool emanations to the obviously self-conscious and stilted drawings of the same child at twelve or thirteen years old, these questions become even more complex and perplexing to both the art educator and theorist. Even the casual observer of this phenomenon must ultimately ask, Why do we have so much artistry from our youngest, including "gifted," offspring and so few older children capable of continuing to develop and maintain this early passion for creative self-expression? Furthermore, one must ask, What do these initial school drawings signify, and how have they been accepted and interpreted by the society from which they came?

Acknowledging and developing these complex questions has inevitably drawn me toward an interdisciplinary inquiry, since the record immediately reveals that adults have tried to explain the creative impulse in children from deeply biased and rather narrow fields. Thus, one inevitably ends up examining and challenging many prevailing attitudes toward children's art from research including, but not limited to the historical, artistic, and psychological perspectives. This lengthy and circuitous academic itinerary unavoidably found me exploring centuries of research from around the world in a pursuit of the many explanatory theories of children's art and drawing. This book is a historical/aesthetic synthesis of this often neglected or misunderstood area of artistic development. This retracing and reinterpretation of the genesis and semantics of children's drawing are meant to provide the present-day practitioners of what I call the psychological Mirror, and

aesthetic, Window paradigms with an awareness of the profound and stimulating record of their overlapping boundaries. These distinctions—Windows and Mirrors—reveal two models or paradigms that have evolved over the years about the ways in which we look at the world artistically and further manifest two deeply held belief systems that have often created stratified positions and boundaries separating the field instead of bridges that connect us collectively.

My investigation has been an attempt to bring together an unwieldy spectrum of readings from diverse places and times to tell the hidden history of this too-long neglected subject. Unfortunately, this paucity of hard scientific or historical analysis tracing the progress of children's drawing and art requires a reader to glean existing information from dissecting sundry and very diffuse documents such as autobiographies, letters, exhibition notes, conference papers, and footnotes to books written on ancillary subjects. Following the methods pioneered by the Annals school (Bloch, 1959), it was necessary to recombine all of this analysis and constitute it into a linear arrangement to be analyzed in its totality and appreciated for the diverse richness of its authors and their disparate social status, training, and viewpoints. My paradigms helped to control and shape what might be seen as a disarray of opinions, incomplete thoughts, and disorder and further clarify my own thoughts on not just the subject at hand but the very future of art training in contemporary America.

This cross-disciplinary history has uncovered more than two centuries of research that supports visual learning and values contingent to children's art. At the outset, it is apparent that the general understanding of children's art came from three perspectives: the earliest emphasis emerged from a Childhood paradigm into a childhood-pedagogy paradigm initiated by commercial considerations informed by the growth of industrialization, that is, that children should learn drawing for strictly commercial motivation. This initial training was hardly sentimental or altruistic, for its emphasis was to develop proficient artisans/crafts people who might provide a cheap but skilled, labor force for the burgeoning urban factories. Out of this pedagogical beginning, toward the end of the 19th century and continuing unabated into the 20th century with the establishment of psychology as a social science in the academies, a strong psychological perspective was established that sought to reveal the workings of the child's mind and provide what I call a Mirror of reflection on these operations of children's cognitive processing. This became the dominant voice of the inquiry into children's drawing. There was, however, little mention and even less interest in the artistic endeavor that was at the root of a child's image-making. Later, with the work of Franz Cizek, we finally encounter the recognition of children's art as an aesthetic process—the third, or Window, perspective. A paucity of reflection on the child/art within these paradigms fueled my commitment to examine the two major perspectives of psychology and aesthetics as a way to more comprehensively understand the study of children's art, fusing and contesting these two matrices, these two ways of looking at children and the world. It is my intention to uncover the rich and complicated history of children's art so that it can take its rightful place alongside other important subject

inquiries of our age and to give art educators a renewed sense of pride and purpose as we defend art against the relentless movement that has minimized its study and training in the schools.

I write this work with great concern and urgency because the psychological Mirror paradigm has been the dominant voice in this explanation of children's drawing and art. In this industrial age, our "objective" scientific thinking has ruled over the creative process to such an extent that the artistic abilities of individuals are not promoted or supported in favor of other curricular choices in our schools such as science and mathematics. This inquiry hopes to convince the reader of the importance of this almost hidden artistic self that is buried within the curriculum and to give it the prominence it deserves. It is, in a sense, a call to arms for the aesthetic Window paradigm practitioners, so that they do not lose the paradigm set up by those from long ago.

Rudolf Arnheim and his myriad disciples throughout the world in his nearly half century of teaching have strongly argued for the linkage of science and art that the processes that advance physics or medicine are intimately tied to those that initiate all creative endeavors, the artistic impulse. Arnheim, as a cognitive Gestalt psychologist, who recognizes perceptual duties of the mind and the inventiveness that children use to change what they visually perceive into a drawing or sculpture form. He acknowledges a viewpoint of art and mind that puts perception and creation at the center of the educational process, not as an after-thought. Arnheim was unlike so many of the behavioralists who have dominated American educational psychology, and are concerned with efficient learning through behavioral techniques. We further explore his significant contributions to the aesthetic Window paradigm in 11.

Art, both its production and its appreciation, should indeed be central to all education. We need not only support and challenge our own students but also welcome other curricular disciplines into the art classes—encouraging cross-curricular dialogue. We must teach our students to build skills to communicate their ideas and feelings visually to others, establishing expectations for all students for visual literacy as high as those expected in verbal communications. Reestablishing the status and validity of visual literacy is at the center of a strong teaching philosophy. Art teachers need to be viewed as integral, not tangential, in the learning process. Those special students who are art majors should feel that we have created around them an open and experimental environment and an atmosphere of enthusiasm shared by faculty and students concerning the importance of their vocation. Despite these many challenges, art educators should be pathfinders on this difficult voyage to establish visual literacy in art education beginning with the earliest primary school grades. This work goes even further in arguing for art perception and production in preschool years, a proposition bolstered by centuries of research.

THOMAS S. KUHN AND PARADIGMS

This inquiry has uncovered over two centuries of research that supports visual learning. The support comes from across the disciplines. As my course of study be-

gan, it was apparent that the understanding of children's art came from three perspectives. The earliest emphasis was a pedagogical motivation; children should learn to become proficient artisans to provide the society from which they came a productive labor force to work in the factories. Second, toward the end of the 19th century, with the establishment of psychology as a social science in the academies, a strong psychological perspective was established that sought to reveal the workings of the child's mind or provide a Mirror of reflection on these operations of the child's mind. It became the dominant voice of the inquiry of children's drawing. There was little mention of the artistic endeavor that is at the root of a child's image-making. Later, with the work of Franz Cizek, the recognition of children's art was established as the third perspective. This paucity of recognition propelled my research to present the two perspectives of psychology and aesthetics as a way to fully understand the study of children's art. It is my intention to uncover the rich and complicated history of children's art so that it can take its rightful place alongside other important subject inquiries of our age to give art educators a renewed sense of pride and purpose to defend against the relentless insistence that we justify the importance of art in the schools.

In this work we look not only through the lenses used in the 20th and 21st centuries to gain an insight into children's drawing/art but at the lens itself that has shaped the myriad interpretations. This book demonstrates that, through the years, the activity of children's drawing/art has been described as everything from a child's physical exercise, or a first language system, to a genuine art form The purpose of this work is to clarify what has happened to this line of inquiry, by establishing two paradigms or "disciplinary matrix" that govern the study of children's drawing/art (Kuhn, 1970) as they emerged from a pedagogical paradigm. By identifying the composite of commonly held beliefs, values, and rules, we can better understand the theories sanctioned by the practitioners in what I will refer to as the Mirror and Window paradigms. These two perspectives on this subject developed out of a single pedagogical paradigm at about the same time and have continued as parallel paradigms throughout most of the 20th and 21st century. These psychological Mirror and aesthetic Window paradigms have recently begun to merge into a synthetic paradigm with the work of Rudolf Arnheim and his many followers in which the practitioners of both paradigms share common problems and goals. This book then, is an interdisciplinary inquiry representing the disciplines of psychology and art.

Kuhn's notion that a paradigm is an accepted model or pattern reflecting the beliefs of a group of practitioners is central to this work (Kuhn, 1962). In an updated (1970) explanation, Kuhn suggested that the term "disciplinary matrix" should be used instead of "paradigm" to avoid confusion. According to Kuhn, a disciplinary matrix or paradigm is made up of four components. The first is symbolic generalizations that include the communication system of the group that is both expressive and visual. The second component entails the shared commitments. Included in this is an established pattern of inquiry that determines common problems for current investigations as well as establish unsolved problems for future investiga-

tion. The third element in the disciplinary matrix includes the shared values of the practitioners. These, according to Kuhn, provide a strong sense of fellowship among members of a paradigm. "Though they function always, their particular importance emerges when the members of a particular community must identify crisis, or, later choose between incompatible ways of practicing their discipline" (Kuhn, 1970, p. 185). The fourth element is what Kuhn calls "exemplars." Exemplars are facts and ideas that support the paradigm theory or model that is held by the members of the community.

The interest in children's drawing/art began in earnest in the late 19th century, although its roots can be found in the late 18th century. The examination of children's drawing/art in Europe and the United States can be separated into two paradigms. For the purpose of differentiation, I designate these paradigms as the psychological Mirror and the aesthetic Window paradigms. By identifying the inquiry into these two paradigms, I show the reader that the investigation into children's drawing/art proceeded in two diverse directions. Because each paradigm has become exclusive of the other in its goals and objectives, it is important for the practitioners, who include psychologists, artists, art historians, and art educators, to recognize that both began out of a common purpose: to train a generation of skilled artisans. But, as more was understood about child development, this common thread split and has remained split for many years. Because of the gradual separation of practitioners into two paradigms with their shared values and different exemplars, it is doubly important that both sets of practitioners recognize their common lineage and their similarities. In addition, a re-emergent, synthetic pedagogical paradigm combines both the psychological Mirror and the aesthetic Window paradigms.

This is important to the art educators of the Window paradigm because it adds leverage to their argument that art education is necessary for the betterment of society. By joining forces with the psychological Mirror paradigm practitioners, curricular support and encouragement are strengthened for art classes. The importance of children's art and drawing is more firmly established in the schools.

The very fact that the subject labeled "Children's *Drawing*" appears as an index in *Psychological Abstracts* and the subject label "Children's *Art*" appears in the *Art Index* substantiates the claim that presently two paradigms or perspectives co-exist. This distinction indicates that the psychologists generally do not invest child image-making with any aesthetic quality and thus refer to these images as "drawings", whereas the artists find beauty or artistic qualities in the child's renderings and call them "art." The language of the disciplines substantiates these tenets. The Mirror paradigm is characteristic of a psychological focus on children's picture-making. James Sully (1896) exemplified this paradigm when he pointed to the ability of the child to see his or her image in a mirror and to understand this image as a representation of the self. This marks the ability of the child to represent images of something other than the object itself. This then is the genesis of drawing for children. This "mirroring" notion was also expressed by Jacques Lacan (1901–1981), a French psychoanalyst who was influenced by Sigmund Freud and

his psychoanalytic theories. Lacan elaborated on the mirror stage as a conflict relationship between the ego and the id. He placed this stage between six and eighteen months and suggested that the formation of the ego is dependent upon this realization. "Lacan insists on the fact that this initial prefiguring of the ego and first differentiation of the subject is constituted on the basis of identification with an image in an immediate dual relationship belonging to the imaginary. This entry into the imaginary precedes access to the symbolic" (Aumont et al., 1994, p. 201).

From the psychologist's perspective, images of children's art allow the viewer of children's drawings to delve into the inner workings of the child's mind. These practitioners are interested in developing theories of child development and early cognitive functioning; they share vocabulary, common problems for past, current, and future investigation, and research goals and directions, in addition to values. They also have common "exemplars" (Kuhn, 1962, 1970) or facts and ideas that support child development theory. The psychologists are interested in the self-reflective qualities of children's drawings as they relate to developmental and cognitive issues, such as an interest in language, and interpretive analysis for intelligence and mental development. Much attention in the study of children's drawings focuses in this area, as demonstrated prominently in 10 with the emergence of child-study psychology.

The second approach, or the Window paradigm, is an aesthetic perspective followed by those working in the art community, such as some artists , art historians, art critics, aestheticians, and art educators. Children's art serves a Window on the world to make a fragment of that world visible. It is an objective reproduction of reality that carries all the meaning within the image. The image is a child's reality, and the act of representation is the goal, not the truth behind the goal. The purpose of the act is the verisimilitude of what is viewed from the perspective of a window with everything within the frame of the window viewed as reality.

These "practitioners" are from very different professional worlds and are not as united in their interests, values, vocabularies, and exemplars as are those of the psychological Mirror paradigm, and perhaps they are a more fractious group. The aesthetic Window paradigm practitioners value children's picture-making for its artistic value, although each particular group comes from a slightly different perspective. The art historian, for example, explores how the art image fits into a style or period, whereas the art critic analyzes the work for its artistic integrity and application of materials. The aesthetician examines children's art to find where to include the object into the accepted standard of beauty and good taste of the time. The art educator is often also an artist and looks at the image for its expression and visual clarity with an eye for material usage and application standards.

HISTORICAL THREADS

The establishment of these two paradigms and their evolving focal points for this inquiry can now be coupled with a method of interpreting history. Historical analysis is commonly patterned into three broad categories: linear, cyclical, and

random. The linear pattern connotes an intended destination and assumes progress but can also be regressive. The cyclical pattern finds repetition in subsequent epochs. The random pattern shows no direction whatsoever and the unknowable is anticipated and prevalent (Dray, 1964, pp. 60–62).

In the historical examination of children's drawing/art, the analysis demonstrates a combination of linear and cyclical patterns. It shows what Dray called a linear pattern as the inquiry evolves from an educational focus to a psychological focus (Mirror paradigm) and then to an aesthetic focus (Window paradigm). This evolution is progressive because it demonstrates a more comprehensive understanding of the subject. The move from an educational objective to a psychological perspective illustrates a better comprehension of the workings of the mind, or cognitive theory, that was applied to the inquiry. The move to an aesthetic focus shows a general understanding and acceptance of the modern art movement and the impressionist and expressionist art theories that it produced. With each consecutive change, there is more information to apply to the subject for analysis. At the same time, in cyclical fashion the inquiry into this subject will calls upon former research in subsequent analysis. The initial explanations of children's drawing as a primary language system, aesthetic on its own merits, plus emotional and intellectual, remain in vogue today with the major researchers.

Only a paucity of historical analysis can trace this progress of children's drawing/art investigation. What information there is can be found by looking through various documents such as autobiographies, biographies, letters, exhibition notes, conference papers, and books written on ancillary subjects. Following the methods pioneered by the Annals school (Bloch, 1959), it is necessary to combine all of this analysis and place it into a linear arrangement where it can be analyzed in its totality and appreciated for its richness of thought and philosophy.

As we travel on this historical journey, several questions are considered. The first question is answered by tracing the genesis of the inquiry. When exactly did this inquiry of children's drawing/art begin? How did children's drawing/art find its place as a subject of various theorists? Who were the theorists who found this subject interesting, and from what perspective did they come? What was their intellectual framework? What were the precursors of the study of children's drawing/art? How broad an influence did the initial inquiries have? Finally, why did the whole investigation into the study of children's drawing/art split into a psychological Mirror paradigm and an aesthetic Window paradigm? The transformation was socially and intellectually determined.

The influences upon this inquiry are far-reaching. They are found in France, Switzerland, Austria, Germany, England, Italy, Norway, and the United States. In each of these countries, the exploration of children's drawing/art went through similar evolutionary shifts. The investigation begins with the influence of Jean-Jacques Rousseau as found in *La Nouvelle Héloise* (1761). Rousseau gave us "permission" to look at children in a new and more "romantic" way. He was responsible for allowing and accepting the study of childhood as important for the betterment of his society. This attitude influenced many theorists, one of the ear-

liest of whom was Johann Heinrich Pestalozzi of Zurich. 3 shows how he was influenced by Rousseau and, in turn, how he influenced others not only in Switzerland but across Europe and the United States. The interest in children's drawing/art shown by Pestalozzi, Friedrich Froebel (4), John Ruskin (5), and Herbert Spencer (6), will be discussed as we thread our way toward the 19th century, and the Englishmen Ebenezer Cooke, Thomas Ablett, John Sparkes, and. A. F. Brophy are found in 7 as we learn about a conference held in London in 1884. Cooke was a student of Pestalozzi and also influenced by John Ruskin and Herbert Spencer, both early writers on children's art and its implications for pedagogy. He was the first to write on this subject from an entirely different perspective in 1885. Cooke is widely cited as the founder of the study of children's drawing/art. Although my research does not find this to be entirely correct, his writings can be seen as the very beginnings of a paradigmatic revolution from an interest in pedagogy toward an aesthetic Window paradigm. Cooke and James Sully, a psychologist from England (1896), influenced one another as they both sought an evolutionary and scientific theory of image-making. 8, discusses modernism and its influence on both the psychological Mirror paradigm and the aesthetic Window paradigm. Sully, the first exemplary practitioner of the psychological Mirror paradigm, is also discussed in this as well as a host of others who followed with investigations into this subject.

Among practitioners in the aesthetic Window paradigm, Franz Cizek from Vienna coined the term "child art" and opened a juvenile art school in 1897. Cizek, discussed in 9. was most instrumental in changing the attitudes of theorists to appreciate the art of children as distinguished from adult art in a way that Cooke and his collaborators could not.

Following the psychological Mirror paradigm, 10 traces the investigations of practitioners who followed in the traditions set down by James Sully. These include Corrado Ricci from Italy (1887); Georg Kerschensteiner from Germany (1905); Georges Rouma (1913),and G. H. Luquet (1913), both from France; and Karl Bühler from Germany (1918). Florence Goodenough (1926), from the United States, was a pivotal practitioner who moved the paradigm into a new area of inquiry that explored intelligence utilizing children's drawings as measurements. Helga Eng (1931), from Oslo, Norway, provided the first longitudinal study of her niece from ages one to eight to explore the developmental issues surrounding children's drawing. Jean Piaget, the renowned developmental psychologist, has also been influential in the psychological Mirror paradigm, although his influence was not wide-ranging because he did not consider children's drawing as a key component to his theory, Inhelder & Piaget, (1958), (Piaget and Inhelder, 1967), (1972). Robert Coles is a Freudian therapist who uses drawings as a means to analyze his young patients (1967, 1990, 1992). Finally, Seymour B. Sarason, who was influenced by Henry Schaefer-Simmern, an aesthetic Window paradigm practitioner, is our final psychological Mirror paradigm practitioner, who urges the Window practitioners to support their paradigm before it is usurped by the Mirror paradigm practitioners.

Following the path set down by Cooke, Ablett, and especially Cizek, the next generation of aesthetic Window practitioners includes the following philosophers, artists, and art teachers: Henry Schaefer-Simmern (1946), Viktor Lowenfeld (1974, 1966, 1954), and Rudolf Arnheim (1974a, 1974b, 1986, 1989). These theorists are discussed in Chapter 11. Each of these practitioners contributed his own brand of investigation into the understanding of children's art from an aesthetic perspective.

Rudolf Arnheim, a Gestalt psychologist, has had a major influence on the understanding of children's drawing/art and, in fact, served as the catalyst to merge the study of children's drawing and the study of children's art closer together developing a synthetic pedagogical paradigm that is interdisciplinary in its focus (1974a, 1974b, 1986, 1989).

With the psychological Mirror and aesthetic Window paradigms firmly established, as shown by these key contributors, this inquiry continues through the 20th century by examining the second generation of researchers. It shows how the Mirror and Window paradigms have validated and carried on their intentions with evolving interpretations of the original symbolic generalizations, shared commitments, shared values, and exemplars. It also shows how the psychological Mirror paradigm became the dominating theory and how the aesthetic Window paradigm has been weakening over the century and the reasons for this. It is in memory of the practitioners mentioned in this work and for their causes that this book has been written. Even more importantly, it has also been written for our children, yours and mine.

2

Jean Jacques Rousseau (1712–1778): The "Childhood" Paradigm

ELOISA

The established research into the inquiry of children's drawing/art places its beginnings at the end of the 19th century (Goodenough, 1926; Harris, 1963; Macdonald, 1970; Efland, 1990; Thomas and Silk, 1990). Various reports state that it originated in England (Cooke, 1885), Italy (Ricci, 1887), Vienna (Cizek, 1897), and France (Luquet, 1913). The research is abundant but contradictory, and it does not begin to reveal the overall pattern of approaches taken in this investigation. To find the origins of children's drawing/art, we might find ourselves going all the way back to Aristotle, who included drawing as a subject necessary for educating Greek youth (Compayre, 1910, p. 89). Instead, this thesis begins in the age of the Enlightenment, with the "permission" granted by a society to look at, and seriously examine, child development, and it explains how interest developed in examining this facet of childhood. This was an age when intellectuals believed that human beings and their institutions could be studied rationally like the natural sciences, and their faults corrected. This was also a time when men and women saw themselves becoming more tolerant and more honorable.

This trail leads us back to Jean-Jacques Rousseau (1712–1778), who called attention to the needs of children. "For the first time in history, he made a large group of people believe that childhood was worth the attention of intelligent adults, encouraging an interest in the process of growing up rather than just the final product" (Robertson, p. 407). Rousseau was an Enlightenment thinker who spoke out against the social ills of his time despite the fact that his fellow *philosophes* found him defiant and misanthropic. Although the *philosophes* did challenge the traditional values of European society, Rousseau found them to be arrogant members of the cultural elite and no longer able to be critics of a society in which they themselves had become so privileged. The young intellectuals of the time turned to

Rousseau, who became their inspiration as they continued to speak out against the established conventions and authority. They supported independent thinking and believed change was necessary to improve society. Many of those who supported the French Revolution of 1789 were followers of Rousseau.

As an outspoken voice for social reform, Rousseau made the education of children an important subject in his writings, but it is not in *Emile* (1762), his seminal work on pedagogy, where we discover our "permission" or an interest in children's drawing/art. Rather, it is first found in *Julie ou La Nouvelle Héloise: Lettres de deux amans, habitans d'une petite ville au pied des Alpes* (1761), or, as translated in English, *Eloisa, or A Series of Original Letters* (1803). As one scholar notes: "Nearly all the ideas crystallized in this great work [*Emile*] are to be found in *Julie* or *La Nouvelle Héloise*, though in a fluid, unclarified state" (Green, 1955, p. 225). The idea for this novel came at a time of despondency for the French author, due primarily to the demise of a passionate—if socially forbidden and even scandalous—love affair with Mme. d'Houdetot. For Rousseau, "it was both the wish fulfillment of his dreams of love and the catharsis of guilt for his treacherous liaison with Mme. d'Houdetot" (Crocker, 1973, p. 53).

Rousseau was undoubtedly influenced by Samuel Richardson's groundbreaking novel *Pamela* (1740), which was widely recognized as the initial effort of a new genre of writing—the modern novel. *Clarissa Harlowe* (1748), also written by Richardson, was the more immediate model for Rousseau. Richardson shrewdly and frankly acknowledged the emerging middle-class readership growing throughout Europe and spoke directly to their experiences, desires, and anxieties. *Pamela* and *Clarissa Harlowe* are both narratives structured through a series of letters written by the characters describing their relationships. Their popularity—even more surprising since they subverted the codes and conventions of the typically noble and heroic protagonists of myths and legends—led to a series of imitations both in England and on the continent. Characters in these new novels were now drawn from among the whole fabric of society. Scullery servants and stable boys, as well as the emerging middle class and titled aristocracy, now were all subjects of the artists' brush and writers' pen. The family life of their employers and everyday problems of love, morality, and relationships among the classes and castes were analyzed and exposed, often from the wickedly satiric, "naive" point of view of the lower-class narrators in these novels. These new novels frequently emphasized the evolution of values and mores of the middle class and increasingly scrutinized with a microscopic intensity the complexities of family relationships.

Rousseau was considered an iconoclast among these emerging novelists of this era, yet he used the new genre of the novel as a vehicle for his societal concerns. He was very much a philosopher preoccupied with the larger themes of nature, reason, and freedom, not with the satiric notions familiar to readers of Henry Fielding or Samuel Richardson. These social themes are threaded through the novel *Julie ou la Nouvelle Héloise* (1761). The protagonist's (Eloisa) marriage to M. Wolmar, her father's choice of husband, foregrounds the shifting social and cultural paradigms of Rousseau's France: the unbearable tensions incumbent on the shifting values of the

bourgeois family, the tenacity with which this class clung tenuously to its privileges, and the anxiety of its offspring to find new, freer, and more independent models of contemporary behavior. This novel, like Richardson's, uses the epistolary mode but complicates the structure by constantly refocusing the point of the writers. It comprises of a series of letters written by each of the main characters of the novel: Eloisa, Saint-Preux, Wolmar, and Milord Edward, or Lord Bomston, a patron and benefactor of Saint-Preux, thus allowing the reader a privileged and radically democratic access to the personal thoughts and actions of all its principal players.

The two protagonists of the novel, Julie d'Etange (Eloisa) and Saint-Preux, are torn between their personal desires and social conventions, and this conflict was the novel's strongest appeal. The melodramatic tale, however, revolves around more serious thematic concerns about a perfect society—ideas that completely absorbed Rousseau. It is on this level of narrative that we find the outlines of Rousseau's philosophy. It is particularly relevant to this chapter that in the concluding "parts" of his novel Rousseau set down his opinion of education. Here, woven into the narrative, he directly addressed the reader and established his revolutionary and astonishing notion of "childhood." This is found in the letter addressed to Milord Edouard (Lord Bomston), written by Saint-Preux, who was a guest at the home of M. Wolmar and Eloisa many years after his affair with Eloisa.

At the time of the publication of *Eloisa* there was much discussion about the changes in education, especially with the impending suppression of the Jesuits in France (1764), who were primarily responsible for all pedagogy. Eventually, this debate raised the questions concerning the family unit as the central secular educational influence: "The rising rebellion against the church and its faith perhaps contributed something towards a movement that, if it could not break the religious monopoly of instruction, must at least introduce the parent as a competitor with the priestly instructor for influence over the ideas, habits, and affections of his children" (Morley, 1923, pp. 246–247).

Rousseau's central themes of nature, reason, and freedom are intertwined in his philosophy of childhood and his educational pedagogy to give a framework for his novel. These are found throughout the chapter "Letter CXXXIX to Lord B____," written by Saint-Preux (1803 edition). On the subject of nature, Eloisa is concerned with preserving the natural pace of childhood so as not to hasten young children into adulthood before they are developmentally ready. She addresses Saint-Preux: "Nature . . . would have children be children before they are men. . . . Infancy has a manner of perceiving, thinking, and feeling peculiar to itself" (Rousseau, 1803/1989, p. 291). She continued this discussion along the same vein: "Nothing is more absurd than to think of submitting ours in its head; and I would as soon expect a child of mine to be five feet high, as to have a mature judgment at ten years old" (p. 292). These statements made by Eloisa clearly define childhood as separate from adulthood and rebuke any attempts to treat children in the same manner as adults.

M. Wolmar joined in the discussion and again speaks to the natural order of things: "Everything (says he) tends to the common good on the universal system of nature" (Rousseau, 1803/1989, p. 293). Saint-Preux also had his opinion about nature: "Every man at his birth brings into the world with him a genius, talents, and character peculiar to himself" (p. 299). Finally, Eloisa brings the discussion around to children again as she describes how it is best to educate the young: "If nature has given to the brain of children that softness of texture, . . . it is not proper for us to imprint . . . insignificant words of no meaning to them while young, nor of any use to them as they grow old" (p. 322). The theme of reason echoes throughout this letter as the three characters discuss the education of the Wolmar children. Eloisa remarks: "The common error of parents . . . is to suppose their children capable of reasoning as soon as they are born. . . . Reason is the instrument they use, . . . the art of reasoning is the last and most difficult to learn" (pp. 290–291).

Eloisa is convinced that reason does not develop until later in life, as she explains to Saint-Preux: "The understanding does not begin to form itself till after some years, and when the corporal organs have acquired a certain consistence. The design of nature is, therefore, evidently to strengthen the body before the mind is exercised" (Rousseau, 1803/1989, p. 292). Once understanding is in place, instruction can begin. At this point in the conversation Eloisa states that she has adopted M. Wolmar's rules of education but felt she was less philosophical than her husband. Eloise explains her guiding principle to mothering and caring for her children: "namely, to make my children happy" (p. 301).

Eloisa shows her awareness of what we know today as developmental child study. She comments that her children are not ready for learning at this point in their maturation: "I am a woman, and a mother, and know my place and my duty; hence, I say again, it is not my duty to educate my sons, but to prepare them for being educated" (Rousseau, 1803/1989, p. 318). Rousseau believed in negative education at an early age, that is, no education at all until twelve years of age. Instead, he advocated a closeness to nature. Eloisa then explained her husband's philosophy toward reason: "M. Wolmar lays, indeed, so great a stress on the first dawnings of reason, without considering that nothing is less necessary than for a man to be a scholar, and nothing more so than for him to be just and prudent" (p. 323).

Finally, in addressing the theme of freedom, Eloisa had two objectives, "namely, permitting the natural disposition and character of her children to discover themselves, and empowering herself to study and examine it" (pp. 326–327). She explained further: "My children lie under no manner of restraint, and yet cannot abuse their liberty. . . . They think themselves neither powerful men nor enslaved animals, but children, happy and free" (p. 327).

Eloisa concludes her discussion about child-raising by likening it to gardening: "A naughty word in their mouths is a plant or seed foreign to the soil . . . I only weed to garden by taking away the vicious plants: it is for him to cultivate the good ones" (p. 329). In this passage Rousseau shows his desire for great control over the "bad" influences in a child's life so there is only an illusion of freedom. Eloisa attempts to empower all mothers by declaring their importance in educating and

raising their children: "O ye mothers of families! when you complain that your views, your endeavours, are not seconded, how little do you know your own power!" (p. 330).

EMILE

Following *Eloisa*, Rousseau published *Emile* (1762). This work continued to synthesize the opinions expressed in *Eloisa*. Here we find a concise plan to teach drawing to children as part of their education. The guiding principle for Rousseau was a respect for, and an acquiescence to, nature. In the author's preface Rousseau wrote: "We know nothing of childhood; . . . The wisest writers . . . are always looking for the man in the child, without considering what he is before he becomes a man" (Rousseau, 1911, p. 1).

Rousseau continued to explain the purpose of his book, which originally was to be a treatise of a few pages: "It is to this study that I have chiefly devoted myself, so that if my method is fanciful and unsound, my observations may still be of service" (Rousseau, 1911, p. 1). Rousseau urged his readers to consider his opinions: "When I freely express my opinion, I have so little idea of claiming authority that I always give my reasons, so that you may weigh and judge them for yourselves; I think it my duty to put [my ideas] forward; . . . for on them depends the happiness or the misery of mankind" (p. 2).

From *Emile* (1762), the reader will discover Rousseau's deep concern for children. The work is divided into five books, each covering a different age span: Book I—infant to five years of age, Book II—ages five to twelve, Book III—ages twelve to fifteen, Book I—ages fifteen to twenty, and in Book V—the education of girls (Sophy) is discussed. Rousseau advocated freedom of the body as opposed to swaddling so common at that time: "We make our children helpless lest they should hurt themselves." He then asks his readers: "Is not such a cruel bondage certain to affect both health and temper? . . . They cry because you are hurting them; if you were swaddled you would cry louder still" (p. 11).

Rousseau also encouraged maternal feeding as part of natural child-raising. "Since mothers have despised their first duty and refused to nurse their own children, they have had to be entrusted to hired nurses. Finding themselves the mothers of a stranger's children, without the ties of nature" (p. 11). He asked the question: "Does not the child need a mother's care as much as her milk?" He then wrote: "Other women, or even other animals, may give him the milk she denies him, but there is not substitute for a mother's love" (p. 13). He believed this was the remedy for a faltering society: "But when mothers design to nurse their own children, then will be a reform in morals. . . . The charms of the home are the best antidote to vice." He concluded this argument: "Thus, the cure of this one evil would work a wide-spread reformation; nature would regain her rights. When women become good mothers, men will be good husbands and fathers" (p. 14).

Rousseau stressed that learning has a developmental pattern and that sense perception is necessary before cognition (memory) is in place. He believed that it is through the senses that thought begins:

The child's first mental experiences are purely affective, he is only aware of pleasure and pain; it takes him a long time to acquire the definite sensations which show him things outside himself, but before these things present and withdraw themselves . . . from his sight, taking size and shape for him, the recurrence of emotional experiences is beginning to subject the child to the rule of habit. (Rousseau, 1911, p. 29)

Later in Book II, Rousseau continued to write on this subject and recommended that we not only sensitize ourselves through training but also use our senses to form an opinion and pass judgments.

Rousseau discussed the use of observation and experience to understand abstractions. He recommended: "Let the child's vocabulary, therefore, be limited; it is very undesirable that he should have more words than ideas, that he should be able to say more than he thinks" (Rousseau, p. 40). Rousseau found the peasants shrewder than city folks; and he attributed this shrewdness to a smaller vocabulary. "They have few ideas, but those few are thoroughly grasped." In *Emile*, Rousseau extolled childhood: "Men, be kind to your fellow-man; this is your first duty, kind to every age and station, love childhood, indulge its sports, its pleasures, its delightful instincts" (p. 43).

Rousseau was especially concerned with the development of the child's sense of sight. "It takes a long time to compare sight and touch, and to train the former sense to give a true report of shape and distance" (Rousseau, p. 107). He recommended the study of drawing from nature with the intention of forming skilled workers who are not necessarily artists. He introduced a drawing lesson when Emile was twelve years of age. "All children in the course of their endless imitation try to draw; and I would have Emile cultivate this art; not so much for art's sake, as to give him exactness of eye and flexibility of hand" (p. 108). He was also interested in developing an understanding of perspective, but Rousseau discouraged the drawing from copies that was common practice at the time to prepare designers and pattern work for the factories:

So I shall take good care not to provide him with a drawing master, who would only set him to copy copies and draw from drawings. Nature should be his only teacher, and things his only models. He should have real things before his eyes, not its copy on paper. . . . I would even train him to draw only from objects actually before him and not from memory . . . for fear lest he should . . . lose his sense of proportion and his taste for the beauties of nature. (p. 108)

Rousseau has an objective for this exercise: "My purpose is rather that he should know things than copy them" (p. 109).

Of note is a passage in which the author described using drawings as decorations. This is a tiny premonition of the later aesthetic Window acceptance and ap-

preciation of children's drawings. Rousseau then took this gesture and made a platitude of the entire matter; nevertheless, this foreshadows the coming change of attitude toward this precious part of childhood. The author began to describe their need for decorations and found Emile's drawings useful for this. He described the arrangement for the room showing the progress in skills:

The first and roughest drawings I put in very smart gilt frames to show them off; but as the copy becomes more accurate and the drawing really good, I only give it a very plain dark frame; it needs no other ornament than itself, and it would be a pity if the frame distracted the attention which the picture itself deserves. Some day perhaps "the gilt frame" will become a proverb among us, and we shall be surprised to find how many people show what they are really made of by demanding a gilt frame. (Rousseau, 1911, p. 109)

This, then, is the first literary example of framing children's drawing/art. It is obvious that Rousseau did not appreciate the beauty of child art, yet he saw the importance of representational drawing, and in some way by gilt-framing these lovely first drawings, perhaps he intuitively saw the change that was to come. His comment that the drawings "would be a source of interest to ourselves but of curiosity to others" illustrates this point (Rousseau, 1911, p. 109). Yet, Rousseau showed that he wants to progress with greater and greater accuracy and control for the children so drawing has only a pedagogical value for them. Rousseau coupled the study of geometry with drawing. He stated that geometry is taught for the purposes of reasoning yet it should be taught for the art of seeing. He recommended: "Draw accurate figures, combine them together, put them one upon another, examine their relations, and you will discover the whole of elementary geometry in passing from one observation to another without a word of definitions, problems, or any other form of demonstration but super-position" (p. 111). Rousseau suggested that the student will discover the reasoning behind the study of geometry with this method. He was careful to point out: "Geometry means to my scholar the successful use of the rule and compass; he must not confuse it with drawing, in which these instruments are not used." So by including drawing in his course of study for Emile, Rousseau was responding to his need for visual sensory enhancement. Children's drawing was at this point a means to an end—becoming a more skillful worker.

To fully appreciate Rousseau's contribution to our current state of understanding childhood, it is necessary to remember that he lived in a time of transition. The mid-18th century saw the dismantling of earlier social, economic, and political institutions. The Enlightenment with its notion of progress and the Industrial Revolution brought economic changes beyond even Rousseau's imagination. There was a spirit of change and uneasiness throughout Europe, especially in France. Rousseau tapped into this sense of impending transformation, and although he often found himself an outcast for his outspokenness, he actually predicted some of these changes. With all the institutional changes, the notion of childhood also changed. Rousseau was one of the forerunners who heralded this transformation. It included the notions that children need to be revered and respected as separate

and distinct from adults and that children need to be carefully guarded from the evils of society and carefully educated to become capable members of society at their own natural pace. Finally, an analysis of the developmental stages of childhood was first presented by Rousseau. The new paradigm of childhood—or a disciplinary matrix, with its symbolic generalizations, values, and exemplars—had now been firmly established. To install shared commitments and shared values, Rousseau needed to have followers or practitioners.

Rousseau's response to the rationalism of the Enlightenment and the *philosophes* has been called Romanticism. This movement began at the close of the 18th century and continued to occupy the consciousness of Europe well into the 19th century. It is a confusing and complex movement that embodied the arts, music, and writings of many diverse people, and that diversity has made it difficult to define. It is often suggested that it is with *La Nouvelle Héloise* that Romanticism was born. "Romanticism brought in personal statement, individual insight, penetrating intuition, as these had not been known before" (Stromberg, 1966, p. 179). These were all demonstrated in this novel.

Stromberg, a noted historian, points out that Romanticism reached its pinnacle in 1810–1830 (Stromberg, 1966, p. 208). Romanticism has been defined variously as Christian, republican, liberal, and revolutionary:

It was romantic to suffer, to pray, to fight. . . . It was romantic to love passionately and transcend the conventional moral boundaries. . . . It was romantic to read about the Middle Ages. . . . Fate was romantic; so was soul-baring. . . . Romanticism was a mood and a style much more than a doctrine; moods and styles are hard to define. (p. 209)

Romanticism was about sincerity, not artificiality, and intuition, not analysis, so prevalent in the Enlightenment. Although Romanticism was primarily a literary movement, it drifted into other areas such as education. We can see the influence of Romanticism in education with the affirmation of nature and its link to humankind: "This attachment to the trees and flowers and hills had, or came to have, a metaphysical foundation which, forming a link to philosophical Idealism, is one of the leading ideas of the age. Rousseau believed vaguely that nature soothes and calms us, returning us to fundamentals and reminding us of deeper truths than those of human society" (Stromberg, 1966, p. 212).

Feelings were especially important to Romantics. Through revealing and expressing the heart, human nature could be understood and imagination could be developed. All else was abstract "intellectualizing typical of people who lacked true emotion and therefore a true soul" (Mosse, 1988, p. 29). The following chapters show the great influence Rousseau and the Romantic ideology had on developing the paradigms of children's drawing/art and demonstrate how leading voices in this inquiry were products of their time and how the Romantic "mood" exhibited its influence on them as they developed their theories of children's drawing and art.

Johann Heinrich Pestalozzi
(1746–1827)

One of Rousseau's foremost disciples, Johann Heinrich Pestalozzi, was born in Zurich in 1746 and died in 1827. He was sixteen when *Emile* was published and as a young man was receptive to the new ideas presented by Rousseau concerning his natural educational philosophy. Pestalozzi followed many of Rousseau's guiding principles. Among these is that humans are inherently good and that society corrupts this natural goodness; an education based on nature can block this breakdown of natural goodness, growth is determined by stages, and the senses are the first pathway to knowing. Pestalozzi, like his predecessor, argued that the child needed to be carefully habituated to be good.

Pestalozzi continued the discussion of children and the importance of education so resolutely put forth by Rousseau. He believed education would lead to progress or an improved society at a time that Europe was suffering because of the French Revolution and Napoleon Wars and because the Industrial Revolution was causing many families to weaken their bonds due to long working days and distant factory locations. It was the time of the Dual Revolutions and a time of crisis throughout Europe. Through all of this, both Rousseau and his disciple Pestalozzi argued that women who were encouraged to restore their families' bonds through attentive love, sensory development, and moral education could maintain society.

Like Rousseau, Pestalozzi saw the natural person in conflict with society, but, according to Pestalozzi, the natural person and the social person could complement one another. A natural education would achieve a complementary blend in which he recognized three phases in development: childhood as the natural state, adolescence or the social state, and maturity, where the moral state is achieved.

Pestalozzi's many writings converged upon his two greatest concerns: the poor and the education of children. Always interested in the concerns of his countrymen, Pestalozzi personally felt obligated to help those who could not help them-

selves. His active concern with improving the lives of the poor is well documented. He lived in the late 18th century, at a time when the economy was shifting from farming to industry. As the population was growing, people were looking desperately for income, as Europe was moving toward an Industrial Revolution, which brought many new conditions and problems. Established traditions had to be established as people learned to handle currency and be educated.

"The initial phase of the Industrial Revolution 1776 to 1850 caused a social dehumanization of the working man" (Gutek, 1968, p. 17). This affected entire families that were required to go to the factories and work long hours. With this breakdown of the family structure, children were neglected, and that soon led to delinquency. Neglect of working-class children now had two supports: "[1] The Calvinist concept that the child was born in sin and naturally corrupt; [2] the concept born during the Industrial Revolution that the working class, as the dregs of society, produced children who were vicious, idle, and mean" (p. 18). In contrast, Pestalozzi agreed with Rousseau that the child has a natural goodness and that it is the environmental instability that causes this malaise. In this place and time Pestalozzi found himself in the struggle for the improvement of all society through an educational plan, and this is where we find his point of departure for his entire life's work.

After college, Pestalozzi bought a tract of land at Neuhof with the intention of settling down in an agricultural life to be close to nature. He married in 1769, and his wife gave birth to their son a year later. In the winter of 1774–1775 the Pestalozzi family opened their home to poor and abandoned children of the area for a simple education rather than subject them to all sorts of indignities and overwork in the textile factories. In Rousseau fashion, Pestalozzi planned to prepare the children toward better futures by educating them according to "nature." He insisted that the children be prepared for their futures so that when they left the school, they could find a practical and satisfying life. From the onset, the project was plagued by a series of missteps. As sincere as Pestalozzi was for his cause, many of the children and their parents saw his school as an opportunity to receive clothes and food gratis without investing themselves in any of Pestalozzi's teachings and philosophy. By 1780 bankruptcy forced Pestalozzi and his wife to close their doors.

HOW FATHER PESTALOZZI INSTRUCTED HIS THREE AND A HALF YEAR OLD SON

Pestalozzi's first son was specially named Jacob or Jacobli, some say in homage to Rousseau. A short work, *How Father Pestalozzi Instructed His Three and a Half Year Old Son* (1774), records the daily education of young Jacobli based on nature, like Emile, young Jacobli could not read or write at twelve years of age: "Things before words, the intuition of sensible objects, few exercises in judgment, respect for the powers of the child, an equal anxiety to husband his liberty and to secure his obedience, the constant endeavor to diffuse joy and good humor over education— such were the principal traits of the education which Pestalozzi gave his son"

(Compayre, 1910, p. 420). Whereas Rousseau invented a child (Emile) on whom to try out a hypothesized experimental natural education method, Pestalozzi used his son to this end. Pestalozzi was, like Rousseau, concerned with a strict level of obedience or control. His journal is important as well as interesting, for it reveals to the reader a father whose intent is to apply Rousseau's theories to the education of his son with assiduous care but who is faced with the realization that he disagrees on many points. This journal shows a clear reflection of Pestalozzi's educational principles which in many cases proved to be a reaction against Rousseau's theories. Following the closure of Neuhof in 1781, Pestalozzi published his educational romance, *Leonard and Gertrude*. This novel is about a working-class family, with the mother, Gertrude, elucidating Pestalozzi's educational theories. This work helped to launch Pestalozzi as a European thinker and it received the gold medal award from the Economic Society of Berne. Just as Rousseau used the character Eloisa, Pestalozzi used the character Gertrude to reveal how education is vital to reshape the new society. Also like *La Nouvelle Héloise*, the novel was read for its romantic subject and generally ignored for its educational content.

The plot centered around Gertrude's ability to restore order to the village after the local bailiff brought havoc on the community. Through the character of Gertrude, the noble and sensible mother and teacher, the villagers learned that they could change the situation caused by the bailiff and that any improvement in their lives would come to them through a natural education. Like Eloisa, Gertrude educated her children through their senses by observing nature. Through Gertrude and her home education of a spiritual, intellectual, and natural focus, that the village is restored to its former morale and economic status.

After the closing of his school at Neuhof, even though his novel had been a success, Pestalozzi was despondent and he withdrew for many years to continue to write about the poor and his thoughts regarding social and educational reform. Finally, in 1790 he was appointed by the government to take charge of an institution at Stanz for poor children and orphans. This gave Pestalozzi an opportunity to try out his newly developed pedagogy and the efficacy of his theories of development in an attempt to elevate the human condition. Although Pestalozzi published many other works, most interesting for this inquiry are an examination of *How Gertrude Teaches Her Children* (1800) and the *Letters to Greaves* (1827), which show Rousseau's continuing influence and the inclusion of children's drawing into the educational curriculum for children.

HOW GERTRUDE TEACHES HER CHILDREN

How Gertrude Teaches Her Children, first published in 1800, is an extension of the earlier publication, *Leonard and Gertrude*. It was written as a series of fourteen letters to Gessner, who was Pestalozzi's publisher in Zurich. This work demonstrates the development of man's moral, physical, and intellectual abilities through natural education as influenced by Rousseau. Pestalozzi personally struggled to develop a natural system of education that is founded on one central principle,

Anschauung. This German term when translated means "sense impressions." In his editor's notes to *How Gertrude Teaches Her Children*, Ebenezer Cooke wrote:

Pestalozzi uses the word *Anschauung*: 1. For the knowledge obtained by the direct contemplation of the object before the senses—sense-impression. 2. (a) For the mental act by which the above knowledge is obtained—observation, (b) And for the mental faculties, by which it is obtained—the senses (c) And again, for objects of the world, about which such knowledge is gained—seen objects. (Pestalozzi, 1889/1977, pp. 9–10)

Pestalozzi believed that *Anschauung* was his most important offering to pedagogy. It was used and applied across the entire curriculum, in arithmetic, reading, geography, the physical and natural sciences, religion, and drawing. *Anschauung* was a departure from the standard pedagogy that was then current. Children were educated with abstractions that provided no experiential knowledge for them to grasp the meaning. For example, children were taught about the government yet had no reference point from which to understand this concept. *Anschauung* showed most clearly that Pestalozzi was influenced by Rousseau's experiential and sensory educational methods, and there is also a sense of the Lockean principle of tabula rasa, that the mind is a blank slate until the senses receive information through experience:

The sentiment, of course, is impelled and amplified by the idea of harmony, and it is a return to the Greek vision, a turning away from progressivism. This is but one more of our modern ironies, for, what we ordinarily mean today by "progressive" education—education based on "learning by doing," on "experience," on "real life"—is, in fact, a reactionary idea, and one with impeccable "conservative" credentials. (Pestalozzi, 1889/1977, p. xxxi)

To move from the natural state into the social state, it was necessary to move into the moral state, which he considered the keystone to his system: "How is religious feeling connected with these principles which I have accepted as generally true for the development of the human race?" (Pestalozzi, 1889/1977, p. 283).

In his search for the beginning of this developmental process, Pestalozzi suggested that it all begins with the love a child learns from his mother. Upon this love, trust is developed and when the child is appeased, he or she then learns and understands gratitude: "The germ of love, trust, and gratitude soon grows. The child knows his mother's step. . . . He loves those who are like her. . . . The germ of human love, of brotherly love is developed in him" (Pestalozzi, 1889/1977, pp. 284–285). Through a child's bond with his mother the child then moves into the social state with ever widening circles of personal affiliations.

Pestalozzi was very much aware of the social aspect of education. It is apparent in his suggestions of what today we refer to as peer pressure, peer modeling, and role-playing—all important in the socialization process. He also seems aware of critical periods of development. Another key term of Pestalozzi's theory is *Fertigkeiten*, which when translated literally, means "promptitude" or "readiness."

Pestalozzi saw "readiness" as the crucial factor for successful learning (Pestalozzi, 1889/1977, p. 14). He wrote: "Learn therefore to classify observations and complete the simple before proceeding to the complex. Try to make in every art graduated steps of knowledge, in which every idea is only a small, almost imperceptible addition to that which has been known before, deeply impressed and not to be forgotten" (Pestalozzi, 1889/1977, pp. 132–133).

Rousseau provided Pestalozzi with a philosophy of education through nature and the senses, which Pestalozzi elaborated into an educational psychology. He wrote in *How Gertrude Teaches Her Children*: "I now sought for laws to which the development of the human mind must, by its very nature, be subject. I knew they must be the same as those of physical Nature, and trusted to find in them a safe clue to a universal psychological method of instruction" (Pestalozzi, 1889/1977, p. 132). Out of the concepts of stages of development and simplicity of information, Pestalozzi identified three elements: language, form, and number. "An element was a point of origin from which appropriate exercises could be devised to develop each of these fundamental powers" (Gutek, 1968, p. 93). Here within the elements Pestalozzi looked for the root of all knowledge.

Focusing on the subject of children's drawing/art, *How Gertrude Teaches Her Children* offers some insight into Pestalozzi's viewpoint. Pestalozzi placed this subject as a category of the element of form and conjoined it to the importance of measuring; "Thus the capacity of measuring correctly ranks, in the art education of our race, immediately after the need of observation" (Pestalozzi, 1889/1977, p. 186). Cooke provides for the reader an insight to the term "form" that is clearer than the explanation of Pestalozzi. In his "Notes" Cooke wrote: "[T]he manner in which we think is determined by the nature of our minds, and it is impossible for us to think of any object except as in time and space" (p. 363). Pestalozzi then defined drawing as "a linear definition of the form, of which the outline and surface are rightly and exactly defined by complete measurement" (p. 186). This contradicts the then-current art education practice that did not begin with measurement but started the children with figure drawing and then, after many corrections introduced measurement. Pestalozzi was familiar with Egyptian art works and was inspired by their artistic expressions, believing that their beauty was dependent on the ability to utilize and master measurement.

Pestalozzi proposed that the best way to teach art education that incorporated using measuring aptitude was with the square: "Thus in order to found the art of drawing, we must subordinate it to the art of measuring, and endeavor to organize as definite measuring forms the divisions into angles and arcs that come out of the fundamental form of the square" (Pestalozzi, 1889/1977, p. 189). Pestalozzi then took the subject of geometry and merged it with drawing lessons to understand geometry better through measurement and visual acuity. "This ABC of Form (ABC of *Anschauung*), however, is an equal division of the square into definite measure-forms, and requires an exact knowledge of its foundations—the straight line into a vertical or horizontal position." This, of course, satisfied his sensory-impression educational goals (*Anschauung*). Pestalozzi continued to outline his program:

"As soon as the child draws readily and correctly the horizontal line, with which the ABC of *Anschauung* begins, out of the whole chaos of objects seen and shown we try to find him figures whose outline is only the application of the familiar horizontal line, or at least offers only an imperceptible deviation from it" (p. 195).

As the child improves, the figures vary, and with this method, the children move more rapidly into accurate drawings. He also found this more conducive to creating an art, "when having the measure-forms actually before him becomes gradually superfluous, and when of the guiding lines in art none remains but art itself" (Pestalozzi, 1889/1977, p. 196). Only with this statement did Pestalozzi come close to articulating an aesthetic value in his education methods. He was mainly concerned with the developmental lessons that would lead to a creation of art or actual rendering. Once he got to that point, he stopped hypothesizing. His concern with nature and its wonders never moved on to an appreciation for nature and into an aesthetic awareness or expression for his students. Perhaps it is because his primary interest was with young children, he saw drawing as a means to an end. It was not an aesthetic end, but it was sense and physical growth for children. Pestalozzi's method was pragmatic and sensible as a pedagogical tool for his mostly poor students.

Pestalozzi saw a continuum from measurement to drawing and then to writing always from the simplest to the more complex. He wrote:

Nature herself has subordinated this art [writing] to that of drawing and all methods by which drawing is developed and brought to perfection in children must then be naturally and specially dependent upon the art of measuring. . . . But also because if it [writing] is made easy to the child before drawing, it must necessarily spoil the hand [for drawing], by stiffening it in particular directions before the universal flexibility for all the forms which drawing requires has been sufficiently and firmly established. Still more should drawing precede writing because it makes the right forming of the letters incomparably easier. (Pestalozzi, 1889/1977, p. 197)

Pestalozzi's writings are somewhat indeterminate both in German and in the translations, due to his inability to formulate his thoughts and due to translation difficulties, yet an examination of his methods shows a zealous interest in the drawing skills of children. By examining the element of form, we come to understand Pestalozzi's position on drawing.

THE LETTERS TO GREAVES

The Letters to Greaves contains some of the more fluent educational writing by Pestalozzi. James Pierrepont Greaves, an Englishman and a friend of Pestalozzi, was a former student at Yverdun in 1817–1818. Pestalozzi made such an impression on Greaves that they started a correspondence in the winter of 1818–1819 to further clarify his theories after Greaves left the school. These letters, translated from German into English, were published in England in 1827, and in 1829 they

were published in the United States. In letter 24 dated February 27, 1819, Pestalozzi wrote about the element of drawing by comparing it to the imitation of sound in speech and music. "In the very same way, as this applies to the ear and the organs of speech it applies also to the eye and the employment of the hand." Pestalozzi recommended drawing for improving and sharpening children's observational skills, yet he warned, "It would be unreasonable to expect that they should begin by drawing any object before them as a whole. It is necessary to analyze for them the parts and elements of which it consists." Pestalozzi found the advantages of early drawing to be obvious to everyone: "It is from this same reason that, even in common life, a person who is in the habit of drawing, especially from Nature, will easily perceive many circumstances which are commonly overlooked, and form a much more correct impression even of such objects as he does not stop to examine minutely, than one who has never been taught to look upon what he sees with an intention to reproduce a likeness of it" (Pestalozzi, 1912/1977, p. 234).

Pestalozzi continued to write to his friend that drawing would lead to a realization of the whole and that its requisite parts would become a habit for the child that would carry over into other areas of learning and enjoyment. He reiterated that drawing should not be done from copying other drawings, but from nature:

The impression which the object itself gives is so much more striking than its appearance in animation; it gives a child much more pleasure to be able to exercise his skill in attempting a likeness of what surrounds him, and of what he is interested in, than in labouring at a copy of what is but a copy itself. . . . It is likewise much easier to give an idea of the important subject of light and shade, and of the first principles of perspective . . . by placing it immediately before the eye. (Pestalozzi, 1912/1977, p. 234)

Pestalozzi concluded in his letters that drawing was helpful in the studies of geometry and geography. As for the subject of geometry he wrote: "It must be easier to understand the properties of a circle, for instance, or of a square, for one who is already acquainted with the manner in which they are formed" (Pestalozzi, 1912/1977, p. 235). In geography, map illustration is an important subject for Pestalozzi. "It gives the most accurate idea of the proportional extent and the general position of the different countries; it conveys a more distinct notion than any description, and it leaves the most permanent impression on the memory" (p. 236).

Pestalozzi observed that children draw without any encouragement or assistance from adults but with little control, so they can't even draw a horizontal line first. They also do not seem to need any knowledge of art to find this an enjoyable pastime. He designed a model of education that put the child as the focal point. In this child-centered position, the child developed his or her own abilities, rather than memorized rote facts. He was concerned with the children's finding an education that would fit their individual life chances. Therefore, individualized education was emphasized. Also emphasized was the process of learning as much as the end results. We still see his legacy today with the interest in information-processing skills.

These writings show us the profound influence Rousseau and Pestalozzi had on pedagogy. Their writings were published when the worldview was in a state of flux due to the new ideas of progress from the Enlightenment and the Industrial Revolution. We see how they were instrumental in our current understanding of childhood as separate and different from adulthood and we see how they were pathfinders to child psychology. But perhaps their greatest contribution was their veneration for childhood and their educational innovations.

As we have seen in these innovations, they inserted drawing into the curriculum. These were a practical approach to art education and drawing. It served their larger design of educating children for the purposes of providing them with a mechanism for training the senses and developing motor skills. Rousseau and Pestalozzi saw drawing as a practical means to that end. They had little, if any, interest in the aesthetic quality of children's drawing, but their emphasis on the value and purity of childhood experience provided a base for the appreciative perspective later taken by practitioners of the aesthetic Window paradigm. At the same time, their emphasis on the particularities of child development as reflected in drawings served as an inspiration for the psychologizing of the Mirror approach to children's drawing/art. We shall trace these developments through the work of Friedrich Froebel and his successors.

4

FRIEDRICH WILHELM AUGUST FROEBEL
(1782–1852)

Perhaps the most Romantic version of childhood is found in the writings of Friedrich Wilhelm August Froebel. "Let us live with our children: then will the life of our children bring us peace and joy, then shall we begin to grow wise, to be wise" (Froebel, 1887/1977, p. 89). These words were written by Friedrich Froebel in 1826 and serve as the foundation of his life's work:

This implies on our part sympathy with childhood, adaptability to children, and knowledge and appreciation of child-nature; it implies genuine interest in all that interests them, to rejoice and grieve with them in the measure of their joy and grief, not merely in the measure of our appreciation of loss or gain, of substance or shadow; it implies seeing ourselves with the eyes of a child, hearing ourselves with the ears of a child, judging ourselves with the keen intuition of a child. (Froebel, 1887/1977, p. 90)

Froebel was born at Oberweissbach in the Thuringian forest in 1782. He grew up and was studying and writing at a time when the Protestant Reformation influenced Europe. This was an era of rejection of the authority of the Catholic Church and of a reassessment of the tenets of the Enlightenment celebrating the progress of humanism and the Romantic rebellion.

Unlike Rousseau and Pestalozzi, Froebel was deeply religious and located religion as the cornerstone of his educational system. In all his works he makes it clear that his system is built upon a moral foundation. Building on this moral education and a faith in God, he hoped to create good citizens as he wrote: "Education consists in leading man . . . to a pure and unsullied, conscious and free representation of the inner law of Divine Unity, and in teaching him ways and means thereto" (Froebel, 1887/1977, p. 2).

It is apparent from his writing that Rousseau influenced Froebel in his attitude toward children and his knowledge of child-nature. Froebel was also acquainted with Pestalozzi. These men helped to mold the life and principles of Froebel. Froebel is the third practitioner in the first childhood-pedagogy paradigm. He is responsible for adding our final element of this investigation: the installation of "creativity" into the early education of children, which then led to the importance of very explicit drawing lessons in Froebel's curriculum. With this segment in place, we can move on to the direct examination of children's drawing/art, not as a means to learn about nature or for a better understanding of mathematical study but, in and of itself, as a subject worthy of study and praise and a new paradigm, but this did not occur until the end of the 19th century.

Like Pestalozzi, Froebel is "more praised than known, more celebrated than studied" (Compayre, 1910, p. 447). Froebel chose to publish his work privately so that it was not easily obtainable, and because the bombastic and complicated language was too arduous for the general public, his readings were not widely read. Influenced by Hegel, Froebel's philosophy was diverted into the metaphysical, which added to their complexity. Although the name Froebel is synonymous with "Kindergarten" and his early child education theories were well known, his writings remain obscure.

In his autobiography (published in the English translation in 1889), he maintained the central thesis of all his works, both literary and vocational: that "all education not founded on religion is unproductive" (Robinson in Froebel, 1977, Vol. 1, p. xxxix). Compayre, a noted historian of pedagogy, contends that Froebel's writing is gnarled but "his practical work is worth more than his writings, and he cannot be denied the glory of having been a bold and happy innovator in the field of early education" (Compayre, 1910, p. 447).

There are many similarities to Rousseau and Pestalozzi in the youth of Froebel: they all lost a parent; Rousseau lost his mother at a very early age, Pestalozzi lost his father and was raised by his mother, and Froebel lost his mother shortly after his birth and was educated by his father. All, as young boys, were considered peculiar by their peers. Froebel, like Pestalozzi and Rousseau, was profoundly enraptured by nature. In his autobiography he wrote about his first Botany class at the University of Jena (1799): "However, my view of Nature as one whole became by his [the professor] means substantially clearer, and my love for the observation of Nature in detail became more animated" (Froebel, 1889, p. 31). Later, at the end of April 1805, as he contemplated the landscape at a friend's farm, he wrote: "The more intimately we attach ourselves to Nature, the more she glows with beauty and returns us all our affection." Commenting on this passage, Froebel wrote: "This was the first time my mind had ventured to give expression to a sentiment which thrilled my soul. Often in later life has this phrase proved itself a very truth to me" (pp. 48–49). During his time while an apprentice at Pestalozzi's school at Yverdon, he wrote about Pestalozzi's nature walks:

These walks were by no means always meant to be opportunities for drawing close to Nature, but Nature herself, though unsought, always drew the walkers close to her. Every contact with her elevates, strengthens, purifies. It is from this cause that Nature, like noble great-souled men, wins us to her; and whenever school or teaching duties gave me respite, my life at this time was always passed amidst natural scenes and in communion with Nature. (Froebel, 1889, p. 82)

Like Pestalozzi, Froebel tried various vocations in his early years, demonstrating his impractical nature. For both men, the field of education was settled upon with passionate enthusiasm but only after other failed attempts in other occupations. Froebel was twenty-three when he started his teaching career at Frankfurt. He was preparing for a career in architecture, but when his files were lost, he took this as a sign of God's plan for him to accept a position in the Model School of Frankenfurt-on-the-Main that was offered by his friend Gruner, who was a teacher there at the time. He wrote: "The watchword of teaching and of education was at this time the name of PESTALOZZI. It soon became evident to me that Pestalozzi was to be the watchword of my life. The name had a magnetic effect upon me" (Froebel, 1889, p. 52).

As a supporter of Pestalozzi, Froebel has been remembered for organizing his principles and methods into a system of pedagogy. Froebel went to Pestalozzi's school at Yverdon with three of his students and remained for two years (1808–1810). His apprenticeship at this time to the master had a lasting effect on his work and his life. Froebel returned to Berlin to study crystals in the mineralogical museum (1812), but after several years, he decided to devote his life to children and to their education. He opened a small school at Griesheim (1816) and eventually at Keilhau (1817), where the Pestalozzi methods were practiced. "Religion, artistic study, mathematics, language, and nature were emphasized in order to promote the individuality of each student" (Compayre, 1910, p. 456). Here Froebel published his notable work, *The Education of Man*, in 1826. This school closed in 1829, and after a few other failed attempts, Froebel became the director of an orphan asylum at Burgdorf in 1835. Here he began in earnest his efforts to develop a working pedagogy for early child education. In this small village Pestalozzi also had his asylum, where he afforded shelter and support for the destitute. The "Kindergarten" was slowly conceptualizing for Froebel; the term was first used in 1840, but the idea had been long established at Burgdorf in 1835 and in 1837 at Blankenburg, where he first founded an infant school.

By 1840 his methods became popular, but a lack of funds forced the closing of Blankenburg in 1844. He traveled throughout Germany in order to promote his methods. With the help of his benefactress, Baroness von Marenholz, he leased the Castle of Marienthal, where he established a "Kindergarten," but his work was cut short with his sudden death in 1852. At the time of his death, Froebel had many followers and inspired many educators across Europe, in England, and in the United States.

THE EDUCATION OF MAN

An examination of Froebel's major educational treatise, *The Education of Man*, will help us to understand why he has been so influential and will also enable us to better understand his principles. Like Rousseau and Pestalozzi, Froebel was interested in the development of very small children. However, Froebel, unlike Rousseau, was a man of great faith who saw the connection between the spirit of God and creativity. "God created man in his own image; therefore, man should create and bring forth like God" (Froebel, 1887/1977, p. 31). With his emphasis on creativity, Frobel began to forge new territory in education. In praise of children, Froebel wrote: "Of children, too, is the kingdom of heaven; they yield themselves in childlike trust and cheerfulness to their formative and creative instinct."

Froebel attempted to establish occupational workshops in his institutions, but his projects failed at the time, only to have the idea picked up throughout Europe in later years. Partly through these theories of Froebel, physical work is recognized as a creative activity in education. Through the efforts of Froebel: "They look to the establishment of true school workshops . . . which center in the adequate development of the physical and psychical powers of a complete human being, destined to the mastership of inner and outer life" (Froebel, 1887/1977, p. 39).

It should be understood that these school workshops differed from the manual technical schools, whose specific aim was occupational training.

Especially important for this examination was the fact that Froebel saw the importance of the arts in his curriculum. He compared the work of art to the work of God as seen in nature: "the work of art lives and moves in accordance with its spirit" (Froebel, 1887/1977, p. 162). As much as Froebel believed that art is an expression of man's internal life he wrote: "So art has links with mathematics, language, the representation of Nature, and religion" (Lilley, 1967, p. 154).

Froebel was also fascinated with child's play, and it is to his credit that the study of this pastime has become known. He described play as a "coherent system, starting at each stage from the simplest activity and progressing to the most diverse and complex manifestations of it. The purpose of each one of them is to instruct human beings so that they may progress as individuals and as members of humanity in all its various relationships" (Lilley, 1967, p. 98).

Froebel set up his kindergarten lessons in a system of sequential "Gifts" presented to the learner that served as learning tools. In 1850 he started to publish on a weekly basis what he called a "System of Gifts and Occupations." The development of this system took root as he watched children near Burgdorf play ball in the fields. It occurred to him that the ball is the essence of all play and that play was, in fact, a developmental continuum. In a pedantic and systematic way he designed the play of his kindergarten children. In the original plan of Froebel these gifts were:

A. BODIES (Solids)

1. (color) colored worsted balls, about an inch and a half in diameter;
 lesson: individuality
 (First Gift)

2. (shape) wooden ball, cylinder, and cube, one inch and a half in diameter;
 lesson: personality
 (Second Gift)

3. (number divisibility) eight one-inch cubes, forming a two-inch cube;
 lesson: self-activity
 (Third Gift)

4. (extent) eight brick-shaped blocks (2x1x1/2), forming a two-inch cube;
 lesson: obedience
 (Fourth Gift)

5. (symmetry) twenty-seven one-inch cubes three bisected and three quadrisected
 diagonally, forming a three-inch cube (3x3x3);
 lesson: unity
 (Fifth Gift)

6. (proportion) twenty-seven brick-shaped blocks, three bisected longitudinally and six
 bisected transversely, forming a three-inch cube;
 lesson: free obedience
 (Sixth Gift)

B. SURFACES: (Seventh Gift)
 1. squares
 2. half triangles
 3. thirds of triangles

C. LINES: (Eighth Gift)
 1. straight
 2. circular

D. POINTS: (Ninth Gift)
 beans, seeds, pebbles

E. RECONSTRUCTION: (Tenth Gift)
 (By analysis the "system" has descended from the solid to the point.)
 Includes softened wax pellets and sharpened sticks or straws.

 (Froebel, 1887/1977, pp. 285–286)

Note also the developmental psychological aspect pointing toward the psychologi-
cal Mirror paradigm in these gifts. Although Froebel constructed a rigid system of
play development, his choices of objects are uncomplicated, plain, and basic. The
order of these Gifts designed by Froebel not only coincided with the supposed laws
of the universe but helped the children to conform to these laws according to their
developmental level.

Along with these Gifts, Froebel also introduced Occupations to the children. These included: solids, surfaces, lines, and points, again these were made out of simple materials. There was a distinct difference between the Gifts and the Occupations. He wrote that the Gifts "are intended to give the child . . . new universal aspects of the external world, suited to a child's development. The Occupations, on the other hand, furnish material for practice in certain phases of skill" (Froebel, 1887/1977, p. 287). The Gifts were alleged to be universal and attended to the whole child, while the occupations were specific in their purpose. "The gift leads to discovery; the occupation, to invention. The gift gives insight; the occupation, power."

Most significant for this inquiry was the third Occupation, lines. In this Occupation Froebel illustrated his attitude toward drawing and painting for his students. Like Rousseau and Pestalozzi, Froebel connected drawing to mathematics, but unlike his predecessors, Froebel believed that children should be educated in the arts to assure their individuality. He also saw the aesthetic importance of art education. Drawing was not a means to an end but the end product itself. For Froebel, creativity was tied to nature. He wrote in his autobiography:

When I now glance over the earlier and later, the greater and smaller, artistic emotions which have swayed me, and observe their source and direction, I see that it was with arts as it was with languages—I never succeeded in accomplishing the outward acquisition of them: yet I now feel vividly that I, too, might have been capable of something in art had I had an artistic education. (Froebel, 1889, p. 35)

In this treatise Froebel devoted Chapter 7 to drawing, entitled "The Child's Love of Drawing." In his second or third year the child looks for additional play materials other than those he has always found enjoyable. At this point children begin to find the joy of drawing. Froebel wrote: "So the child takes pleasure in drawing and painting, and both are essential for his education" (Lilley, 1967, p. 113). In fact, Froebel went further: "Singing, drawing, painting and modeling at an early stage must, therefore, be taken into account in any comprehensive scheme of education; the school should treat them seriously and not consider that it is a matter of mere whim" (p. 155). According to Froebel, drawing is the vehicle by which the children illustrate their understanding of the world and demonstrate their creativity by recognizably visualizing their thinking. He considered it an essential part of the school curriculum, and this foreshadowed the psychological Mirror paradigm.

Keeping within his overall philosophy of developmental and sequential learning, Froebel began his very explicit and rigidly designed drawing lessons with the horizontal line followed by the vertical line. He wrote: "However little we may appreciate the fact or be able to account for it, the horizontal and vertical directions mediate our apprehension of all forms" (Froebel, 1887/1977, p. 288). Again, he connected form to spiritual energy and man's association to his surroundings. He saw this exercise as an extension of previously learned lessons that taught comparisons of lengths. He explained that "as has been said before, there should be no

break anywhere in the instruction, nothing should stand detached and isolated; but, like life, all things together should constitute an inwardly connected whole" (p. 290). The next stage in this lesson was to draw squares and oblongs. The lesson continued to extend to the shapes of squares and oblongs and then to triangles. Each shape presented a unique investigation of a line and a form. Froebel claimed that by the time the child learned the triangle, he or she reached a new stage of development—the stage of invention. "*Invention* is every spontaneous representation of the inner and by the outer, adapting itself to given external conditions, yet obeying an inner necessity easily recognized by the pupil himself" (p. 293). According to Froebel, this instruction "teaches the eye a knowledge of form and symmetry, and trains the hand in representing them; and these find much to do in all relations and activities of practical life" (p. 294). Like Rousseau and Pestalozzi, Froebel found that drawing also addresses a practical need.

He cautioned those who work with children not to stifle their attempts at drawing, as he saw every attempt valuable regardless of its outcome. He explained: "We see that the child's whole activity from his first spontaneous movement to the time when, at the age of seven or eight, his power of expression has been achieved is caused by the effort to externalise his thoughts and to assimilate his surroundings" (Lilley, 1967, p. 114). Froebel saw the importance of children's thinking and the ability that drawing presented in breaking things down into their component parts and in aiding children to find connections in seemingly dissimilar systems: "So he establishes his creativity and in his thought and observance intuitively applies the simple rules of formation which exist in his own mind" (p. 116).

Finally, Froebel summarized his overall aim and purpose of these lessons in his schools:

The effort to draw appears at an early stage of man's development; the effort to express thoughts and feelings in shape and colour also appears early, often in childhood and certainly at the beginning of boyhood. We conclude, then, that the aesthetic sense is a general property of man and should be fostered early in the child's life. In this way he will be trained to appreciate aesthetic values, and a true education at school will show him whether or not he has the ability to be an artist. In everything, whether it is life or religion or art, the ultimate aim is the clear expression of the true nature of man. (Lilley, 1967, p. 155)

It is apparent through these writings that Froebel, like his predecessors Rousseau and Pestalozzi, had enormous love for children. More importantly, he had an abiding respect for children. The consternation with which he looked at the then-current educational methods served to cause sweeping changes in the way children were both socialized and educated. His devoted followers spread his teachings across Western Europe and to the United States. Froebel's keen insight into the child's mental and emotional growth shows us the importance of play and the importance of introducing a wide range of experiences, especially art, to young children. Froebel was one of the first to insist on the efficacy of drawing in the schools for aesthetic purposes alone.

As a practitioner in the child-pedagogy paradigm, Froebel began to open new avenues for teaching but remained steadfast in his devotion to Rousseau. He desired to extend the commitments and exemplars of the child-pedagogy paradigm by supporting the early education of children rather than the noneducation of children until about twelve years of age. Like Rousseau's and Pestalozzi's, Froebel appreciated the developmental issues that were inherent in children and supported a separate and unique approach to their education, keeping in mind their needs as young minds unable to do abstract thought. Like Rousseau and Pestalozzi, Froebel's teaching theories were very rigid and adhered to strict rules of how to accomplish tasks with children in stages carefully planned and executed. This rigidity stood in a contradictory relationship to his appreciation of children's creativity—a tension manifested even more powerfully in later writers on the topic.

JOHN RUSKIN
(1819–1900)

By the mid-19th century, drawing was recommended in the education curriculum, and the movement gathered considerable momentum from artists and educators in Switzerland, Germany, and France prior to its adoption in Great Britain. One of the first artists in England to write in support of this progressive movement, put in place by Rousseau, Pestalozzi, and Froebel, was John Ruskin. Ruskin was born in 1819 of a wealthy wine merchant and an evangelical Puritan mother, both of whom devotedly tended to the needs of their only child long past his middle life, with fortunate and formidable results. "Few brains and few characters have been more profoundly influenced by the circumstances, accidents, and bonds of their family life" (Harrison, 1925, p. 8).

The upbringing of Ruskin is described by the author himself in *Proeterita and Fors* (1856–1858). He was educated first by his mother in a strict household with rigid rules and orders that included copious biblical study. Ruskin attributed his strong interest and competence in literature to these daily readings of the King James Bible. He also had an early exposure to the great English writers, including Pope, Shakespeare, and Byron. Ruskin taught himself to read and write before he was five, with impressive results, evidenced by a multitude of preserved copies of his early work—complete with drawings—collected from the age of seven. He traveled extensively throughout Europe in his childhood, paying special attention to a study of art and nature. His father's passion for art and architecture exposed Ruskin to many cathedrals, country mansions, galleries, and prominent landscapes at an early age. While Ruskin learned to copy drawings as a child, he was less successful at composing original pieces. His drawing of the landscape of nature, nurtured from his earliest youth by his parents, remained Ruskin's primary focus throughout his life. Even when he found considerable contentment in his art, in his delight in nature Ruskin discovered the greatest meaning and satisfaction in his life.

The Romantic influence of Rousseau is apparent in his overriding interest in nature and continued into his adult life. This influence also moved into the social reform area, where he even made a pilgrimage to Les Charmettes in the spring of 1849 to pay his respects at the tomb of his predecessor, Rousseau. While on this visit, Ruskin noted pessimistically in his diary "a chat with an old man, a proprietor of some land on the hillside, who complained bitterly that the priests and the revenue officers seized everything, and that nothing but black bread was left for the peasants" (Cook, 1912, Vol. 2, p. 244). Cook, his biographer, explained that this entry in the diary of Ruskin is "pointing to the awakening of those instincts of political revolt in Ruskin's mind which were to make him claim affinity with Rousseau."

At the age of eleven Ruskin was given tutors in Latin and Greek. In the spring of 1831, he was also given a drawing master, Mr. Runciman, who taught him for an hour a week. He wrote in *Proeterita*:

I suppose a drawing master's business can only become established by his assertion of himself to the public as the possessor of a style. . . . Nevertheless, Mr. Runciman's memory sustains disgrace in my mind in that he gave no impulse or even indulgence to the extraordinary gift I had for drawing delicately with the pen point. . . . Mr. Runciman gave me nothing but his own mannered and inefficient drawings to copy, and greatly broke the force of my mind and hand. (Cook & Wedderburn, 1908, p. 76)

Nevertheless, Ruskin did credit Runciman with assistance in understanding perspective, which he later found invaluable, and gracefully complimented his master: "He cultivated in me,—indeed founded,—the habit of looking for the essential points in the things drawn, so as to abstract them decisively, and he explained to me the meaning and importance of composition, though he himself could not compose" (Cook & Wedderburn, 1908, p. 77). It is important to observe that this ability to see things succinctly and clearly was the principal foundation Ruskin set for all his writing and teaching. From the beginning of his drawing exercises, Ruskin was more interested in recording a true representation of his subject than in creating a pleasing picture.

The disdain that Ruskin felt toward his drawing master was not unusual. At this time, drawing masters and mistresses were former students of the art academies of Europe. These students failed to meet the rigorous standards of the academies, and so instead they moved into these poorly paid tutorial positions. Their poor educational performance and widespread knowledge of it led the way to public ridicule of these art tutors. The pedagogy historian Macdonald explained the limits of the drawing master's task: "It was understood that his task was to help his middle-class charges to make presentable copies of landscapes, ruined abbeys, and castles, from engravings and lithographs" (Macdonald, 1970, p. 144).

Not until the age of fifteen was young Ruskin enrolled in a conventional English day school. At the age of seventeen, he matriculated at Oxford, but due to his erratic and random education it was deemed questionable if he could pass the exami-

nations, so he was allowed to enter Christ Church as a gentleman-commoner. He completed his bachelor's degree from Oxford and at this time decided against his earlier decision to enter the ministry, much to the distress of his parents. He also refused to follow his father into the sherry business. He had already begun writing *Modern Painters*, and during the fall and winter of 1842, at the age of twenty-three, Ruskin completed the first volume at home in Herne Hill. *Modern Painters*, published in May 1843, eventually grew to five volumes by its completion in 1860.

Ruskin's defense of controversial painter J.M.W. Turner became his central thesis. "His mission was to preach the aesthetic study of Nature and to justify Turner as the chief interpreter of the new Nature Worship" (Harrison, 1925, p. 41). The volume was published under the pseudonym of "A Graduate of Oxford" and caused an immediate discordant response in the artistic and literary world. The traditional voices of criticism were outraged but others saw a brilliant new voice in Ruskin. The world of culture soon would embrace Ruskin and his original and opinionated reflections on art and literature.

After the first volume of *Modern Painters* was completed, Ruskin moved on to study medieval history and art. In the winter of 1844 he resided in the historic artistic environs of Pisa and Florence, before moving on to Venice in the spring of 1845. His introduction to Tintoretto offered him an exhilarating voyage into the history of Venice "but this first vision of the Tintorettos of St. Roch seems to have been the most real and most important of all these aesthetic conversions" (Harrison, 1925, p. 48). This second volume of *Modern Painters* had two purposes: "[t]he first, to explain the quality of the beauty in all happy conditions of living organism[s]; the second, to illustrate two schools then unknown to the British public—that of the Angelico in Florence, and Tintoretto in Venice" (p. 51). Although *Modern Painters* was responsible for establishing Ruskin's prestigious position in the art and literature community and for his powerful influence, this research focuses on his writings concerning art education. It is important to note the implication that so great a voice in the culture spoke with seriousness on the subject of children's drawing and the teaching of drawing in the schools.

THE ELEMENTS OF DRAWING

Like his predecessors Rousseau, Pestalozzi, and Froebel, Ruskin was interested in the pedagogy of art. *Elements of Drawing* was prepared as an encapsulation of his teaching at the Working Men's College, founded during the cooperative movement in England. According to Litchfield, the college historian, "There was then, it must be remembered, no means by which a working man or a poor man could get, in a systematic way, any education going beyond the bare elements of knowledge" (Cook, 1912, Vol. 1, p. 378). This institution's goal was to educate the working classes in the same manner as the upper classes. The churches provided some elementary education, and the Mechanics Institutes provided the basics, but for those who had a new vision, the Working Men's College understood education not only as a means of support but as a way of life. It would satisfy both the spiritual and in-

tellectual needs of its students. This was radical at the time, and Ruskin gave it his full support. Thus, wrote Litchfield: "It [the alliance of Ruskin] not only gave a splendid start to the Art teaching, but helped the enterprise as a whole by letting the world know that one of the greatest Englishmen of the time was in active sympathy with it" (Cook, 1912, Vol. 1, p. 379). Ruskin taught and lectured at the college from 1854 to 1858 and also in 1860 until an extended visit abroad broke his customary association. Afterward, he continued with only intermittent lectures.

To outline his primary focus in these lessons, Ruskin harkened back to his first drawing master as he was quoted in one of his class discussions: "I am only trying," he said once, "to teach you to see," and then he continued to describe two men walking through a market and points out the common occurrences that were noticed by only one of them (Cook, 1912, Vol. 1, p. 380). To a Royal Commission in 1857 Ruskin described the object of his teaching at the college. "My efforts are directed," he said, "not to making a carpenter an artist, but to making him happier as a carpenter" (p. 383). Ruskin was one of the first to discuss the importance of what has become known as visual literacy. He was an outspoken proponent for art education to serve as the general improvement of the populace at large.

Ruskin was in the habit of giving drawing lessons by letter and decided that in order to save duplication in this effort he would write a drawing manual, *The Elements of Drawing*. It was published in the winter of 1856–1857 and was an immediate success. He not only gave much technical detail but also incorporated fundamental principles into this work. Relegated to a footnote, Ruskin went into great detail explaining what he referred to in Rousseauean fashion as the "innocence of the eye": "The whole technical power of painting depends on our recovery of what may be called the innocence of the eye; that is to say of a sort of childish perception of these flat stains of color, merely as such, without consciousness of what they signify,—as a blind man would see them if suddenly gifted with sight" (Ruskin, 1905?, Vols. 11–12, p. 3).

Ruskin was criticized for not properly educating future artists and professional designers through this text. His purpose, he wrote, "was not to instruct professional artists, but to show how the elements of drawing might best be made a factor in general education." He claimed that his system "was calculated to teach refinement of perception; to train the eye in close observation of natural beauties and the hand in delicacy of manipulation" and consequently he sought to help his pupils to understand how art was executed and to identify it (Cook, 1912, Vol. 1, pp. 390–391).

His original information sheet for prospective students stated:

The teacher of landscape drawing wishes it to be generally understood by all his pupils that the instruction given in his class is not intended either to fit them for becoming artists, or in any direct manner to advance their skill in the occupations they at present follow. They are taught drawing, primarily in order to direct their attention accurately to the beauty of God's work in the material universe, and secondarily that they may be enabled to record, with some degree of truth, the forms and colours of objects when such record is likely to be useful. (Cook, 1912, Vol. 1, p. 391)

In the preface of *The Elements of Drawing* the author wrote that, "the book is not calculated for the use of children under the age of twelve or fourteen. I do not think it advisable to engage a child in any but the most voluntary practice of art" (Ruskin, 1905?, Vols. 11–12, p. ix). He pointed out that the child with artistic talent would be drawing constantly. He also recommended allowing children to use color as soon as they ask for it. It was the policy in schools not to introduce color at such a young age. He recommended that the child "should be gently led by the parents to try to draw, in such childish fashion as may be, the things it can see and likes,—birds, or butterflies, or flowers, or fruit" (Ruskin, 1905?, Vols. 11–12, p. ix). He further suggested that the boy should be provided with a few well-done prints. This shows a more natural method without the structured and rigid approach taken by Pestalozzi and Froebel: "If a child has many toys, it will get tired of them and break them; if a boy has many prints he will merely dawdle and scrawl over them; it is by the limitation of the number of his possessions that his pleasure in them is perfected, and his attention concentrated" (Ruskin, 1905?, Vol. 11, pp. ix–x).

Ruskin encouraged the parents of young children not to concern themselves with drawing lessons until they are older. He carefully prepared them in how to respond to this important pastime of childhood:

The parents need give themselves no trouble in instructing him, as far as drawing is concerned, beyond insisting upon economical and neat habits with his colors and paper, showing him the best way of holding pencil and rule, and, so far as they take notice of his work, pointing out where a line is too short or too long, or too crooked, when compared with the copy; accuracy being the first and last thing they look for. If a child shows talent for inventing or grouping figures, the parents should neither check or praise it. They should praise it only for what costs it self-denial, namely attention and hard work; otherwise they will make it work for vanity's sake, and always badly." (Ruskin, 1905?, Vol. 11, p. x)

He further stated that at twelve or fourteen is the age when children can begin to seriously study drawing with the aid of his book. *The Elements of Drawing* had a wide influence not only in England, but in America, Germany, and Italy.

EDUCATION IN ART

The second art education work of Ruskin, *Education in Art*, was presented for Ruskin before the National Association for the Promotion of Social Science in the fall of 1858 and printed in the *Transactions* of the Society for that year. In this paper Ruskin stated his central premise, the notion that art has a universal language:

But the question . . . lies in the same light as that of the uses of reading or writing; for drawing . . . is mainly to be considered as a means of obtaining and communicating knowledge. He who can accurately represent the form of an object, and match its color, has unquestionably a power of notation and description greater in most instances than that of words; and this science of notation ought to be simply regarded as that which is concerned

with the record of form, just as arithmetic is concerned with the record of number. (Ruskin, 1905?, Vols. 9–10, p. 117)

Ruskin clearly tried to convince his readers of the practicality and usefulness of this skill. Ruskin was of the opinion that "true taste" in art is not for all the classes, "yet, I believe we may make art a means of giving him [the peasant] helpful and happy pleasure, and of gaining for him serviceable knowledge" (Ruskin, 1905?, Vol. 9–10, p. 118).

By positioning local natural history instruction in the schools, Ruskin believed that peasant children could be taught the appreciation of local flora and fauna, "so that our peasant children may be taught the nature and uses of the herbs that grow in their meadows, and may take an interest in observing and cherishing, rather than in hunting or killing, the harmless animals of their country" (Ruskin, 1905?, Vols. 9–10, p. 118). Like his predecessors, Ruskin advocated drawing from nature. He recommended conjoining the subject of natural history with art lessons. He wrote: "The student's aim should be absolutely restricted to the representation of visible fact. All more varied or elevated practice must be deferred until the powers of true sight and just representation are acquired in simplicity" (p. 119). He was not concerned that they learn art theories, but he wrote: "In our higher public schools . . . drawing should be taught rightly; that is to say, with the succession and security of preliminary steps,—it being here of little consequence whether the student attains great or little skill."

Ruskin did not expect every child to become an artist, but he believed that every child was capable of understanding the basics. He voiced a concern that the public at large

[d]o not believe the principles of art are determinable. . . . They did not believe that good drawing is good, and bad drawing bad, whatever any number of persons may think or declare to the contrary—that there is a right or best way of laying colors to produce a given effect, just as there is a right or best way of dyeing cloth of a given color, and that Titian and Veronese are not merely accidentally admirable but eternally right. (Ruskin, 1905?, Vols. 9–10, p. 120)

Ruskin blamed the painters for this ignorance. According to him, they seemed to perpetuate the notion that the ability to draw and paint is a gift and cannot be learned through hard work and practice:

Every great painter knows so well the necessity of hard and systematized work in order to attain even the lower degrees of skill, that he naturally supposes if people use no diligence in drawing, they do not care to acquire the power of it, and that the toil involved in wholesome study being greater than the mass of people have ever given, is also greater than they would ever be willing to give. Feeling also, as any real painter feels, that his own excellence is a gift, no less than the reward of toil, perhaps slightly disliking to confess the labor it has cost him to perfect it. (Ruskin, 1905?, Vols. 9–10, p. 120)

Ruskin found this deceit unjust and suggested that when girls learn of the persistence necessary to learn to draw, they will work hard to succeed in their skills. It must be understood as a language with its own rules of grammar and syntax. Ruskin continued to support the importance of art education. At this time, very few girls had drawing lessons and he encouraged them to learn drawing skills. He added a new level of discourse into the discussion: "I attach great importance to the sound education of our younger females in art, thinking that in England the nursery and the drawing room are perhaps at the most influential of academies" (Ruskin, 1905?, Vols. 9–10, p. 121).

Thus we have Ruskin's theories on early art education. This was a natural evolution of the writings of Rousseau, Froebel, and Pestalozzi, yet Ruskin did not openly express the respect and regard for children that had been demonstrated by the former theorists. His concern was for the advancement of art for all Englishmen. In his discussions concerning children, Ruskin was more interested in preparing them for a future life of appreciation and respect for art with reasonable knowledge of what is exemplary art and what is inferior art. He did not appreciate the early "scrawling" of children as charming and beautiful. Art, at this point and in his mind, must be representational if it is to be admired. A youngster must labor and study to achieve this skill. On the other hand, we see something different in Ruskin because he taught from the point of view of an art critic and an artist. This allowed him to advocate much more freedom than Pestalozzi and Froebel. He did not strive for better accuracy from young children as his predecessors had done. He, in fact, did not encourage early lessons for children. In the spirit of Rousseau he supported noneducation in the early years of the child and encouragement of the creativity and spontaneity of young child artists—at least until they reached twelve!

John Ruskin was the predominant artistic opinion maker of mid-19th- century England. He worked to show others how to see and imagine a world in which art would play a pivotal role. For a person of his stature to support the calls for the addition of drawing as necessary to a sound curriculum was indeed a boost to the cause of educational reform. His appreciation and love of children were never expressed with quite the respect and adulation of his predecessors, but his enthusiasm for this subject is indisputable. He did acknowledge the natural inclination of children toward drawing, and he supported leaving them unfettered by lessons and directive teaching until a later age. Ruskin also sowed the seeds of two very important points in the subsequent discussion of children's drawing/art. The first is that drawing can be looked upon as a universal language, and second is that we must learn to draw what we see. These predominant themes along with the emphasis on creativity—were reiterated often in the ensuing discussions and investigations of children's drawing/art and led toward the aesthetic Window paradigm.

6

HERBERT SPENCER
(1820–1903)

If Ruskin prefigures the Window paradigm, his contemporary, Herbert Spencer, prefigures the Mirror paradigm. Spencer (1820–1903) was born in Derby and raised in a middle-class family in England during the first part of the 19th century, a time of great social change. Unlike John Ruskin, Spencer was a man more interested in the sciences than in the arts. He is considered a philosopher but is known best for his work in evolutionary theory. Spencer, together with Charles Darwin and Thomas Huxley, is responsible for the general acceptance of the theory of evolution. In his ten-volume work, *Synthetic Philosophy*, he attempted to prove that all phenomena could be interpreted by following a course of evolutionary progress. It was revolutionary thinking from an individual who was himself a nonconformist.

The expression "survival of the fittest," used to describe Darwin's theory, was coined and used for the first time by Spencer as a synonym for natural selection in *The Principles of Biology*, published in 1864 (Elliot, 1917, p. 262). He expanded this work with a second volume, completed in 1867. Spencer then revised his 1855 publication of *Principles of Psychology* to include two volumes between 1870 and 1872. These texts helped him to design a rationalistic explanation of how life adapted from inner to outer relations in a progressive manner. He is also responsible for the adoption of the discipline of sociology. In *The Principles of Sociology* (3 vols., 1876–1896) he set down the explanation of how the individual separates from the group in order to obtain increased freedom. His family epitomizes the middle-class family of this epic with their independence, energy and hard-work, no-frills ethic. "He was one of those authors of whom it may be most truly said that his works were much greater than himself; and all the best of him will be found in his philosophy" (Elliot, 1917, p. 9).

Most of what we know about Spencer has been prudently written by him in an autobiographical format. He was a meticulous recorder of his life, so the information we have is exactly what Spencer wanted us to know about him. He relates that he had a weak memory, and, perhaps related to this problem, he could not sustain reading for any great time period:

Probably there then existed as there existed later, an early-reached limit to the receptivity. It was as though my intellectual digestive system was comparatively small, and would not take in heavy meals. Possibly also the tendency then, as afterwards, towards independent thought, was relatively so dominant that I soon became impatient of the process of taking in the ideas set before me. . . . While, however, averse to lesson learning and the acquisition of knowledge after the ordinary routine methods, I was not slow in miscellaneous acquisition. General information was picked up by me with considerable facility. (Spencer, 1904, Vol. 1, pp. 91–92)

Spencer was very aware of his thinking processes and examined his cognitive abilities. At the age of thirteen, Spencer wrote of himself:

I knew nothing worth mentioning of Latin or Greek: my acquaintance with Latin being limited to an ability to repeat very imperfectly the declensions and a part only of the conjugations . . . and my acquaintance with Greek being such only as was acquired in the course of word for word translation . . . of the first few chapters of the Greek Testament. Moreover I was wholly uninstructed in English—using the name in its technical sense: not a word of English grammar had been learned by me, not a lesson in composition. I had merely the ordinary knowledge of arithmetic; and, beyond that, no knowledge of mathematics. Of English history nothing; of ancient history a little; of ancient literature in translation nothing; of biography nothing. Concerning things around, however, and their properties, I knew a good deal more than is known by most boys. My conceptions of physical principles and processes had considerable clearness; and I had a fair acquaintance with sundry special phenomena in physics and chemistry. I had also acquired . . . some knowledge of animal life, and especially of insect life; but no knowledge of botany. . . . By miscellaneous reading a little mechanical, medical, anatomical, and physiological information had been gained; as also a good deal of information about various parts of the world and their inhabitants. (Spencer, 1904, Vol. 2, p. 100)

Unlike Ruskin and the very opposite to Rousseau's model, Spencer's formal education was completed by age thirteen. He then moved in with his uncle, who prepared students for higher education. Here he studied Latin and Greek, though he was not very proficient. Rather, he was drawn to the mathematics and was most lacking in the humanities. This interest led him directly into an engineering profession that lasted for many years but eventually became only a means to earning a living and he eventually gave it up.

At this time, his attention shifted into the social, political, and religious discussions of the day. "He threw himself with a fearless courage and a radical thoroughness characteristic of a powerful theorising intellect untrammeled by considerations of expediency" (Duncan, 1908, Vol. 1, p. 44). During this period he aligned himself

with the "press gang," a group of liberal social writers, and at this time Spencer wrote his best-known educational essays.

EDUCATION: INTELLECTUAL, MORAL, AND PHYSICAL

By 1860, when he drew up the prospectus of his system of synthetic philosophy, his strictly pedagogical writings had been completed. It is interesting that the first book of Spencer's published in the United States, where subsequently he attained so much popularity, was a collection of his four famous pedagogical essays. This volume, *Education: Intellectual, Moral, and Physical,* was published in 1860 through the actions of his American friend Edward Livingston Youmans. The English edition came out the following year. Spencer, however, considered these writings only a prelude to his composite evolutionary theory of man, society, and all of nature. The writings on education were from a flexible time in his philosophical career: "In its relation to his life it appears as a sort of summary review of the lessons which his childhood training and his youthful studies had taught him" (Royce, 1904, pp. 126–127).

The essays, published in a single volume in 1861, had already been individually published between 1854 and 1859. This volume is germane for our purpose of examining children's drawing/art. Like many others, Spencer felt that children's drawing should be incorporated into the curriculum of the elementary schools. It is significant that a man so vociferous on matters of social justice and higher scientific inquiries found this a subject of such importance. Like his predecessors, he believed that the education of children was necessary for the continuation of a wholesome civilization and for progress in citizenry.

Although Spencer readily pointed out that his doctrine was not new, he did deviate from the current reforms that were preparing the youngsters of the country for a more technological society in one area. "How to live? —That is the essential question for us. Not how to live in the mere material sense only, but in the widest sense" (Spencer, 1911, p. 6). In his essay "What Knowledge Is of Most Worth?" he maintained that the purpose of education was to prepare us for complete living and that an educational course should be judged on its ability to carry out this function. He arranged the activities he believed necessary for this education into a hierarchy of importance:

1. Those activities which directly minister to self-preservation;
2. Those activities which, by securing the necessaries of life, indirectly minister to self-preservation;
3. Those activities which have for their end the rearing and discipline of offspring;
4. Those activities which are involved in the maintenance of proper social and political relations;
5. Those miscellaneous activities which fill up the leisure part of life, devoted to the ratification of the tastes and feelings. (Spencer, 1911, p. 7)

Spencer concurred with Rousseau's reformers when he wrote critically of those who fail to recognize the abilities of early childhood: "Not perceiving the enormous value of that spontaneous education which goes on in early years—not perceiving that a child's restless observation, instead of being ignored or checked, should be diligently ministered to, and made as accurate and complete as possible; they insist on occupying its eyes and thoughts with things that are, for the time being, incomprehensible and repugnant" (Spencer, 1911, p. 24).

Spencer understood developmental concerns and the necessity to follow prescribed paths to educating young children from concrete to abstract, and he concluded, "The training of children—physical, moral, and intellectual—is dreadfully defective." He suggested that the understanding of physiology and psychology is "indispensable for the right bringing up of children" (Spencer, 1911, pp. 25–26). Explaining the path toward this last category of educational activities, Spencer wrote: "After considering what training best fits for self-preservation, for the obtainment of sustenance, for the discharge of parental duties, and for the regulation of social and political conduct; we have now to consider what training best fits for miscellaneous ends not included in these—for the enjoyment of Nature, of Literature, and of Fine Arts, in all their forms" (p. 30).

Although he positioned the study of the Fine Arts last in his hierarchy, he wrote: "We yield to none in the value we attach to aesthetic culture and its pleasure. Without painting, sculpture, music, poetry, and the emotions produced by natural beauty of every kind, life would lose half its charm" (Spencer, 1911, p. 30). But he asserted that it is nevertheless true, that the highest Art of every kind is based on Science—that without Science there can be neither perfect production nor full appreciation" (p. 32). In fact, through science that Spencer found the under pinning for all five levels of educational activities. "Thus to the question we set out with—What knowledge is of most worth?—The uniform reply is—Science. . . . Necessary and eternal as are its truths, all Science concerns all mankind for all time" (pp. 42–43). This essay contradicted the established theory that languages (Greek and Latin) and mathematics were the basic foundations for an education.

"INTELLECTUAL EDUCATION"

Spencer's essay "Intellectual Education" contains a reference to drawing. It has been noted by all of our practitioners that children have a natural inclination for the activity of drawing, but Spencer was most notable in establishing this. "The spreading recognition of drawing as an element of education, is one among many signs of the more rational views on mental culture now beginning to prevail" (Spencer, 1911, p. 71). He called upon teachers to recognize the natural inclination of children to draw those things around them. Spencer seemed to be referring to the developmental understanding that was becoming known at the time and supported an education that would incorporate these concerns in pedagogy: "Had teachers been guided by Nature's hints, not only in making drawing a part of edu-

cation but in choosing modes of teaching it, they would have done still better than they have done." What is it that the child first tries to represent?" (p. 71). He conveyed the things children are most apt to represent as colorful and large and with pleasurable associations. The primary subject themes are people, houses, trees, and animals, which are so well known to them. "This effort to depict the striking things they see is a further instinctive exercise of the perceptions—a means whereby still greater accuracy and completeness of observation are induced. And alike, by trying to interest us in their discoveries of the sensible properties of things, and by their endeavors to draw, they solicit from us just that kind of culture which they most need" (p. 71).

Spencer also observed that color is what most interests children. He stressed its importance in the art education of children: "Paper and pencil are good in default of something better; but a box of paints and a brush—these are the treasures. The drawing of outlines immediately becomes secondary to colouring—is gone through mainly with a view to the colouring; and if leave can be got to colour a book of prints, how great is the favour! . . . The priority of colour to form, which, as already pointed out, has a psychological basis, should be recognised from the beginning" (Spencer, 1911, pp. 71–72).

In agreement with earlier practitioners, Spencer also encouraged drawing from objects, not from copies, and representational drawing attempts from the children, but, as an evolutionist, he realized that this would come only gradually, which is reason enough not to ignore those attempts that are unsuccessful realistic rendering: "No matter how grotesque the shapes produced; no matter how daubed and glaring the colours. The question is not whether the child is producing good drawings. The question is, whether it is developing its faculties. It has first to gain some command over its fingers, some crude notions of likeness; and this practice is better than any other for these ends, since it is the spontaneous and interesting one" (Spencer, 1911, p. 72).

Spencer agreed with our other practitioners such as Rousseau, Pestalozzi, Froebel, and Ruskin that it is not necessary to give early childhood drawing lessons, but he suggested providing maps and woodcuts to "[k]eep up the instinctive practice of making representations, however rough; it must happen that when the age for lessons in drawing is reached, there will exist a facility that would else have been absent. Time will have been gained; and trouble, both to teacher and pupil, saved" (Spencer, 1911, p. 73).

Spencer vigorously condemned "the formal discipline in making straight lines and curved lines and compound lines, with which it is the fashion of some teachers to begin." He called this a "grammar of form." He compared this method with the same method used to teach language. "We are to set out with the definite, instead of with the indefinite. The abstract is to be preliminary to the concrete. . . . This is an inversion of the normal order, we need scarcely repeat" (Spencer, 1911, p. 73). He told his readers that if they followed his guidelines and principles of education, drawing should be included throughout the process with confirmation and support.

Spencer supported the belief put down by Pestalozzi and applied by Froebel that geometry and the manipulation of lines and cubes are helpful in the practice of drawing and in learning perspective. He placed his advice within a developmental, evolutionary framework:

In the early civilisation of the child, as in the early civilisation of the race, science is valued only as ministering to art; it is manifest that the proper preliminary to geometry, is a long practice in those constructive processes which geometry will facilitate. Observe that here, too, Nature points the way. Children show a strong propensity to cut out things in paper, to make, to build—a propensity which, if encouraged and directed, will not only prepare the way for scientific conceptions, but will develop those powers of manipulation in which most people are so deficient. (Spencer, 1911, p. 76)

Spencer found the best education by looking toward nature. As for his predecessors, it is a dominant theme of his pedagogical theory. In his autobiography, Herbert Spencer wrote, "Butterflies are very good objects for first drawing lessons; since they present little more than colours on a flat surface, and thus differ comparatively little from copies." Butterflies allow a child to concentrate less on lines and more on the process of coloring:

Initiated thus naturally, I practised drawing all through boyhood to a greater or less extent: working energetically for a time; then tiring and abandoning it; then after an interval discovering on resuming it how much better I drew than before: one of those effects of the normal spontaneous development of the nervous system in progressing towards its adult structure, which is too much ignored in interpreting psychological phenomena. (Spencer, 1904, vol. 1, pp. 84–85)

This helps us to understand his position that drawing should not be taught until twelve years old. As Spencer's drawing ability improved, he began to sketch from nature in the countryside. He was given a kit to take with him that included a stool and board shaped like a walking stick. He wrote: "I remember how proudly I sallied out with it to make my first sketch" (Spencer, 1904, Vol. 2, p. 85). So we have two drawing systems in place: one that favors to the natural form in all its splendor and precision to serve as the model for drawing and the more classical method that uses geometry and progresses sequentially and analytically by introducing parts before wholes and focusing on lines rather than form. Spencer urged the educators to consider psychology in their methodology. He mapped out a progress of the child from simple to complex and from concrete to abstract as established by psychology and discussed in Pestalozzi's "elements." Spencer went to great lengths to establish evolutionary theory in the pedagogy, applying developmental theory specifically to the teaching of children's drawing.

Herbert Spencer embodied the archetype of the liberal mind in mid-Victorian England, that is, the belief in progress through science, the rejection of any and all authority except science, and support for self-government. This, combined with his heterodox opinions and the introduction of evolutionary theory, created a

character of revolutionary stature. We see a new utilitarian model here, linked to science and evolutionary theory. Spencer is the kind of practitioner who causes paradigms to shift. "In Herbert Spencer, the individualist tendency of the age was exaggerated to the point of caricature" (Wingfield-Stratford, 1930, p. 250). Certainly, he was instrumental in setting up the psychological Mirror paradigm. He had symbolic generalizations, shared commitments, shared values, and shared exemplars. This is an example of what Kuhn wrote about, that is, shifting voices in one field creating change in another field:

In short, the total range of Spencer's mind, life, however extreme, exaggerated, and eccentric, is part of that complex cluster of ideas, events, and individuals that make up Victorianism and the Victorian Age. Yet although he shared the Victorian frame of mind, Spencer's ideas are not necessarily circumscribed by the limits of a clearly defined historical period, for the Victorians grappled with questions of universal import: man's place in life, his institutions, and his moral and intellectual development. (Kazamias, 1966, p. 15)

Spencer was a diversified writer who contributed to the subjects of philosophy, sociology, psychology, economics, education, and music. It is significant that, once again, a person of his stature saw the importance of children's drawing just as Rousseau, Pestalozzi, and Froebel did before him, in addition to his contemporary, Ruskin. The notion of childhood as a developmental period distinct from adulthood is further installed into the mind-set of the writers and thinkers of the age. But the child's drawing still remained a means to an end. The objective of children's drawing in Spencer's mind, as shown with all the previous writers, is a progression toward adult representational drawing. It served to promote coordination and dexterity as well as a sense of proportion and sensibility toward beauty. But it was also seen in a different way because it was now specifically part of a developmental psychology.

International Conference of Education (1884): Colliding Theories in Art and Education

Toward the last quarter of the 19th century great changes were made in art education, influenced primarily by John Ruskin. Although Ruskin taught very little, his writings were widely acclaimed and well received throughout Great Britain. By 1880, national systems of public education were established throughout Europe and the United States that were universal and compulsory, but these systems were largely limited to a few years of elementary education. Of particular interest to this inquiry were the schools of design. In England, during the period from 1852 to 1873 and under the leadership of Henry Cole, the Department of Practical Art oversaw an expansion of art education that was supported by the establishment of art institutions. From the 1830s numerous towns began to open schools of design, mainly to train unskilled workers in craft techniques to use in the local factories and shops. "In 1853 legislation was enacted to create many more Schools of Design, to centralize the direction of those already in existence, and to impose a national curriculum and schedule of examinations on all such establishments funded by the public purse" (Thistlewood, 1985, p. 80).

The purpose of these schools was to train artisans in England to make patterns and designs for the textile manufacturers. This major export good was an important impetus for the industries to encourage the establishment of design schools rather than rely on the importation of foreign-trained artisans:

In response to the demand for homegrown artisans capable of preparing and executing textile designs comparable to the high quality of European work, the Schools of Design were established in 1836 at Somerset House. Branch schools in major manufacturing towns throughout England were set up shortly thereafter. Thus the origins of the South Kensington Schools of Design are tied to economic goals: British industry, despite its renowned efficiency seemed to be ailing. (Savage, 1985, p. 94)

With the burgeoning interest in the establishment of art in the schools of Great Britain tied to the economic development and spurred on by the industrial age, it is no wonder that there was interest in the writings of Rousseau, Pestalozzi, Froebel, Ruskin, and Spencer. Their influence can be seen at the International Conference of Education at the Health Exhibition held in London in 1884: "It was in all probability the first gathering on a large scale at which methods of art teaching were freely discussed, and problems such as the use of the imagination were voiced publicly for the first time. It gave the reformers a chance to confront the advocates of established methods, and the latter certainly had to listen to some forthright views" (Carline, 1968, p. 30). Educators from all over Europe attended this groundbreaking conference. Here we can see new and opposing themes developing as the old pedagogical paradigm began to reveal internal tensions. The conference was divided into four sections and lists of subjects:

SECTION A.—VOLUME I
> Conditions of Healthy Education
> Infant Training and Teaching
> Organisation of Elementary Education
> Inspection and Examination of Schools
> Gymnastic and Other Physical Exercises.
> Teaching of Music in Schools

SECTION B.—VOLUME II
> Technical Teaching
>> a. Science
>> b. Art
>> c. Handicrafts
>> d. Agriculture
>> e. Domestic Economy
> Subsidiary Aids to Instruction
> Thrift in Schools

SECTION C.—VOLUME III
> Organisation of University Education

SECTION D.—VOLUME IV
> Training of Teachers
> Organisation of Intermediate and Higher Education

(Cowper, 1884, p. viii)

The "Technical Teaching" segment included art and drawing as a discussion subject. The discussions in this section offered a glimpse into the impending interest in children's drawing and the debate forming around the subject of education—a debate that would later solidify into the competing aesthetic Window and psychological Mirror paradigms. Several reformers attended this conference. Among them was Ebenezer Cooke, with an extensive background and a vociferous voice for art educational reforms. He was not only a student of John Ruskin but

eventually a colleague who helped to spread his teachings. Ruskin's greatest influence can be seen in Cooke's focus on natural artistic abilities rather than vocational abilities. Cooke was a member of the Society for the Development of the Sciences of Education, and he spoke critically of the art education system in the design schools. At the conference, the central topic presented for papers and discussion was "The teaching of drawing and colouring as a preparation for designing and decorative work." But, as Ebenezer Cooke pointed out: "This proposition is obscure, and when understood, restricted" (Cooke, 1885, p. 462). He wanted to expand the topic to begin with the early drawings of children that would then naturally lead into the intended subject put before the conference, rather than initiate discussion with a focus on the design schools and older children.

John Sparkes, who represented the School of Art, South Kensington, began the proceedings with a paper entitled, "The Teaching of Drawing and Colouring as a Preparation for Designing and Decorative work." In this paper, Sparkes outlined the education of illustrators in form and color. As he recounted the early training of these young people, one cannot help but see the influence of his early predecessors as he described the geometrical and ornamental design that were considered important in the early education of these students. "His focus, however, was with technical art that included a convergence of draughtsmanship, color, the knowledge of ornamentation, and an understanding of the technical difficulties that were inherent in production" (Macdonald, 1970, p. 301). He was interested in the artistic potential of young teenage boys only after they were accepted into the art schools. This rationale was based on the principle of payment by results. This meant that the teacher was given a grant or a percentage of it, in addition to a salary based on the success of the students' examination results (p. 207). Their training was expected to be somewhat advanced by this point. Sparkes did not indicate just how these budding artists got their start as youngsters. His paper briefly mentions what he considered the ideal drawing instruction:

The boy has learned that every figure he has drawn, whether geometric or ornamental, is built, and thoroughly built in a geometrical plan; he has been taught to analyse and dissect his copy, until he finds by habit, and almost unconsciously at last, the main lines of its construction, its proportions, the masses which contain its details, and the shapes and exact contours of those details. (Cowper, 1884, p. 201)

The abstract shape is sought before the complete form. He criticized the lack of freehand drawing and copy to which the young students were exposed:

The only instruction he may have received when he had sketched his copy has amounted to little, perhaps, no more, than to be told his representation was too long, or too broad or too something or other; not a word as to principles, nor proportions, nor construction, no more than suffices to cram him for the government examination. All one may say is that, perhaps his is a little better off than if he had been educated at a higher middle class school, or private school, where the beginning and end of drawing is the picturesque pigsty of our youth not altered in the least from the pre-South Kensington era. (Cowper, 1884, pp. 201–202)

Sparkes referred here to a national course of instruction for government schools of art that was in place until 1889. The drawing course comprised the "ornament stages," of which there were five, and the "figure and flower" stages consisting of five more stages. For each of these stages copies were provided that were then copied by the students to satisfy the course requirements that allowed them to then move on to the next stage. The drawing course was as follows:

Ornament Stages

Stage 1 Linear drawing with instruments
 a) Linear geometry
 b) Mechanical drawings of architectural details
 c) Liner perspective
Copies: plates mounted on card of Geometry, Architectural detail and Perspective from the Department

Stage 2 Freehand outline of rigid forms from the flat copy
 a) From a copy of an object
 b) From a copy of an ornament
Copies: for a) Brown's eight plates of freehand drawing; for b) copy of Tarsia Scroll supplied by the Department, No. 256; or the Trajan Scroll from Specimens of Ornamental Art by L. Gruner; or the Trajan frieze from Albertolli, Department No. 1271

Stage 3 Freehand outline from the round (solids or casts)
 a) From models and objects
 b) From a cast of ornament
Cast: either lower portion of the pilaster of the gates from La Madeleine, or a portion of the two pilasters from the tomb of Louis XII, Department Nos. 460 and 478

Stage 4 Shading from the flat, examples or copies [usually in chalk]
 a) From copies of models and objects
 b) From a copy of ornament
Copies: for ornament, either Renaissance Rosette, Department No. 291, or copy of an ancient car or biga from Specimens of Ornamental Art by L. Gruner (p. 14)

Stage 5 Shading from the round, solids or casts (usually in chalk)
 a) From solid models and objects
 b) From cast of ornament
 c) Time sketching and sketching from memory
Cast: either the Egg Plant of the architrave of the Gates of Ghiberti, or the lower portion of the Florentine Scroll, Department No. 474

Figure and Flower Drawing Stages

Stage 6 Human or animal figure from the flat
 a) In outline
 b) Shaded
Copies: outline of "Laocoon," Department No. 249 or 579; or Farnese "Hercules," Department No. 501; or outlines of the figure by Mr. Herman, 22 plates

Stage 7 Flowers, foliage and objects of natural beauty from the flat
 a) In outline
 b) Shaded

Copies: Dicksee's Foliage, Fruit and Flowers, mounted 25 in. x 21 in. (e.g. The Wallflower, The Passion Flower), or Albertolli's Foliage, 8 plates

Stage 8 Human or animal figures from the round or from nature
 a) Outline from cast
 b) Shaded from cast
 c) From the nude model
 d) Draped
 e) Time sketching from memory
Casts: a) the Panathenaic frieze from the Parthenon, Department No. 497, British Museum 29, or the portion of British Museum 30, to be drawn 22 in. x 251/2 in.; of b) the "Discobolus" of Myron, Department No. 453, or the "Discobolus" of Naucydes, or the "Fighting Gladiator"

Stage 9 Anatomical studies
 a) Of the human figure from the flat
 b) Of animals from the flat
 c) Of either modelled
Examples: bones and muscles filled within the outline of the "Discobolus" of Myron, Department No. 459, or man and horse from the Panathenaic frieze

Stage 10 Flowers, foliage, landscape details and objects of natural beauty from nature
 a) In outline
 b) Shaded

 (Macdonald, 1970, p. 388)

Macdonald recounts that a majority of the students were on Stages 1–10 and that on occasion as many as half of them were on Stage 2. These examinations reflected on the Victorian notion that beauty was absolute, and since this absolute was obtained in the past, the students were then required to copy the art of the past in order to achieve beauty. This viewpoint continued throughout the century with originality frowned upon and students never doubting the accomplishments of the ancients.

It was presumed that only in art school would a boy receive an excellent artistic education. "The shortcomings of his early experience will be corrected and put right, or the good seed that may have been early sown will be encouraged to fructify and develop with the growth of his character and his powers" (Cowper, 1884, p. 202). Note that this training was also meant to build character with no discussion of technical education. Sparkes argued, "In the largest sense, colour cannot be taught—the colourist is like the poet, born not made. . . . He will while still young, do everything right and nothing that is wrong, and will be wholly unable to say why he does it. . . . No method of study can endow everyone with taste. If it is found in a student the greatest care should be taken not to spoil so precious a gift, but to cultivate it aright" (Cowper, 1884, p. 207).

The idea that talent is innate was suggested by Sparkes. He was concerned that the child's natural ability would be disturbed by the influence of formal teaching. Instead, he preferred to abide by the natural inclinations of talented children. Again, we can see the influence of Rousseau and his notion of a natural education

at an early age, one that would follow the natural inclinations of children without the interference of adults with their unnatural rules and procedures. In his appreciation of spontaneous childhood creativity Sparkes stands clearly with later expressions of the aesthetic Window paradigm.

The second paper was presented by A. F. Brophy (Finsbury Technical College) "Drawing is all important—to draw is to create. Drawing is both the body and soul of Art. Colour is but the garment an artist's creation wears" (Cowper, 1884, p. 214). Brophy's paper was based on Rousseau's call to nature, which has become standard by now: "Every field and hedgerow presents numerous suggestions for arrangements of colour, from the most varied contrasts to the most subtle harmonies, all beyond the definition of a rule, and defying classification in the infinite varieties of their blending hues" (Cowper, 1884, p. 214).

In his paper, Brophy called for an early recognition of children's drawings:

From the very first entry of the elementary student into the class, you must try and impress him with the idea that every drawing, even his first, should be a complete work in itself—a training to the mind—a work executed with care and interest, one in which the student not only receives a lesson in the imitation of form, a lesson in technique, but one in which you give him the opportunity of exercising his invention. (Cowper, 1884, p. 214)

This is perhaps the first time that "invention" or imagination was mentioned in such a forum. Brophy proposed that an effort should be made to cultivate creativity in children rather than stifle it with conformist pedagogical tactics. Brophy also told the convention that children must be interested in their lessons: "You must love your labour to do good work, and you must think your work worthy of all your labour, and capable of becoming a work of art, to love it" (Cowper, 1884, p. 215). However, in his discussion of training, Brophy was far from recommending spontaneity or appreciating childhood creativity. Rather, his approach was quite rigid.

Brophy then continued to specify the steps taken in his system of instruction to students studying design and decorating at the Finsbury Technical College. Brophy was emphatic in his explanation that he approached this in a developmental manner. "I divide a student's training into three periods. The Elementary, the Historic, and the Practical" (Cowper, 1884, p. 216). He stated that the elementary is the most important: "Because of the difficulties to be overcome in capturing the student's attention, above all things not allowing him to feel his first work is a grind at something that will prepare him for art-work, he must feel that he is engaged in making use of the material, acquiring the power of developing bye and bye his own invention and feeling." He then outlined the first lessons as copying exercises to sketch correct shapes. He recommended a charcoal material due to its erasable nature. Once the form is correct, the student then is taught how to hold a brush and can freely apply color: "This brings all the student's powers into play at once. He feels, when the form is declared right, the pleasure is in exercising his own judgment in selecting the colours and the finishing with brush outline, he gets a com-

pleteness in his work that becomes with him a habit through his career, he even learns from his failures what to avoid, above all he learns to finish his work" (p. 217). The mention of the importance of finishing work no doubt refers to the need to control labor and the completion of design work that must be instilled at this level of education so that manufacturing can be carried on efficiently and successfully.

Brophy pointed out the importance of geometry and perspective in advancing the student to the next level by drawing models that are geometrical and three-dimensional. This was necessary to Brophy, whose function was to provide designers and decorators to the industries. He maintained: "There is no industry in which any artisan has to work in which you cannot find some material in which he can be taught elementary art from the beginning" (Cowper, 1884, p. 218). The next step was to become acquainted with historical ornamentation. Again, this was to be acquired through exact copying of original ornamental examples. After these lessons, the student was ready for the most advanced level that concluded his training:

In this latter period, to which I have given the name of practical, I only wish to give this especial name, because here, by bringing the student face to face with Nature, I want him to acquire that knowledge and creative power that will so store his mind with material drawn from the life, that the filling of a space with appropriate ornament becomes to him an instinct, and he has merely to be given some object whose manufacture he understands to beautify it. (Cowper, 1884, p. 220)

By placing nature before the students to copy, Brophy attempted to teach not only form but also an appreciation of color and its subtleties. Once the form was understood, he wrote:

The student now has the scheme of colour that the plant suggests pointed out: how the stems with their leaves and their varying tones of green take the place of a harmonious background to the flowers; how these flowers themselves, often suggest arrangements of colour. What can be more beautiful than that given by a pale yellow rose, with its various tones from pale to deep rich gold, the centre giving those few touches of purer and more positive colour that are just wanted to make the scheme complete without disturbing the harmony. Here is a lesson for application. Take the flower, a harmony in yellow. This by careful study reveals the fact that although the harmony is complete every tone of yellow differs, still yellow is felt throughout as the predominant hue of colour. (Cowper 1884, pp. 220–221)

Brophy stated that this is by far a better lesson on color than establishing rules that would have to change with conditions and would prove confusing to the students. He wrote: "The sense of fitness for its position seems to me the only general rule that can be laid down for all decoration, whether coloured or not" (Cowper, 1884, p. 221). Brophy concluded his paper with the comment: "The highest art is that which contains the greatest thought combined with the greatest technical power" (p. 223). Brophy's lessons were aimed at what he described as "Technical Art." This was a special stage of applied design that included mechanical drawing, mapping,

and surveys, also architectural design, surface design, plastic design, lithograph, wood engraving, and porcelain painting (Macdonald, 1970, p. 391).

These positions supporting a natural education are not the only ones expressed at this conference. The other side of this debate supported rule-oriented teaching, as discussed by T. C. Horsfall in the subsequent discussion segment. He began with the following: "I think that Mr. Sparkes and Mr. Brophy both underestimate very greatly the need for the usefulness of training in the right appreciation and the right use of colour" (Cowper, 1884, p. 223). Horsfall understood the importance of color exposure that Spencer first identified. He took umbrage at Sparke's comment that good color sense depended on "taste." He said:

I think that it is quite certain that the relation between good colour and our nervous system is as fixed and capable of development as the relation between certain combinations of sound and our nervous system, which makes those combinations of sound pleasant and musical, whilst others are disagreeable and unmusical to almost everyone who has received a sound musical training. We have not yet had a Helmholtz to show us the physical basis of pleasant colour, but then it is only a few years ago that we had a Helmholtz to show us the physical basis of musical sound; and I do not think that it is over boldness to say that it is almost certain that our own generation will see the rise of a Helmholtz who will point out to us that there is a physical basis for good colour. (Cowper, 1884, p. 224)

Horsfall supported an early exposure to color as useful and important for training and noted a specific educational remedy: "Susceptibility to rightness of colour will be found, I am sure, to depend entirely upon the training of children before their nervous system has formed the bad habit, which it very soon acquires, of not noticing differences between good and bad colour. It is a question to be dealt with before young people enter schools of art" (Cowper, 1884, p. 225). This is an opportunity that was recommended for elementary schools but was sadly disregarded, according to Horsfall.

At this point the chairman stated that he thought it necessary to separate the discussion of technical art teaching from elementary drawing but acknowledged Horsfall's statement that found them interconnected. He then introduced Thomas Robert Ablett (1848–1945), a young art teacher who was then superintendent of drawing for the London School Board. His first teaching experience was in 1862 at Beverly Grammar School, where he was taught according to Ruskin's *Elements of Drawing*. Ten years later he joined the staff of Bradford Grammar School. Ablett raised questions on the educational efficacy of the art training that Great Britain was giving its children at the time. He asked: "Is our system of education adopting itself to the children or are they adopted to our system of education?" (Cowper, 1884, p. 226). He posited that most children not only enjoy drawing but also feel the need to express themselves:

Why do we give them practice in outline only? Nature does not only display her charms by means of outlines so much as by masses of light and shade, tone and colour. Can we not find means for enabling the young to easily reproduce those beauties which attract them, instead

of insisting on the exclusive practice of drawing form in outline for which they do not care? If it be true that nothing is of the least use to young children but what interests them, should we not leave the development of technical skill to arise naturally from a delight in the practice of painting? (Cowper, 1884, p. 227)

Ablett explained that the methods for teaching writing and drawing should not be different. The art teacher employs broken lines in the drawing lessons. He explained that young children naturally use the same strokes used in writing: "Each separate idea or perception of form is represented by one effort of the hand. In drawing a man, for instance, a circle is swept in for the head, an ellipse for the body, and a straight line for each arm and leg. The finished artist sketches on a similar plan, for each stroke are the record of one observation" (Cowper, 1884, p. 227).

Ablett understood the developmental issues of children when he stated that young children have sharp insight. "Their difficulty in representing form is chiefly that of finding a medium which will obey the hand with readiness and ease in its attempts to give expression to the perceptions of it, in themselves tolerably correct" (p. 228). He further stated: "If a system of teaching elementary drawing can be established which will keep up and develop zealous practice in pictorial expression, for which so many young people show a strong inclination, it will have succeeded where our present system has hitherto failed."

Ablett implored his listeners to consider the sensitive nature of their art students: "Art students are human beings. Let care be taken that advance in technical skill be not gained at the expense of enthusiasm, and all the possibilities it brings with it, or by reducing the intellect to a stagnant state. Art training should be regarded as a privilege and not a punishment" (Cowper, 1884, pp. 228–229). He called into question the practice of line copying and traced its origin to the Greeks but noted a decided change:

This form, when uncoloured, is typical of those from which practice is given. Originally it was drawn by a Greek decorator with the brush direct, simply because it was an elegant shape which the brush is admirably adapted to make. Will drawing it in outline with a lead pencil give a student any conception whatever of the aptness of the original design or any of the technical power the Greeks enjoyed? Little pleasure is to be found in copying the dazzling combination formed by tracing only the outlines of brush markings compared with the joy of using the brush in marshalling in pleasing array the forms it readily lends itself to depict. The use of the brush stirs the intellect and calls out the inventive faculty at the onset of a student's career. Freehand! (Cowper, 1884, p. 229)

Ablett warned that art teachers must look to their near future, when as encouraged by Ruskin they would need to justify their positions to a country that is becoming more cultured. "If they cannot show that their work is based on principles which make an appeal to the intellect it will surely stand condemned" (Cowper, 1884, p. 230). He called for teachers to work toward the betterment of society by demonstrating the importance of art for everyone and to help establish homegrown artisans and artists who can compete in the factories for jobs.

Ablett's comments are especially important since he later became an extremely influential figure in art education in Britain. He visited art schools in London and on the continent and persuaded the Bradford School to enlarge its art department to a greater extent than had been seen in England. This soon was enlarged to include girls from the Girl's Public Day School. His ideas took hold. His objective was to develop the child's artistic faculties rather than to promote good penmanship: "He taught his pupils to memorize complete shapes of an object rather than the contour, and thus draw with a continuous line which would immediately establish the shape, instead of making a series of broken lines, recording a succession of detached observations" (Carline, 1968, p. 133). As was the custom, children were taught to draw hard outlines with pencils.

Ablett went on to design tests according to his methods. These tests no longer sought a skilled copy of established drawings and still-lifes. His were tests to establish a visual memory of a complete form with a stroke that was continuous, rather than an image that was made up of short, interrupted strokes. He was the first to sponsor an exhibition of children's work in London in 1890. "It was Ablett's aim to make the value of art known to the general public, who would therefore, demand it for their children, and in this he had considerable success" (Carline, 1968, p. 135). Ablett began the appreciation of children's art, but it was still within the pedagogical framework. With this exhibition, children's drawings were soon discussed in leading journals. He began what would take many years to finally take hold; the aesthetic Window paradigm with the Juvenile School of Franz Cizek. From the outset, Ablett echoed Ruskin in stressing the educational value in learning to draw: "Drawing should be used as the foundation study of all education (he wrote some years later). It makes the acquisition of all knowledge simpler and easier" (Carline, 1968, p. 135). Ablett firmly believed that an early education is best established with children's ability to carefully observe nature through their drawing lessons. From this exercise all education can be developed. Ablett disagreed with Ruskin, however, as he proposed early-age lessons for the youngsters rather than wait until twelve years of age, as both Ruskin and Rousseau recommended.

Charles Bird from the Mathematical School in Rochester, a public school, raised an interesting point as he joined the discussion. As the head of the Mathematical School, he appreciated Ablett's concentration on reforming the education of art for young children. He expressed the importance of creating more interesting lessons for the children so that better learning would take place:

Teachers are now beginning to appreciate the necessity of infusing a great deal more interest into the work of schools. In his school, for example, they began drawing by putting a ruler and a pencil into the hands of the little boys of the first form, and telling them to draw a line three inches long, and then to erect a perpendicular line at the end of it two inches long, and then to put a cross-piece on the top four inches long. In that way the children got into the habit of using their mathematical instruments from the beginning, and taking an interest in their work, and seeing to what it led. . . . And in this way they began a course of geometrical design with little boys of seven or eight years of age. They had done this for two years with very satisfactory results. (Cowper, 1884, p. 242)

Note here the mathematical model that considers art training as a technical skill.

Ebenezer Cooke was also a respondent in this second discussion segment. During the conference, he seconded Ablett's statement that there was a loss of enthusiasm about art for the majority of students. Cooke called for a revolution in the methods of art teaching. "What the child's own natural method is we must learn first from children, then we must be willing to adopt their method if we would teach them" (Cowper, 1884, p. 246). He agreed with Spencer and others who said that children love colors. He continued:

But the teacher says you must go through a long study of light and shade before you attempt it. The child delights to use drawing as a means of expression; delights to draw from memory or imagination; and enjoys the invention of new combinations of known forms. The teacher treats all this with contempt, gives a long series of ornamental outline, and holds out the hope, perhaps, that in the far future, when the copy can be faultlessly executed, design shall be attempted again. The child's power of analysis stops at whole things; these he separates often carefully from each other; so far he can analyse but he does not break up his outline into parts, he draws the line at once as Mr. Ablett states. (Cowper, 1884, pp. 246–247)

This is very different from the statements of Bird, Horsfall, and Brophy. Cooke confirmed that children draw naturally in outline. He explained that Ruskin focused on this in his "Elements" and encouraged his students to use shading rather than outlines, but Ruskin changed his mind, and so did Cooke through his own teaching experience. Both followed a child-centered approach: "I accepted outline, for I saw all students used it naturally, and later observation of young children, with whom it is universal, leaves no doubt that for them it should be used is right. The child wants to express itself, but the teacher limits its exercise to perfecting the means of expression" (Cowper, 1884, p. 247). Then he forewarned: "We had better in these days of science observe the child's nature and method, and adapt ours to it" (Cowper, 1884, p. 247).

Cooke supported Ablett and Horsfall in early use of color before the child's interest is lost. He finds the teaching of drawing:

[n]eglects to include simple elements and necessary processes. In every drawing, for example, at the instant of execution, the pupil is not looking at all, but at his pencil. For what is he then drawing? From the memory of the object represented in his imagination. Yet who thinks of specially training these? Mr. Ablett does train memory, but the imagination, the necessary factor in every process, is not only neglected, but also condemned. Again, the memory of the object being drawn is modified by preconceived notions. And the fact to which I refer now is a most remarkable one. (Cowper, 1884, pp. 248–249)

In other words, children do not draw what they see but what they know and understand. He continued: "Children delight in scribbling; we scold them where we should carefully govern. The first drawings of little children are for some time only incoherent scribbles, yet they like it; the muscular action itself is pleasant. . . . It is a force of great value when so controlled" (Cowper, 1884, p. 250). Children also en-

joy repetition, according to Cooke: "If a child follows its bent and draws animals its own way, in action, and repeats them, outlines them, and colours them too, he will produce a drawing which may be comparable to the archaic period of more than one historic school" (p. 251).

Cooke reminded his audience of the words of Pestalozzi:

There was a parallelism in development between the individual and the race. The Greeks gradually attached perfection by accepting hints from nature, and strangely do their archaic work and that of the child agree. They too, worked in outline and colour, loved men and animals in motion, drew from memory and imagination, delighted in the disciplined scribble, the real freehand work, and out of this delight in expression and in handling arises their great technical skill. (Cowper, 1884, p. 251)

He then quoted Ruskin: "First make your artist, and then let him direct your decoration" (Cowper, 1884, p. 251). In other words, the technically skilled artisan should be trained only after the artist is born. Both Ruskin and Cooke were interested in artistic endeavors before training for manufacturing. He concluded with his support for Ablett's system of elementary drawing, which would encourage pictorial expression because he believed that the current system failed to do just that.

Monsieur Couvreur, a Belgian educator, next explained to the congress the art education of Belgian children, particularly in their drawing. He explained that drawing was compulsory in all their elementary schools: "Drawing, like the spoken and written language, is a means of expressing and communicating thoughts. In many cases it is a more rapid and clear process. Drawing was the original form of writing. It should be restored to its former position, and this can only be accomplished by the schools, and in the schools by the teachers" (Cowper, 1884, p. 259).

The drawing lessons advocated by M. Couvreur rejected copying from prints such as they did in France. "As soon as a child is able to draw lines, and his eye is accustomed to measure distances, he is set to reproduce geometrical forms, plane surfaces, and later on, solid bodies" (Cowper, 1884, p. 259). This was in opposition to the natural drawing model of Cooke and Ruskin. M. Couvreur continued to explain that the reason for these reforms in the Belgian schools was to develop the skills of the children both mentally and physically. The Belgian government felt an obligation to support the study of art and its appreciation to the Belgian population through its schools.

The Belgian schools had a need to teach not only drawing but also color. At a very early age Belgian children were exposed to a series of exercises to promote this appreciation. As a nation they felt very proud of their color sense and worked to develop it at an early age. "This natural gift has to be cultivated, and this duty devolves upon the schools" (Cowper, 1884, p. 260). Because the ink that the children used in their drawings was not appreciated by the parents, the schools moved to a new method that would not stain the clothing of the children:

This method, as is well known, consists in placing in the hands of children, of the ages of from three to seven, pieces of paper, wool, and wood, of all colours, and in getting them to form with these materials objects of common use. They thus learn, whilst playing, the names of colours, their shades, their harmonies, and their contrasts. Their taste is developed, and their aptitudes are thus discovered at the earliest age. (Cowper, 1884, p. 260)

Once the children were older, inks were introduced. Since this reform was introduced only in 1879, the results of this were not known at this time, but as Monsieur Couvreur stated: "My opinion is that it will contribute to raise to a very high level the taste of the working people and the value of labour" (Cowper, 1884, p. 261).

At this first-of-its-kind conference, Sparkes, Brophy, Hortsfall, Ablett, Bird, Cooke, and Couvreur heralded a new direction in art education despite disputes. A careful examination of their papers and discussion comments shows us they believed children's drawing is a language and that their drawing is an end itself, not the beginning of the process toward another product. The conference was responsible for shifting the paradigm from children's art as a stepping-stone toward adult art skills as a natural and legitimate stage in itself—a movement toward the emphasis on childhood creativity that is the hallmark of the aesthetic Window paradigm. At the same time, credit was given as well to developmental stages.

In December 1885 and January 1886, Ebenezer Cooke reviewed these proceedings in the *Journal of Education*, published by the Society for the Development of the Science of Education. In this publication, Cooke set down his theories on children's drawing as a stage theory. He also voiced criticism of John Sparkes, the head of the School of Art, South Kensington. Since Sparkes was so influential, it is important to note that he felt the discussion leaning toward children's drawing was superfluous to the subject put before the conference, that of training artisans for technical work. Cooke wrote: "No other section was so bound, nowhere else was education excluded. The educational value of art was not to be referred to, nor its elementary stages, nor its use for any other purpose; but only this fraction of the established curriculum for technical training in decoration, excluding, so far as possible, education" (Cooke, 1885, p. 462).

Cooke described Brophy as representing change. Brophy encouraged teachers to turn to nature for lessons and to find lessons that the students would find interesting. Although the papers presented were aimed at technical education, Brophy went the next step by including nature in that goal. Yet, Cooke suggested Brophy was returning to the past and the writings of Rousseau, Pestalozzi, and Froebel, as well as incorporating a progressive understanding of child development that was supported by the writings of Ruskin and Spencer.

According to Cooke, Brophy represented change and Ablett represented reform in his calls to teach from nature: "Beware of loss of enthusiasm. Let not the aim at technical skill stagnate the intellect. Do not copy merely, but originate, invent, educate" (Cooke, 1885, p. 462). He continued, "Mr. Ablett is seeking and suggesting a science of teaching drawing based on nature, including the child's. He observes and experiments." Cooke explained that at this time a system of teaching based on

the nature of the child did not exist and that it was up to the teachers to craft this new system.

Color was a subject that Cooke especially commented on. He noted that there were a number of theories on how this should be taught. "One says it cannot be taught; another that it can be learned by a man as a recipe or trick; thirdly, it can be learned or received from nature, that is, by 'self-teaching.' This is valuable, if varied, testimony to such teaching" (Cooke, 1885, p. 462). Horsfall encouraged early color exposure to ensure sensitivity to color. By this he meant early exposure to the great colorists like the Venetian artist Titian. Cooke replied to this theory: "While advocating needful teaching, Mr. Horsfall forgets the nature of the child, its love of bright colour, and the natural beginning of observation and culture from startling colours" (p. 463). Cooke referred to James Sully, a psychologist, to support his theory of color teaching in the schools. "Training a faculty means regular calling it into activity by supplying the conditions of its existence; first of all, suitable motives adapted to the stage of its development, and in its natural order." So, according to Cooke, the early stage of color appreciation must be gone through in order to achieve the higher level of appreciation. This accords with the theories of Rousseau, Pestalozzi, and Froebel, who "held that each age had its own completeness, and that the later stage was only perfected through the perfection of the earlier." Cooke concluded by stating, "Beginning of colour can and should be taught; higher knowledge and faculties may be self-acquired,—to what degree, depends much on the method of early teaching, on the exercise of existing powers."

Cooke then responded to the talk given by Monsieur Couvreur, whose system was influenced by Froebel. He criticized the British system of keeping the kindergartens and the art schools mutually exclusive. They were both struggling years ago, but the art schools were more successful. He wrote:

The Kindergarten is still unrecognised, poor and struggling; but if, thirty years ago, schools of design could have understood its purpose, not art teaching alone, but the whole education of the country would probably to-day be on a sounder basis for its drawing is no isolated fraction of its method. The two institutions are strangers, ignorant of anything in common, still less of value mutually until a foreigner reveals it. Mr. Sparkes is surprised to find that in Belgium children of eight years old are able to produce original design, and to work to scale, far in advance of anything which we have done in this country." (Cooke, 1885, p. 464)

Cooke praised Froebel's system of education: "This wide-reaching faculty, which enters into various mental operations, Froebel desires to exercise; and design or inventive drawing is the means not the end; and, though incomplete, his is probably the only system existing of teaching elementary design founded both on the elements of the subject, and the nature of the child" (Cooke, 1885, p. 464).

He agreed with Froebel, that the current teaching methods were contrary to the nature of children:

The mistake seems to be, so much stress is laid on accurately copying this, without intentional exercises, that the teacher, who should far exceed the child in design, considers careful copying sufficient. To give to the child what may be suitable to the teacher,—the results, the science, the organised knowledge—instead of letting it follow its nature and acquire the knowledge first, is to reverse the order of mental development. . . . To leave imagination without exercise is to misunderstand Froebel's central principle,—nay more, it is to oppose it..(Cooke, 1885, p. 464)

Influenced by Spencer's evolutionary vision, Cooke described children's drawing as moving in distinct stages, which must be taken into account in teaching art and improving the "mental facilities." He described four stages, depending on development of the child. In the first stage (ages two to five) "Busy acquiring knowledge the imagination is not yet active. Their first attempts at drawing are muscular movements, resulting in scribbles, not without interest even to us; to them they are full of meaning" (Cooke, 1886, p. 13). Cooke explained this stage as imitative:

The seen action of the hand is probably imitated; that is, the first drawings are copies, but they are copies of actions. The freedom is worth noting; the whole arm moves swinging from the shoulder, unlike that cramped hand and a tight grip on the pencil, which engraves the lines in early efforts at representation. . . . The scribble leads to new, yet old design, method and materials for freehand drawing. (Cooke, 1886, p. 13)

In the second stage he wrote "Mind controls and imagination becomes evident" (Cooke, 1886, p. 13). "There is in this later stage, analysis; but the parts are put together without controlling knowledge, with little idea of relation. In the third stage parts of the picture are in better order. "The drawing is from knowledge or incipient imagination, not directly from object or copy; direct drawing from objects being later, and an acquired process" (p. 14). In stage 4 (ages four to nine) "The child can analyse further. Parts are seen composed of elementary lines, which can be imitated." Cooke called for a renewed effort to follow the child's nature in art instruction. He wrote: "The head may be absent, as when art teaching ignores imagination, or when science instructs without observation. The nature of plant and child must be learned, while the construction of the one, and the instruction or education of the other, must agree with general truth, if their fullest and best nature is to be set forth" (Cooke, 1886, p. 15).

Illustration 7.1 illustrates these stages, with numbers 16–22 representing the second stage. "There is, in this later stage, analysis: but the parts are put together without controlling knowledge, with little idea of relation. The eye may be in the middle of the body (16), or larger and outside the head; (17 is the copy for 18; it was presented, part at a time, in the order indicated by the figures; 4, is the eye, larger than the head, and partly outside the body)" (Cooke, 1886, p, 12). Numbers 23–25 represent the third stage, and number 26 represents the fourth stage. This is the first recorded example I have been able to discover of children's drawing published in a journal for serious discussion. These are examples of the drawings of Cooke's daughter and were also published by his friend and colleague James Sully in his

later writings about children's drawing. Note they are not presented as aesthetic objects.

The purpose of this article was twofold for Ebenezer Cooke. Cooke's main concern was to publicly condemn the abysmal educational standards being practiced in the design schools. He knew that the child's needs were not being met, and he said that if these were not addressed, it would be at the peril of the design schools themselves. As the population was becoming more cultured and educated, the design school educators would be called to justify their beliefs based on what was known about child nature. Although his analysis of children's drawing was used to develop better drawing lessons for art teachers, he also can be said to be the first to take the inquiry of children's drawing to a new level of understanding. He was describing in detail what Rousseau alluded to many years earlier, that is, that children learn to draw in sequence, with each stage leading directly to the next. This was a revolutionary concept. It was also in Cooke's commentary that we could clearly witness a conflict of ideas about children's art and design as the two developing paradigms began to separate. A creative school was taking shape that opposed a more focused technical school based on imitation. The former was theorized by Ebenezer Cooke, who linked it to a stage theory of development and the notion that learning hadn't followed the child's natural development. These opposing ideas were best summed up by Cooke when he wrote: "The choice is between accuracy and interest, technical skill and child nature. . . . The teacher who includes child-nature in his subject . . . will try and get this and all natural forces on his side. The nature of the child can no more be altered by us. We must study, sympathise, and conquer, by obeying it" (Cooke, 1886, p. 15).

At the turn of the 20th century, when the acceptance of children's drawing in the schools became firmly established, the investigation of children's drawing/art really had its beginnings. As we have seen, children's drawing has been written and talked about since Rousseau's *Emile*, but mainly as it relates to the acquisition of pedagogical skills that facilitate adult accomplishment and gainful employment. Throughout we find homage paid to the ideas of drawing from nature, geometry, and perspective. However, Ablett and Cooke set a course with a different trajectory perspective, the aesthetic Window paradigm, but this did not come into favor until the next century, when there were an establishment of child psychology as a field of study and an acceptance and understanding of modern art. At the same time they also prefigured the psychological Mirror paradigm with an emphasis on stage development and art as a way to gauge a child's maturity and inner life.

Illustration 7.1

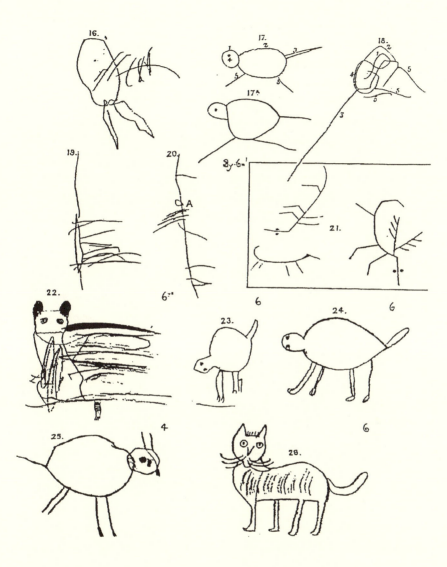

Source: Cooke, 1885, Supplement.

8

JAMES SULLY
(1842–1923)

MODERNISM

At the turn of the 20th century, not only were enormous strides taken in science, but also the world of art erupted in convulsions. With the discoveries of science, the positivist world of Newton was pushed aside for an ambiguous world of abstraction and uncertainty. The mood of Romanticism inspired many of the changes occurring in the 19th century. Although much can be said for World War I as the divider between epochs, there was, perhaps more importantly, a new worldview or "mood" that ushered in a new modernist consciousness. These changes occurred as a result of an altered perception of nature, cognizance, and art.

The strides in physics were the major catalysts that heralded this change of mood. Up until this time, classical physics as presented by Newton was the accepted worldview. According to the prevalent theories, space, matter, and time existed independently from each other and were separate from the observer. Nature followed natural laws of cause and effect; the atom was the basic unit of matter. Classical physics was deterministic; that is, everything was prearranged and occurs according to a plan devised since the beginning of the universe. Because of this deterministic quality, life was predictable. In addition, it was believed that physicists had the capability to solve any equation presented to them. All of this led to a confident view of the stability of the world.

However, in 1900 Max Planck discovered quantum theory, calling into question the theories of Newton and the orderliness of the universe. Quantum physics is about the study of motion: "Energy was not a continuous stream but consisted instead of discrete units . . . called quanta. To the layman this meant a further disorientation of what had been a harmonious universe" (Mosse, 1988, p. 290). Newton's physics was the study of the motion of visibly sized objects like cars,

planets, and stars. This modern physics was a micro physics, a probabilistic type of physics that studied very small objects like atoms, protons, electrons, and other nonobservable entities.

In 1905 Albert Einstein elaborated on Planck's theories by suggesting that all radiant energy moves through space in bursts of energy. As the atom was further explored, it became obvious that nature was ambiguous and unpredictable. According to Einstein's theory of relativity, time and space, which were thought to be fixed and distinct, were interconnected and dependent upon each other. Motion could only be explained by comparing something in motion relative to a stationary frame of reference. Einstein's formula $E = mc2$ demonstrated that we could convert mass to energy. Nature, formerly seen as independent and outside of ourselves, was actually based on our frame of reference. Heisenberg's principle of uncertainty in 1927 continued the exploration of the new physics when he showed that it is impossible to determine the location and speed of an electron simultaneously. In other words, the laws of cause and effect did not apply, and only probabilities were left for the scientists. There was no longer any certainty. This new paradigm or collective voice of probability, relativity, and uncertainty spoken by the modern physicists resonated across the social fabric of the 20th century.

A similar displacement occurred in other fields. For example, Sigmund Freud (1856–1939), a Viennese psychoanalyst, was interested in the irrational and unconscious workings of the mind. Just as Planck and the modern physicists changed the foundations of the understanding of nature, Freud was responsible for changing the foundations of cognition in Western civilization. "I have the distinct feeling that I have touched on one of the great secrets of nature," he wrote (Stromberg, 1966, p. 336). Born in Freiberg, Moravia (Czechoslovakia), in 1856, Freud and his family moved to Vienna, where young Sigmund was educated and spent the rest of his life. After graduation from medical school, Freud connected with a respected family physician, Josef Breuer, who was using a relatively new technique, hypnosis, to treat hysterics. He and Breuer published their studies in 1893–1895, considered the beginning of psychoanalysis:

It consisted in studying the psychology of the hysterical condition not by direct manipulation, but by letting the patient talk freely about his condition, especially allowing him to talk when in a drowsy, or dreamlike, or dissociated state, in which he would ramble over the area of his difficulties and much besides and talk about episodes distressing to him which had been sealed off, or repressed, or made unavailable to recall. (Murphy & Kovach, 1972, p. 274)

Toward the very end of the 19th century Freud began his work on dream interpretation. He wrote *Interpretation of Dreams* in 1900 and explained psychoanalysis as a method that he used to examine and analyze the unknowable or unconscious dream state by raising it to the conscious level. It was here that psychology made a major shift:

From the time of Aristotle onward, thoughts had been regarded as basically different from motives, drive, impulses. . . . Freud seemed to be finding that thoughts were first of all the embodiment of wishes. In their primary form, thoughts tell what we immediately wish. But in time they are partially replaced by an inclination to delay gratification so as to give attention to reality—the process of "reality testing." This is a secondary process. But primary process, the initial guidance of thought by the impulse of gratification, is a central key concept for the understanding of psychoanalytic dynamics. (Murphy & Kovach, 1972, p. 280)

Psychoanalytic theory states that the self is divided into three parts; the id, the ego, and the superego. The id is made up of powerful inner forces and biological drives that combine with unconscious motives, irrational impulses, and repressed desires. "Its goal is to maximize pleasure and minimize pain" (Freud, 1965a, p. 365). These unconscious urges are repressed or sublimated through the ego with the support of the superego, or conscience, into socially acceptable behavior. As Freud wrote: "The id stands for the untamed passions, the ego stands for reason and good sense" (Freud, 1965b, p. 76). Through psychoanalysis these unconscious urges are exposed to reveal the underlying motivation behind behavior. It is significant that within the psychoanalytic framework, Freud recognized the importance of childhood in shaping the adult's personality. He urged that more care be taken in meeting the emotional needs of children, for this is where the neuroses of adults begin. Although Freud did not invent or discover the unconscious, through his work this notion was pushed into the foreground of modern theory (Mosse, 1988, p. 268). His name has become a household word, and his influence extends to education, literature, the arts, religion and philosophy, morals, popular culture (Stromberg, 1966, p. 336).

The paradigm shift that occurred simultaneously in physics and in psychiatry can also be seen in the literature, music, and art of the late 19th century, but it is most clearly demonstrated in the visual arts. To place an exact beginning to modern art is an exercise in futility. What is universally agreed upon, however, is that it is a reversal of the naturalism that came before it. Sir Herbert Read, the British poet and critic, explained its genesis as follows:

Its origins are extremely obscure and, like roots, proceed from different levels and contradictory directions. One cannot exclude either the revolutionary romanticism of a Blake, or the revolutionary classicism of a David; Constable's scientific naturalism is certainly a factor, but so is the historical idealism of Delacroix (to Cézanne always "le grand Maître"). The realism of Courbet and Manet; the expressionism of Van Gogh and Munch; the symbolism of Emile Bernard and Gauguin—all these precede and in some degree predetermine the specifically modern movements of fauvism, cubism, constructivism and surrealism. (Read, 1953, p. 17)

The modernist movement was born out of the experimentation of form and expression to reflect relativity, internal feelings, and unconsciousness, as in Freudian psychoanalysis. This was a direct rebuke to the Renaissance discoveries of perspec-

tive, proportion, and realism. Modernism sought to extol the imagination and inner subjective, creative feelings and thoughts. Considered an extension of Romanticism, modernism sought to critically examine the styles developed in the Renaissance and to press for a more acute contemplation that pushed the intellect aside to reach true human feelings. Much like Freud, modernist artists looked beyond the surface for a reality found hidden in the unconscious.

As far back as the Renaissance, Western artists depicted their world as an orderly universe, as indicated by their worldview of mathematics and science. This is the world they knew and understood. With the new physics and its insistence on an unordered and unpredictable time, space, and motion, artists had an opportunity to depict their world as a relative world, with multiple frames of reference. The potential of the image was inhibited only by one's imagination. The object was not as important as the interpretation of the object by the artist. No longer was the direct imitation of nature through representation considered art.

Modern painting is rooted impressionism, which began with an exhibit held in 1874 and lasted for a total of eight exhibits; the last exhibit was in 1886. "Impressionism is the most important thing that has happened in European art since the Renaissance. . . . From it virtually all subsequent developments in painting and sculpture have stemmed, and its basic principles have been reflected in many other art forms" (Denvir, 1989a, p. 11). It was started in Paris by a number of artists, including Edouard Manet, Berthe Morisot, Claude Monet, Alfred Sisley, Camille Pissaro, Pierre Auguste Renoir, Edgar Degas, Mary Cassatt, Paul Cezanne, Georges Seurat, Vincent van Gogh, and Odilon Redon:

For a conceptual approach, based on ideas about the nature of what we see, it substituted a perceptual one, based on actual visual experience. . . . Rejecting the idea that there exists a canon of expression for indicating moods, sentiments and arrangements of objects, it gave primacy to the subjective attitude of the artist, emphasizing spontaneity and immediacy of vision and of reaction. Formulating a doctrine of "realism" which applied as much to subject matter as to technique, it eschewed the anecdotal, the historical, the romantic, concentrating on the life and phenomena of its own epoch. (Denvir, 1989a, p. 11)

The impressionists moved their easels outdoors and painted according to the natural light of the sun and skies. They eliminated outlines of objects that did not occur in nature, and shadows were included in complementary colors of the objects. There was much experimentation with color and brush technique. Forms were broken up with blotches and dabs of multiple colors so as to create an "impression" of the subject.

The expressionist movement has its connection with psychoanalytic theory. The expression of inner forces and feelings and the motivation of the artist and the understanding of the creative process are explored through this aesthetic. It offers the liberal use of colors and shapes that are personal and individual to each artist and in which expression supersedes form: "For now man ceases to take natural appearance seriously; what matters is his response to it, the image which the pictorial in-

stinct evokes in the mind. Nature is no more than a pretext, and already the idea was emerging that it might be dispensed with altogether" (Haftmann, 1965, p. 94).

Just as the physicists were redefining time and space and motion in the 1890s, the painters of the impressionist movement were also influenced and tuned into the great strides that were taken in science. "Unconsciously, they were moving towards a concept of the nature of matter which was to find expression half a century later in the discoveries of Einstein" (Denvir, 1989a, p. 14). Time was also a prominent concern at this time.

The advent of the machine, with its fixed temporal rhythms in the demands it made on its users to comply with them, had fostered an obsessive concern with time, symbolized by the vast proliferation of clocks in public places that took place after about 1840, by the emergence of history as a dominant discipline, and by the appearance of systems such as the Darwinian and the Marxist, which were essentially time-oriented (Denvir, 1989a, p. 14).

Space and motion were also important to the impressionists. The ability to travel at fast speeds with the new locomotives in the 1840s brought new images to the artists: "To see objects and landscapes from a train travelling at 50 to 60 miles an hour emphasized still further the subjective nature of visual experience, underlying the transitory, blurring the precise outlines to which post-Renaissance perspectival art had accustomed the artist's eye, and unfolding a larger, less confined view of landscape" (Denvir, 1889a, p. 14).

In the field of chemistry new and improved pigments were developed, and paper was more readily available and cheaper to purchase; all of this combined to create a more favorable time for the artists to deliver their new expressions of forms. Another important occurrence at this time was the development of photography, which was included in a photographic exhibit in 1859 at the Salon in Paris and after a lengthy court battle was declared an art form in 1862 (Denvir, 1989a, p. 14). This suddenly changed the reason for drawings and paintings to reflect reality and allowed the artists the freedom to use self-expression to interpret subjects. "No longer is there the academic insistence that the subject should be coherent, complete and seen from a compositionally convenient viewpoint. The unity is now in the painting, and in the elements which compose it" (p. 16).

Next, we will see how this new mood influenced the installation of the two paradigms for the inquiry into children's drawing and art, Mirror and Window, and set the course in two directions.

THE MIRROR PARADIGM

We now leave the philosophers, the educators, and the artists with their innovations in place, to examine the imprint of modernity on the first of our paradigms, the psychological Mirror paradigm. With the introduction of the science of psychology into the investigation this paradigm solidified, and James Sully (1884–1923) was responsible for putting children's art into psychology: "James Sully studied for a University of London honours degree in philosophy while a

resident at the Baptist College at Regent's Park, and was treated to a staple diet of J. S. Mill, Spencer, and Bain. He was appointed lecturer on the theory of education at Maria Grey Training College in 1879, and Grote Professor of Mind and Logic at University College in 1892" (Macdonald, 1970, p. 325). He was working at the turn of the 19th century, a scientific age that turned the eyes of its trained scientists toward the child. Through careful scientific method the child was observed. Sully wrote: "We want to know what happens in these first all-decisive two or three years of human life, by what steps exactly the wee amorphous thing takes shape and bulk, both physically and mentally" (Sully, 1896/1977, p. 4).

Sully gave three reasons for this interest. The first was the child's primitive nature. Modern science, he explained, was looking for its beginnings to better understand subsequent complexities. He argued that Darwin's careful observation of his infant child strongly suggested the child's connection with natural history and the natural world. The child, Sully thought, can help in understanding customs generated by a variety of societies:

It is hardly too much to say that it [childhood] has become one of the most eloquent of nature's phenomena, telling us at once of our affinity to the animal world, and of the forces by which our race has, little by little, lifted itself to so exalted a position above this world; and so it has happened that not merely to the perennial baby-worshipper, the mother, and not merely to the poet touched by the mystery of far-off things, but to the grave man of science the infant has become a centre of lively interest. (Sully, 1896/1977, p. 6)

We are seeing a shift from a perspective of the child as naturally good to one where the child serves as a view on the primitive.

The second and greater interest to which psychologists addressed their inquiry is the notion of progress prevalent in the age of science. In evolutionary science there was a sense of a connectedness with the earlier humans. At the same time, this gave the psychologist the ability not only to track backward but the incentive to track the progress of the child and the whole of humankind forward. The third area of interest to turn-of-the-century psychologists was education. There continued to be a great deal of interest in raising youngsters. "What was once a matter of instinct and unthinking rule-of-thumb has become the subject of profound and perplexing discussion" (Sully, 1896/1977, p. 10). Supposedly needing guidance from scientists were not only the parents but also the teachers to whom the child was entrusted. Their task in the education of the child would most assuredly benefit from an understanding of child nature.

STUDIES OF CHILDHOOD

With this in mind, Sully, an influential and prolific writer, wrote his seminal work *Studies of Childhood* (1896/1977) as a guide to parents, teachers, and psychologists interested in this subject. Sully understood that the mind of the child was pliable and continually developing into a mature, adult mind, and he recognized the

variations present in these developing minds. Much like Rousseau, Pestalozzi, and Froebel, he drew attention to natural activities such as play and drawing. As one of the forerunners in child psychology, Sully emphasized the abundance of psychological material in these rituals of childhood, and he recommended further areas of investigation and hypothesis, although he recognized the difficulties inherent in observational methods. He wrote: "In spite of some recently published highly hopeful forecasts of what child-psychology is going to do for us, I think we are a long way off from a perfectly scientific account of it. . . . Children are probably much more diverse in their ways of thinking and feeling than our theories suppose" (p. 13).

"The Child as Artist"

"The Child as Artist" and "The Young Draughtsman" are two chapters in this book that are of special importance to this thesis. The chapter entitled, "The Child as Artist" begins with an acknowledgment to M. Bernard Perez, a child psychologist, who found the importance of examining the early stages of child art activity both useful and informative in his study of the child. Sully added that his purpose was to examine the connections with primitive cultures and so utilized a comparative cultural-psychological approach. The first point he made was: "Art and play are closely connected. It is probable that the first crude art of the race, or at least certain directions of it, sprang out of play-like activities, and however this be the likenesses of the two are indisputable" (Sully, 1896/1977, p. 299).

When is the child first responsive to beauty? Sully believed the answer lay with the brightness of objects followed by a fondness for bright colors as well as strong color contrasts. As a man of science he then gave examples of several studies that attempted to prove this. Sully was always trying to prove his theories through observation and experimental approaches. His topics of study were influenced by the necessity of observing children in a scientific manner that validated psychology as a discipline.

Sully next explored form in its relative attraction to the child. He observed that the children in his experiments were drawn to very small objects and symmetrical shapes, although he did not know how much of an influence a cultured home has in these choices. He then compared the first sensibilities of colors and forms to the aesthetics of primitive people and then made an interesting observation concerning the manner in which children break up a whole view into smaller parts: "When they (children) are taken to see a 'view' their eye instead of trying to embrace the whole, as a fond parent desires, provokingly pounces on some single feature of interest, and often one of but little aesthetic value. People make a great mistake in taking children to 'points of view' under the supposition that they will share in grown people's impressions" (Sully, 1896/1977, p. 306).

The child's early opinions of art depend on development; "we find that a child's aesthetic appreciation waits on the growth of intelligence, on the understanding of artistic representation as contrasted with a direct presentation of reality" (Sully,

1896/1977, p. 309). So at what time in a child's development is the ability apparent to understand representation as symbolic of the real object? Sully explained:

The development of an understanding of visual representation or the imagining of things has already been touched upon . . . the first lesson in this branch of knowledge is supplied by the reflexions of the mirror, which, as we have seen, the infant begins to take for realities, though he soon comes to understand that they are not tangible realities. The looking-glass is the best means of elucidating the representative function of the image or "Bild" just because it presents this image in close proximity to the reality, and so invites direct comparison with this. (Sully, 1896/1977, p. 309)

At this time children able to begin their journey to "aesthetic appreciation" and toward an ability for pictorial representation. Not until children can recognize their reflection in the mirror as representative of themselves, can they begin to make their own representatives of other objects on paper. The realization of a symbol representing something other than itself is necessary to begin drawing. With this explanation, we have found the genesis of the psychological Mirror paradigm:

Sully shows his direction in examining this subject of children's drawing as one of perception and form. He gives several examples of instances of object recognition and the age of the child. Sully also was interested in examining the phenomenon of children not being concerned with the direction of the picture to enjoy its form. It did not necessarily have to hold a picture right-side up. He wrote: "He [a child] may be able to concentrate his attention so well on form proper that he is indifferent to the point how the form is placed." (Sully, 1896/1977, p. 311)

In this first chapter, Sully defined art-activity as any activity that directly relates to making something beautiful. This can include gesturing or a voice modulation as much as a drawing. In other words, he accepted the imaginative play of the child as potentially artful in any of its manifestations: "The ever-renewed contention of artists' 'art for art's sake,' points to the fact that they, a least, recognise in their art-activity something spontaneous, something of the nature of self-expression, self-realisation, and akin to the child's play" (Sully, 1896/1977, p. 327). He concluded, then, that the artist's impelling force has its beginnings in child-play and that at its root is the "all engrossing effort to 'utter,' that is, give outer form and life to an inner idea, and that the play-impulse becomes the art-impulse."

"The Young Draughtsman"

In the following chapter, "The Young Draughtsman," Sully explained his rationale for examining children's drawings in the following statement:

We shall therefore study children's drawings as a kind of rude embryonic art. In doing this our special aim will be to describe and explain childish characteristics. This, again, will compel us to go to some extent into the early forms of observation and imagination. It will

be found, I think, that the first crude drawings are valuable as throwing light on the workings of children's minds. Perhaps, indeed, it may turn out that these spontaneous efforts of the childish hand to figure objects are for the psychologist a medium of expression of the whole of child-nature, hardly less instructive than that of early speech. (Sully, 1896/1977, pp. 331–332)

Sully told his reader that the only way he could carry out his investigation of children's drawings was to compare them to primitive people and what he called "early art" (p. 332). This was an offshoot of the evolutionary model we saw with Spencer. As a prudent scientist, Sully set up the parameters of the study to include the drawings of the human figure and animals because he could easily find his samples. The children were between the ages of two or three and six years. Sully acknowledges his indebtedness to Ebenezer Cooke for his "many valuable facts and suggestions bearing on children's modes of drawing" (p. vi).

Sully examined children's drawing using a stage-theory approach. He found that a child begins this process by using a free-swinging movement to produce lines of a disordered nature (scribbles). On occasion these lines become something intentional but only after they are produced. There is no prior intention. At this point the child's imagination is noticeable. The same imagination is apparent when the child first attempts to draw from memory. "Here it is evident we have a phase of childish drawing which is closely analogous to the symbolism of language. The representation is arbitrarily chosen as a symbol and not as a likeness" (Sully, 1896/1977, p. 334). Sully believed all children's drawing to be symbolic.

From this initial stage of scribbling, the lines are joined by loops that allow the child to eventually outline shapes. He continued the development. "With practice the child acquires by the second or third year the usual stock in trade of the juvenile draughtsman, and can draw a sort of straight line, curved lines, a roughish kind of circle or oval, as well as dots, and even fit lines together as angles" (Sully, 1896/1977, p. 334). At this point the child begins to make very rough resemblances of figures and animals. Sully found these early drawings to be the most interesting: "They follow standards and methods of their own; they are apt to get hardened into a fixed conventional manner which may reappear even in mature years. They exhibit with a certain range of individual difference a curious uniformity, and they have their parallels in what we know of the first crude designs of the untutored savage" (p. 335).

Sully noted that children begin their drawing of human figures with the front view of the head. From this point he described the various head shapes in addition to the eyes, nose, and mouth and the way in which various children interpret them. He also gave a cultural comparison with primitive people of Australia and Brazil. He was very surprised to find that the child does not seem to obey any laws of position or proportion. Sully found an underlying evolutionary process as he observed the figures becoming increasingly complex. The eye, originally a speck, becomes an oval or circle and then develops an iris and eyelashes, and the mouth has teeth added to the lips, which started as a speck, then as a circle, then as a line. The nose

also evolves from a speck to a vertical line to an angle. Added to these increasingly complex parts of the face, the child appends ears and hair.

Sully used eighty-five examples of drawings by children, including those used by Cooke in his published articles of 1885/1886. The sampling is diverse in both the ability of the child and the culture of the child. He took care to show an evolutionary process with these examples. Each section takes a topic such as heads and starts with the most obvious patterns he found in his large sampling. The youngest child's drawing in the group was by a boy of two and a half years. This showed arms and legs emerging from the sides of a head with eyes, a nose, and mouth. The final drawing is a side perspective of a lady with a parasol done by a six-year-old girl. Interestingly, Sully observed children characterizing sex, rank, and status by outfitting the figures with hats, pipes, uniforms, and so forth. He showed that our youngest members of society intuitively understand these adult concerns as they become socialized.

Sully next turned his attention to animal drawings. His sampling of twenty-one drawings follows the same type of development. Animals are drawn quickly after the first attempts of human figures. He even went so far as to suggest that cats and ducks are the first attempted animals. In Sully's observation, the animals are very crude, with a considerable lack of proportion and position. The next subject for Sully was the odd combinations children devise such as a man and horse with the figure standing directly on top of the animal. There is also a tendency to show everything even if it should be covered. This is illustrated in many examples of both legs showing in a profile drawing. There are also a few examples of houses drawn by children. The same tendency to show what is hidden by drawing three sides is seen. This can be observed in primitive drawings as well as the cubist style of painting, which also had its influence from the primitive.

Sully was resolute in stating that in no stage of child drawing should it be considered artistic (Sully, 1896/1977, p. 382). The child is not interested in accuracy but "is content with a schematic treatment, which involves an appreciable and even considerable departure from truthful representation" (p. 383). Most puzzling to Sully was what occurs in the most sophisticated stage, including what is not visible to the eye of the child. The point of view of the child is not taken into account. According to Sully, children draw what they know about the subject rather than what they actually see before them. The inclusion of items the child values, such as a parasol or pipe, in their picture also illustrates this tendency. (This is a point disputed by a later theorist, Rudolf Arnheim.) Sully wrote that he did not understand children's art to be like that of an untrained adult. The adult has more information than the child, but still, the similarities are evident in comparing children's drawing with that of primitive people who were understood by Sully to be "childlike."

Sully concluded the chapter by recapitulating the three stages that children pass through in their drawing development. The first stage is an imitative one, in which the child has little muscular control and lacks the ability to preplan the layout of the drawing. This is not the case of primitive artists, however. The child is impelled by imaginative thought and is not at all interested in form. "His first drawings are

thus, in a sense, playthings, which, . . . his imaginative intention corrects, supple-
ments, and perfects" (Sully, 1896/1977, p. 389). With practice, the child moves into
the second stage (age three or four) to the beginning of accurate representation, "as
illustrated in the first abstract schematic treatment of the human face and figure."
The schema shows very little concern for correct form, yet it is doubtful that the
child does not observe figures in their correct form. Sully explained: "The little art-
ist is still much more of a symbolist than a naturalist, that he does not in the least
care about full and close likeness, but wants only a barely sufficient indication. This
scantiness of treatment issuing from want of the more serious artistic intention is
of course supported by technical limitations" (p. 390).

Habit is also important in understanding these early drawings. The child follows
the earlier patterns of execution. The third stage (about five years of age) is shown
with more sophisticated shapes of mouths and eyes. Arms and legs are attempted,
and overall there is a general movement toward naturalism. This new level of
achievement does not follow a smooth progress but substitutes one convention for
a new convention. We can now see the child's intellectual limitations prohibiting
his or her growth. For example, the figures tend to lean: "But the really noticeable
thing in this later sophisticated treatment is the bringing into view of what in the
original is invisible, as the front view of the eye as well as both eyes into what other-
wise looks a side view of the face, the two legs of the rider and so forth" (Sully,
1896/1977, p. 392).

Sully then began to question childhood perception. He thought that this mental
activity of children may hold the key to understanding the peculiarity of their
drawings: "This being so it may be said that defects of observation are reflected in
children's drawing through all its phases. Thus the primitive bare schematism of
the human face answers to an incomplete observation and consequently incom-
plete mode of imagination, just as it answers to a want of artistic purpose and to
technical incapacity" (Sully, 1896/1977, p. 394).

Youngsters' ability to generalize through the use of language also tends to con-
fuse their visual interpretation of an image. Because of this they do not have the
same mental vision as an artist:

> He is led not by the lively and clear sensuous imagination, but by a mass of generalised
> knowledge embodied in words. . . . This, I take it, is the main reason why with such supreme
> insouciance he throws into one design features of the full face and of the profile; for in
> setting down his linear scheme he is aiming not at drawing a picture, an imitative
> representation of something we could see, but rather at enumerating, in the new expressive
> medium which his pencil supplies, what he knows about the particular thing. (Sully,
> 1896/1977, p. 395)

Sully explained that the child is concerned not with linear description but with a sym-
bolic explanation. The wholeness of the idea concerns the young artist. At a very young
age, children represent on their paper what they know to be there rather than what is in
front of their eyes. Intelligence gets in the way of artistic vision.

Sully closed with the remark that from an adult's point of view, even though children's drawing is defective, it does have its redeeming qualities. "The abstract treatment itself, in spite of its inadequacy, is after all in the direction of a true art, which in its essential nature is selective and suggestive rather than literally reproductive" (Sully, 1896/1977, p. 396). Sully pointed out that it is not until the child tries to create beauty can a drawing be considered to have an aesthetic quality. Wanting to create something beautiful gives the child a reason to attend to details that are necessary to draw a pleasing picture.

James Sully was part of the burgeoning movement taking place in Europe and the United States ushering in the child-study paradigm. The inception of child psychology can be dated from Rousseau and continued by Pestalozzi, and Froebel. It even caught the attention of Charles Darwin, as shown in his essay about his son. The last quarter of the 19th century saw a growth in the interest of childhood development. Sully is but one example of a practitioner in this movement. Interest in the nature of children and their intellect, so eagerly begun by Rousseau long ago, was followed by Pestalozzi's concern with the raising of children and his interest in their world of the senses. Froebel continued this with the institution of the "Kindergarten," added to by Spencer and Cooke, who called for education that included an exposure to drawing. It finally evolved into disparate perspectives sharing a common focus on the child. The ideas called forth by these philosophers and educators helped to usher in a new worldview that found the child worthy of study and has helped to shed light on many aspects of child development.

With James Sully, the study of children's drawing developed into a fully formed psychological Mirror paradigm whose practitioners are men and women of science. Their focus and perspective include a study of the child's mind and early individual development. These practitioners use a scientific methodology that includes observation and experimentation. For them, the child's mind has become an area of experimental investigation. Simultaneously, the child has garnered new prestige among scientists with the acceptance of Spencer's and Darwin's evolutionary theory. The child is now looked upon as an individual whose development is not a time of deficiency but a period of plasticity. Humankind's long dependency in childhood came to be understood within an evolutionary framework, while the interest in education and growth was a response to the concept that intelligence can be shaped and nurtured as well as inherited.

The Mirror paradigm is aptly named to reflect the central interests of the psychologists in examining children's drawing. The educators were already in the habit of referring to the renderings as drawings so that reference term continued with the psychologists. Sully was the first to practice in the psychological Mirror paradigm, but in the lineage of Rousseau and Pestalozzi, Froebel, Spencer, and Cooke. The research on this subject has followed in the path set down by Sully in 1896. Many subsequent investigators have heeded his call for further investigations. The topics he found interesting have been followed up in the more than 100 years since his writing. Alongside the scientific work of Sully, another paradigm was also taking shape.

Franz Cizek (1865–1946): "Child Art" Becomes the Window Paradigm

Franz Cizek was born in 1865 in the town of Leitmeritz, in the former Austria. After his studies, he moved to Vienna, where he studied at the Academy of Fine Arts in 1885. At this time young artists were responding to the impressionist movement and began to withdraw from the established exhibitions and societies all over Europe. The art nouveau movement arrived in Vienna, where it took a decidedly Austrian direction. Cizek became a member of the "Secession" in Vienna, a group of progressive artists who were looking for new expressions of form in art. Nineteen artists, including Klimt, Olbrich, Moser, and Otto Wagner, organized the group in 1897. Gustav Klimt, the most renowned of its members, whose decorative work is referred to as Secessionstil, headed the Vienna Secession. As a decorative artist, Klimt was interested in patterning. He recognized himself as a muralist who painted in a flat perspective most conducive to abstract-patterned decorative designs.

An appreciation of children's drawing for its aesthetic quality was virtually absent at the end of the 19th century. The first people interested in these renderings, other than art educators, were the psychologists who examined the drawings and determined that they were a developmental language system and symbolic in nature, but definitely not a product of artistic activity. They found no aesthetic quality inherent in the drawings whatsoever. The psychologists did, however, concede that children's drawing could develop into art and agreed that the child's drawing was an immature process leading toward a more mature and realistic drawing style. For them, art could be accepted only in terms of its realistic or naturalistic representation. The psychologists were not alone in this belief. Art educators were also insistent on correct form and execution in their pupils' work. They were hostile to the idea of placing any kind of value on the children's work.

Ablett and Cooke began what took some thirty years to install: A new understanding of children's drawing, an acceptance that it is, in fact, an expression of art. Toward the last decade of the 19th century, the mood had begun to change. Inspired by the new modernist art movements, children's drawing was now viewed by a few art educators and artists as aesthetically valid. Much of the change in attitude was a reflection of the work by the impressionists and the expressionists, who went even further in their subjective interpretations of objects:

Expressionism in this sense involved ecstatic use of colour and emotive distortion of form, reducing dependence on objective reality, as recorded in terms of Renaissance perspective, to an absolute minimum, or dispensing with it entirely. Above all else, it emphasized the validity of the personal vision, going beyond the Impressionists' accent on personal perception to project the artist's inner experiences—aggressive, mystical, anguished or lyrical—on to the spectator. (Denvir, 1989b, p. 109)

The art movements were intertwined in the social changes of the time, including the political unrest. Just as William Morris and his followers were sympathetic with the socialists, the expressionists were sympathetic with the anarchists or communists. They stood for antibourgeois sentiment and morality. This was their way to break away from established tastes and refinements and from their elders and contemporaries who were willing to carry on with traditional aesthetic standards.

The same antibourgeois sentiments animated the lifework of Franz Cizek, whose name is synonymous with "child art," a term he coined sometime in the late 1890s. The exact age of child art is not known, although Tomilinson wrote in 1936 the following: "For centuries Child Art was not known. The word itself is as yet not four decades old" (Viola, 1936, p. 9). Cizek wrote that there are two conditions necessary in order to speak of child art. The first condition is to understand that art is not achieved by skill is a creative process. The second and more important condition is to understand that the child is distinct and very different from the adult. There must be an understanding that the child has his or her own rules or laws of nature and that the child is closer to nature than the adult; that is, the child is not as influenced by society as are adults. Cizek also believed that the child is more creative than a majority of adults (Viola, 1936, pp. 9–10). Only when these conditions are accepted, can we understand what child art means. Cizek called for greater respect toward the child:

We must respect that most clear, fine and delightful expression of the child's soul: the drawings of the child who has not been under the influence of adult ideas. The child who has not been spoiled by adults, expresses his true self in his work, and is most true when representing the image of his thoughts, his often unconscious hopes, desires and fears. A child's drawing is a marvelous and precious document. (Viola, 1936, pp. 10–11)

Embedded in this writing is the premise for the aesthetic Window paradigm. Children's art is like a Window on the world; it works like a window to make a frag-

ment of that world visible. It is an objective reproduction of reality that carries all the meaning within the image. The image is a child's reality, and the act of representation is the goal, not the truth behind the goal. The purpose of the act is the verisimilitude of what is viewed from the perspective of a window with everything within the frame of the window viewed as reality. As a practitioner in this paradigm, Cizek looked at children's art for its truth and visual clarity. He saw an intuitive beauty and aesthetic statement in the renderings. He broke from the established teachers and psychologists of his day to declare a new hypothesis about children's drawing. He began by boldly renaming the "drawings" as "art." Other artists and educators had expressed these opinions, but it was Cizek's voice that was heard. Why did Cizek become the practitioner who was successful in causing this paradigm to finally break off in its own direction, the direction of establishing children's drawings as art. The modernist mood gave the permission that had first been started so long ago by Rousseau and encouraged so passionately by Cooke and Ablett. Child art, like childhood, was not only different from adult art and adulthood itself but legitimate as an art form, not a poorly conceived copy of adult art.

Cizek's interest in child art began in his academy days in Vienna. While studying at the academy, he roomed with a carpenter and his family, and the children of the household often visited his room to draw and paint. He was given the opportunity to observe these children and other children in the neighborhood. To his astonishment they all drew the same sorts of things, as if there was a law of nature that they were following. He shared these drawings with his Secession friends, who proclaimed new groundwork for art education. "Why go back to the Chinese, Japanese, ancient Egyptians, Babylonians, and Negroes? Here was that which they sought" (Viola, 1936, p. 13). Cizek said: "Children's work contains in itself eternal laws of form. We have no art that is so direct as that of children" (p. 35). This is exactly what Sully thought. The difference is that Cizek valued this as aesthetic and authentic—while Sully valued it as a view into the past.

Encouraged by his fellow artists, Cizek decided to open an art school that met on weekends or on school holidays whose program was simply: "Let the children grow, develop and mature" (Viola, 1936, p. 13). The principles upon which Franz Cizek built his school and his underlying philosophy are that each child is creative and must find that expressive outlet. Children should be allowed to draw as they wish, not as others think they should. With the chance to express themselves, children grow up with added poise necessary to be successful adults.

There was much opposition to Cizek's school and his philosophy, especially by art teachers, but by 1897 his Juvenile Art Class opened. His school was in direct opposition to the teaching of the day. As we have seen, in the schools the curriculum was disciplined and tedious, with the vocational focus always in mind: "At seven years the pupils were given books with dotted pages, these dots were to be connected with straight lines. The older children were given drawing books with the dots further apart. Later on designs were copied from the blackboard. To draw something from imagination, even to draw from nature, was never thought

of. . . . It was a training in skill without any regard for creative work" (Viola, 1936, p. 14).

Cizek's insistence at recognizing the creativity in children led him to develop his method of teaching not by teaching in the accustomed manner, but by letting the children teach themselves. In order not to violate what Cizek believed was an innate creativity, he urged the children to draw what they felt like drawing. He insisted that it was he who learned from the children and not the other way around:

The reason why so many adults stand hopeless before real infantile art is the same as why they often have no approach to modern art, or rather never had. Contemporaries seldom have an understanding of the art created in their own time. It is partly laziness, partly the fear of being wrong, and partly defence against something new, or simply the eternal conflict between old and young. (Viola, 1944, p. 54)

Cizek was not a notable or prolific artist but instead found his artistic expression in teaching. Most of what we know about Cizek was written by his former students: Dr. Wilhelm Viola, who eventually became a lecturer at the Royal Drawing Society, and Francesca Wilson, who, as a fundraiser for "Save the Children Appeal," published three booklets based on his lectures in 1921. When questioned about his class, he is quoted by Viola:

My activity in the Juvenile Art Class [JAC] consists in working with the children as an artist and not as a teacher. What is the aim of the J.A.C.? From the beginning it was an artistical aim. I intended to discover the roots of art. This was in the 'eighties, when art was in decay and imitative. The aim was also to give art education to all people. I said in the 'nineties that one understands art only as far as one worked it out. I wanted that children in the schools should work out what they need for a better understanding of art. My aim was also the forming of new customers of good taste. . . . That is a practical aim. . . . Everything connected with the natural growing of child work is quite clear. (Viola, 1944, p. 106)

Cizek hoped to develop good taste, which would not necessarily show up during the school years but which students would carry with them through their adult life and in the spirit of Ruskin and Morris; this was one of the principal aims of the Juvenile Art Class.

Cizek offered classes free of charge for any child between the ages of two and fourteen years, for two hours once a week. He accepted anyone who wanted to attend. Usually the children started classes at five or six, but Cizek preferred to work with the younger children and was most happy when the children were admitted at two or three years of age: "The child is almost entire 'Erbgut' (heritage), and the environment plays a small part. This is the age of purest art. A child draws a great deal in this period, not because, as grownups make out, he wants to communicate something but because he wants to formulate his own ideas—express what is in him" (Wilson, 1921b, p. 4).

This then becomes an expression of, or Window on, the soul of the child. In this first stage of scribbling and smearing, Cizek said:

The very first stage, the scribbling and smearing stage, is of extreme importance and much evil has been unconsciously caused by parents who did not encourage or even allow their children to scribble. This scribbling is an absolute necessity for a child and it should begin between eighteen months and two years of age. . . . It is partly an activity of muscle, partly an expression. . . . What counts is, that the very young child produces entirely from imagination. (Viola, 1944, pp. 25–26)

In the second stage, called "rhythmic" by Cizek, the child continues to draw and enjoys his or her expression of feeling through repetition, with very little purposeful thinking involved. Cizek warned that people make a mistake in thinking that the child's art is a step toward adult art. He says: "It is a thing in itself, quite shut off and isolated, following its own laws and not the laws of the grownup people" (Wilson, 1921b, p. 5). This is a departure from earlier writers who believed that children's drawing was a preliminary to adult art. This contrasts with the developmental theories established by the psychologists concerning children's drawings.

The third stage, or "abstract-symbolic," is manifested by color and form but is not entirely symbolic and the young artist or the viewer of his or her art does not always understand the symbols. The child's production of types or consistent symbols is a signal that this early child stage is being left for a more knowledgeable stage. "The child gradually comes closer to nature—because of more experience—out of this greater experience and knowledge of things more and more characteristic details appear in his works" (Viola, 1944, p. 27). As the child differentiates in his drawings, "the child does not proceed from wrong to right or from making mistakes to what is correct as so many people think, but from no or little differentiation to more differentiation" (p. 28).

The final stage is "Gestalten":

One could describe that way thus: From creating out of pure imagination the child produces more and more from memory and nature. There is no clear break that would separate the different stages. They are overlapping, for hardly any child produces out of sheer imagination." (Viola 1944, p. 28)

Cizek divided his pupils into two age groups: ages 1 to 10 and the other from ages 10 to 14, but they are more divided by developmental skill than age. Getting children to verbalize their art was an important part of Cizek's work as an artist and instructor but he cautioned that the child should do most of the talking using what he called the "indirect method." (p. 73)

Cizek was very interested in the almost complete halt of creativity in children at about fourteen years of age. He believed that at the onset of puberty, an intellectual crisis occurs, or, as Cizek described it: "Puberty, as a rule, is the great caesura" (Viola, 1944, p. 89). The child becomes hypercritical of his work, and production ceases. Cizek urged great care be taken during this phase so as not to lose creativity forever. "The crisis in a child's life usually comes about fourteen—this is the time of the awakening intellect" (p. 63). Cizek once said of this very critical age:

The child starts with symbols. These symbols are more and more enriched by experience and knowledge. The symbols come nearer to nature, and get influenced by adults, until at last Child Art stops. It is an accident that at this time, as a rule, puberty begins. The real reason for the end of creativeness is the fact that the child gets away from symbols and imitates nature. The crisis begins. . . . Thus Child Art and art in general stops. It is an extremely difficult task to bridge over the crisis and to help the production of the child to another level. (Viola, 1944, p. 64)

It is interesting to note that most adults are stuck in this symbolic stage in their artistic development. Cizek did not accept students after fourteen years of age. He urged a study of nature and creative drawing lessons at that age. As he observed in his classes:

The basic problem of the puberty crisis in drawing is the problem of the separation of image and picture. The child is still living in the unity of picture and representation as in earlier culture. . . . The separation would have been successful and no unsolved conflict would have arisen if no artistic aim in drawing had been set, but only technical and scientific tasks had been given. . . . The conflict of the puberty crisis is to a large extent the reaction of the art crisis in our time which is nothing but the conflict between picture and representation. (Viola, 1944, p. 66)

Cizek wondered if people were programmed or designed to do their best creative work before puberty just as some people reach their physical peak between twenty and twenty-four. But then he wrote: "Artistic creativeness may disappear in one sphere to reappear perhaps in quite a different sphere. It cannot be entirely lost" (Viola, 1944, p. 67).

Cizek offered neither technique nor models for his students. He dissuaded his students from any copying but encouraged them to follow their "inner laws" or natural inclinations. His primary focus was on supporting and generating creativity in his classrooms. "The teacher ought to learn to hover like an invisible spirit over his pupils, always ready to encourage, but never to press or force" (Viola, 1944, p. 44). Cizek was opposed to the schools that supported intellectual approaches to art education. He especially cherished children's so-called "faults" that follow innate rules of childhood. Cizek found specific "faults" executed again and again. "The child thinks optically—logically. The adult thinks comprehensively—logically" (Viola, 1936, p. 36). An example is to put a figure at a right angle to the ground in a picture. This is best exemplified when children draw figures as if they are lying down (Sully found the same thing). The lack of perspective is also a common childhood "fault." He said that "perspective in the work of a small child as an unfailing sign of the lack of a gift for drawing" (Viola, 1936, p. 24). This is shown in Illustration 9.1.

Cizek gave no explicit lessons in color. He believed that children had an innate sense of color that was sometimes better than that of adults. Like his predecessors in England, Cizek appreciated the child's delight in bright colors. When asked if children should be given pale shades to draw because nature has pale shades, Cizek

Illustration 9.1

PLATE III

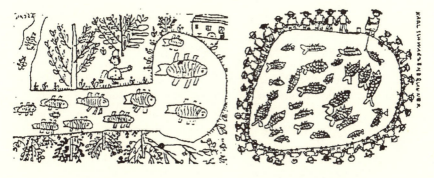

GIRL, AGED 8 BOY, AGED 8

PLATE IV

GIRL, AGED 9

Source: Viola, 1944, plates III, IV

answered: "Art is not nature. Art is not a representation of nature. Children do not copy nature. As strong, courageous creatures they have a birthright for bright colours. The brightest colours are just right. No normal healthy young child will choose pale colours" (Viola, 1944, p. 80).

According to Viola, Cizek stopped painting in 1925, "presumably because he believed that the artistic culture of the people is essentially more important than exhibiting a dozen or more pictures" (Viola, 1936, p. 28). He also believed that the times were not hospitable to art, and he theorized that a new art would emerge from the then-current aesthetic crisis. He, too, sensed the new mood of modernism. He believed that the new art would be reflective of the changing times and attitudes that were occurring in this period, so he chose to direct his creative energies to releasing children's creativity from the shackles of the then-current art methods that were being used in the schools. "I have extricated children from school in order to make a home for them, where they may really be children. I was the first person to talk about 'unschooling of the school'" (p. 38).

Cizek accepted any child who wanted to come to his school and practice art. In the course of his teaching, he found that the poorer students were more creative. He said: "A richer environment is as a rule destructive to what is creative in the child. Too many books, pictures, visits to theaters, cinemas etc. are bad for the child" (Viola, 1936, p. 21). The Rousseauean influence is apparent in the teachings of Cizek. He believed that the closer the child is to nature, the more pure he remains. He concurred with Rousseau and his disciples that society corrupts the child. He also was influenced in his teaching method of "non teaching," letting the child follow his or her own path, a truly child-centered approach advocated by Rousseau, Spencer, and Ruskin. Yet Cizek split from Rousseau and the Romantics by instructing his pupils to break away from nature, teaching them, instead, not to imitate or copy from nature as the Modernists practiced. He encouraged them to draw from memory. He said: "Nature is right enough in its place, but Man should be after creating something fresh. That is what I am always telling them. Get away from Nature. We want Art, we don't want Nature" (Wilson, 1921a, p. 4).

Like Sully, Cizek saw the symbolic nature of children's drawing. This is where the influences in the arts and psychology fields were symbiotic. The symbols are, however, not always obvious and a visitor to his school would witness his hovering over children and asking them to explain their artwork to him. He took his children's art very seriously, as seriously as his own. Discussions were a regular occurrence for the young artists. Also like Sully, Cizek found "an absolute parallel, between the art of the ancients and primitives and that of the child. Only with the ancients and primitives, there is no break in creative power at the age of puberty" (Viola, 1936, p. 25). He blamed the schools for the collapse in children's creativity. Note how Cizek romanticized the primitive, while Sully saw the primitive as a lower form; both, though, shared an evolutionary view. Their attitudes, not their intellectual presuppositions were at odds.

Cizek did not promote or discourage his students, becoming painters or sculptors: "It cannot be said too plainly, that it is not the task of the Juvenile Art Class to

produce artists. Every child in the Juvenile Art Class, whatever he may be later in life, has been given the opportunity to be creatively active. The child can use this creative faculty in every activity of his future life. In every profession we need today actively, creative people, not imitators or automata" (Viola, 1936, p. 27).

Cizek credited William Morris and John Ruskin with encouraging art in every-day life. When he was touring England with his children's exhibition, he said: "It was your William Morris and Ruskin and the rest who first tried to make Art pene-trate every corner of life—brought it right into people's homes, to their wallpapers on the tiles of their hearths and the very clothes they put on. My contribution is that I start with the child and make them begin to decorate the world they live in when they are no more than five or six" (Wilson, 1921a, p. 6).

Viola reported that Cizek had an uncanny way with children, almost as if he himself was a child. This would no doubt be a great compliment to the man who discovered child art. His classes were filled with joy and wonderment as the chil-dren busied themselves with their work. He saw his children as not at play but hard at work. Wilson recalled: "But, whatever the type of class, whether Cizek's part in it is of a mere onlooker, as he loves to call himself, or more active as in the criticism lesson, he is the one person that matters in the room, the magician, for whom all the little gnomes are working, though they know it not, the wizard who has re-leased their powers and enabled them to express the things in them which might otherwise have slumbered forever" (Wilson, 1921a, p. 15).

However, as much as Cizek claimed he did not influence the children's artwork, one cannot help but notice a similarity in the pictures; the cultural influences can-not be lost on a viewer, especially seventy plus years later. Cizek would give the sub-ject of the day's exercise and a bit of direction such as: "They must represent Autumn by a figure. First they must draw a narrow margin round their paper, and the figure must be big enough for its head to reach the top of the margin. . . . The size of the figure was the law of the Medes and Persians, but otherwise they might make their Autumn just how they liked" (Wilson, 1921c, p. 3). Cizek tried to give directions that would not interfere in individual creativity, but common criticism from the classmates actually gave a sense of camaraderie that translated into a similarity in the work of the children.

Wilson recalled after an opportunity to visit one of Cizek's classes:

No description of this lesson can give a full impression of what it was. Cizek is evasive and cannot be quite written down. But I felt, after I had attended it, that I understood a great deal of his secret. He is not only intensely an artist; he is also a keen and incisive critic. But his criticisms have their root (as all true criticisms should have) in understanding and sympathy. He is gifted with a rare understanding and sympathy with the child mind. (Wilson, 1921c, p. 15)

Sensitive to criticism, Cizek rebutted his critics with explanations of why he did not produce more artists. The big concern of those dissenters of child art was that

there appeared to be no progress from three to fourteen years. Cizek explained that
art is not like science, which is cumulative:

Nor is the history of art to be regarded . . . as a steady progression from the work of the
ignorant, primitive man through the Renaissance and on to a culminating point in, perhaps,
the realism of a nineteenth-century academician. . . . The story of art is the story of violating
of canons. . . . Yet the modern work, because of its spontaneity and looseness of handling,
appears to a layman's eye easy to do. . . . Very skilful teaching is required, but it differs from
the teaching of previous years in that it serves the needs of the children as those needs
arise . . . children must live as children before they can function as adults. (Viola, 1944, pp.
102–103)

Cizek was also quite aware of the psychologists' interest in children's art and felt
a need to respond: "There was always psychology in art. But to consider Child Art
from a psychological point of view—as it has been done in recent years—is against
my conviction. Art is not realised psychology but the forming and shaping of life.
All true art contains psychology, but so wonderfully dosed as only nature can dose"
(Viola, 1944, p. 32).

So even as Cizek was willing to see the psychology within art, he held to the tradi-
tion of Rousseau and his followers in his trust in the capacity of nature and here
showed his support to follow the natural inclinations of children in their art.

Cizek also feared what the future would bring and stressed the need to enunciate
very clearly his bold message of child art:

Tests can be made with children's works, but tests are not the main object of children's
drawings. There is a danger in all tests. I could imagine that in the future in teacher's training
colleges one hour per week might be devoted to the "reading" of children's works. We are
today, only at the beginning of this new science. Cizek has opened a door. Others will come,
and explore further. (Viola, 1944, p. 60)

Cizek saw his message as one of freedom for all children. He said:

I have liberated the child. Previous to me children were punished and scolded for scribbling
and drawing. . . . I gave mankind something which until I came had been spurned. . . . But I
have done all that not from the point of view of the pedagogue, but as a human being and an
artist. Such things are not achieved from pedagogy but from the artistic and human or from
human artisticness. (Viola, 1944, p. 34)

Cizek's former student, Wilhelm Viola, was careful to point out to his readers:

Thanks to Cizek and others we can now read many things from children's works. It is quite
natural that a child's drawing, not influenced by adults reveals as much if not more than his
handwriting or language. To learn to know the child's type, his mental age, fears, etc., is
another aim of Child Art. But the analysing or psychoanalyzing of children's works should
not be the first consideration. The work of a child is primarily a work of art. (Viola, 1944, pp.
59–60)

Clearly, through Cizek an appreciation for the beauty of children's art was recognized. Through him, the notion of "child art" took hold and spread among educators. We now have our second paradigm firmly embedded in the social consciousness of the Western world. The aesthetic Window paradigm, reflecting the credos of the modernist art movement, was mobilized to proceed forward into the 20th century.

SECOND-GENERATION PRACTITIONERS:
THE MIRROR PARADIGM

As we look at the inquiry into children's drawing/art at the turn of the 20th century, we can see that these two paradigms are still in place and have grown considerably. The second-generation practitioners have left their mark, have influenced, and are continuing to influence a whole new generation of investigators in both the psychological Mirror and aesthetic Window paradigms. The Mirror paradigm is occupied with practitioners who use children's drawings as interpretive tools to analyze and extract information about children's thinking and their development. The information becomes more extensive and incorporates the processes of planning that go into drawing in a more comprehensive manner. As brain theory is further researched, the cognitive scientists have become the latest subgroup of psychological Mirror practitioners involved in this inquiry. The emphasis of these psychologists is the process of drawing, that is, the planning and execution of these drawings. It is not the finished product that interests them so much as the strategies and planning used to arrive at the finished product. I next outline a few of these more contemporary approaches.

CORRADO RICCI

Cooke's influence in 1885 and Corrado Ricci's *L'Arte dei Bambini* (1887) served as signposts to this new investigative avenue that was established by Sully. On his way from Bologna in the winter of 1882–1883, Ricci sought shelter from the rain under a portico leading to Meloncello, and to his surprise he found what he termed a "permanent collection" of writings and drawings inscribed on the walls (Ricci, 1894, p. 302). He was inspired by the youngest artists' drawings on the lower portion of the walls. He observed their very different interpretation of life as evidenced by their drawings and written expression, and thus he began his study.

Ricci gathered a total of 1,250 drawings from Italian schoolchildren. His collection included pictorial and sculptural arts, but he gave no real analysis in terms of quantitative data. This is, however, the first collection of a body of children's drawings. It is interesting to note that Ricci and Cooke were not familiar with one another's work, but their work took place at the same time in two different places. This is evidence of the "mood" of change that was sweeping across Europe and the United States at the time. Academic psychologists were opening doors to the study of child development and to the better understanding of a very important part of childhood, their "drawing," or the Mirror placed before the children.

Sully's influence can be seen with the attempt to establish taxonomy of children's drawing. Much investigatory descriptive research was done between the years 1890 and 1920. This was a fruitful time for the study of children's drawing. Investigators all over the world, who collected, described, and classified thousands of drawings, continued Sully's initial research in developmental theories of children's drawing. Sully's immediate influence can be seen in the work of Kerschensteiner (1905), Rouma (1913), Luquet (1913), Bühler (1918), Goodenough (1926), Eng (1931), Piaget (Piaget & Inhelder, 1967), (1972), and Robert Coles (1967, 1990, 1992). These practitioners of the psychological Mirror paradigm continued to refine the stages of drawing development that Sully began. They believed that a general survey was necessary in order to continue the investigation with a developmental approach. As a result, there was no attempt to develop a theory of children's drawing/art, although there was an interest in the primitive aspects of children's drawing. There was no attempt to show how these drawings are similar to primitive art, or to show the association with, and influence of, evolutionary theory. Researchers in this period are primarily focused on collecting data and on descriptive analysis of what constituted a child's drawing. There was, however, very rudimentary investigation into retardation and its effects on drawing by Georges Rouma in 1913, which is examined later.

GEORG KERSCHENSTEINER

Georg Kerschensteiner, a Munich educator, studied thousands of schoolchildren during the years 1903–1905. At this time he reorganized the drawing curriculum for the schools in Munich. His findings were published in *Die Entwickelung der Zeichnerischen Begabung* in 1905. "In order to establish a scientific basis for his work, he spent about two years collecting and studying almost 100,000 drawings made under standardized conditions by children in Munich and in the surrounding towns and villages" (Goodenough, 1926, p. 4). He found that they fell into three categories, based loosely on age: "(1) schematic drawings, (2) drawings based on visual appearance, and (3) drawings that attempt three dimensional space."

The book is lavishly illustrated and also includes tables arranged by sex and age in each of these three categories. Kerchensteiner examined both talented children and the mentally retarded, and the differences between normal children and these

groups. He demonstrated that these differences are both qualitative and quantitative. Not only do the feeble-minded tend to produce drawings that are more primitive than those made by normal children, but their drawings also show lack of coherence: *"Zusammenhangebkosigkeit"* (Goodenough, 1926, p. 5).

Kerchensteiner concluded that boys and girls performed very differently depending on the type of drawing they were attempting. Girls outperformed the boys in decorative designs or the schematic type, while the boys outperformed the girls in all other types of drawing such as human figure and still-life drawings or the visual appearance and the three-dimensional-space types.

GEORGE ROUMA

Georges Rouma developed an extensive study on children's drawing in his publication *Le Langage Graphique de l'Enfant* (1913), published in Paris. Rouma employed careful analysis to a number of different studies:

 I. The drawings of eight children during a period of nine months were subjected to analysis. These children came from well-to-do homes and ranged in age from seven to eleven years.

 II. A group experiment was carried out over a period of ten months, in which all the members of a school drew specified objects under Rouma's direct personal supervision for retarded children and for normal children of both sexes in several schools.

III. During a period of ten months, half an hour a week was devoted to observation of the free drawings made by a class of forty children of from six to eight years of age.

 IV. Six half-hour periods a week were devoted to observation of the drawings made by a class of thirty subnormal children ranging in age from nine to eleven years.

 V. Daily observation was made of the drawings of children in a special observation class in one of the schools in Brussels.

 VI. In addition to these direct observations, drawings from several kindergartens and primary schools were collected for Rouma by the teachers, on the basis of which he selected certain children from these classes for individual study. (Goodenough, 1926, pp. 5–6)

Rouma was interested in developmental questions, as were many of the investigators in this early period of inquiry. He developed the following stages:

 I. Le Stade préliminaire [The preliminary stage]

 A) Adaptation de le main à l'instrument. [Adaption of the hand to the instrument]

 B) L'enfant donne une appellation déterminée a des traits incohérents.
 [The child gives a definite name to the incoherent lines that he traces]

 C) L'enfant énonce ce qu'il se propose de représenter par un signe graphique.
 [The child announces in advance that which he intends to represent]

D) L'enfant saisit un rapport visuel de forme entre des ensembles de traits obtenus par hasard et certains objets. [The child sees a resemblance between the lines obtained by chance and certain objects]

II. Evolution de la représentation de la figure humaine
[Evolution of the representation of the human figure]

A) Premiéres tentatives de représentation: rappel du stade préliminaire.
[First tentative attempts at représentation, similar to the preliminary stages]

B) Le stade tétard. [The "tadpole" stage]

C) Stade de transition évoluant vers la representation du bonhomme, complet de face. [Transitional stage of man with face]

D) La représentation compléte de l'Ltre humain vu de face.
[Complete representation of the human figure as seen in full face]

E) Stade du profil de transition. [Transitional stage between full face and profile]

F) Le profil [The profile].

(Rouma, 1913, p. 22).

Another area of interest for Rouma was to explore the differences between retarded children and normal children. He noted characteristics of the retarded children, including automaticity of images, slower development, frequent regression, and incomplete thoughts and follow-through on images. The development served as a Mirror reflecting mental development, which could then be measured. It also allowed for the discovery of normal developmental paths to maturity in artistic development and cognition. This continued to be a line of inquiry among practitioners in the 20th century and today.

G. H. LUQUET

G. H. Luquet was important during this time period for adding the first serious longitudinal study to the literature of developmental research. He published his findings in *Les Dessins D'un Enfant* in 1912. Luquet collected the drawings of his daughter, Simonne, from age three years, three months, and three days, to the age of eight years, eight months, and twenty-two days: "During this time great care was taken to keep the child's drawings free, not only from adult influence, but also from the influence of other children. Each drawing was numbered and dated, and the circumstances within which it was made were noted, together with the child's comments at the time of drawing, and any other significant facts. In all, about fifteen hundred drawings were made during this period" (Goodenough, 1926, p. 8). Luquet believed that because the interpretation of such data was complicated and variable due to the daily fluctuation of performance by the child, it should not be subjected to rigid statistical analysis. He also felt it was important to do more qualitative analysis regarding the process of drawing such as interviewing the child dur-

ing her drawing time to understand her thought processes while making the various decisions in the renderings.

Luquet observed four stages in his daughter's drawing development. The first stage was "*dessin involontaire,*" or the "scribble" stage, where the lines were made with no real consciousness of their symbolic coding or realistic representation. The second stage was what Luquet referred to as "*l'incapacité synthétique,*" or "synthetic incapacity," whereby he meant that the child had not developed a system in which the parts were organized into a coherent whole and in which each part was drawn to join in a bigger, comprehensive picture. The third stage he referred to as "*réalisme logique,*" or "logical realism," in which the child deliberately and consciously reproduced the form they saw. A concerted attempt was made at realistic representation. The fourth stage Luquet called "*réalisme visuel,*" or "visual realism," in which the ability of the child improved, including perspective. At this point in development, the child began to draw like an adult. He wrote that at this adult stage individual differences in ability became obvious. Unless one has innate talent in drawing, drawing skill did not improve beyond that of a child of ten or twelve years of age (Luquet, 1913, pp. 225–226).

KARL BÜHLER

Another practitioner of the psychological Mirror paradigm, Karl Bühler, published *The Mental Development of the Child* in 1913, later translated into English. Bühler, a professor of psychology at the University of Vienna, was interested in child development and devoted the fifth chapter of this book to the development of children's drawing. Bühler's work mirrored that of Sully in that he investigated perceptions, memory, and the imagination of the child. He also investigated the development of drawing and found three areas of particular interest: the preliminary stage of drawing, the schema, and realistic drawing.

In the preliminary stage Bühler described scribbling. "It is the instinct of imitation from which the first impulses come" (Bühler, 1918/1930, p. 107). It is due to this imitative characteristic that the genesis of drawing is so variable among subjects. Bühler wrote: "It has been found to occur as early as the second year, in other cases as late as the fourth." He continued: "At first these playful efforts are no more than an aimless gesticulation with some long object, be it a spoon or pencil, but later, when the connection between the motions of the hand and the results on paper have been grasped, the child begins to derive pleasure from producing lines. The period of scribbling has begun." Bühler compared the first scribblings to the first sounds of the child's speech. As the child continues to scribble, eventually these lines take shape, and the child moves to the second phase: "real meaning" (Bühler, 1918/1930, p. 108). Again, he likened this to the development of speech. The child makes figures with fixed identifications: "The representational intention is apparent in this differentiation long before there is any similarity in the picture to the object portrayed" (p. 108). Once these scribbles are conceived, there is a transition to what he termed "scribble-ornamentation," which occurs once the

lines take on distinct characteristics: "We look in vain for actual, original orna-
mentation, but later, at about school-going age, a strong desire for it develops and
runs riot in the graphic productions of children" (p. 109).

In his consideration of the schema of children's drawings, Bühler listed the ob-
jects preferred by children in their pictures. Humans and animals are the first ob-
jects attempted, then houses, carts, and locomotives, and later, trees and flowers
(Bühler, 1918/1930, p. 109). Beginning with Herbert Spencer, practitioners have
observed the attempt of children to draw humans in their earliest drawings. Most
other investigators agreed with this assertion, and Bühler attempted to explain this
observation: "Why does the budding artist attempt the most difficult things first?
The child does not as yet know any difficulties or the limits of its own capacity. The
chief reason why it draws inspiration from human beings and animals must in
some way be connected with the fact that they are alive and active. The child's
well-being depends on them and it has to enter into relations with them."

Bühler used Sully's published sketches of children's figures to point out the dis-
organized and disproportionate figures found in children's drawings (Bühler,
1918/1930, p. 110). He wrote: "At any rate, at this stage one can recognize outlines
and above all a closed line for the head as well as the most important features. Out
of the circle of the head other lines begin to grow, most frequently two straight lines
downwards, which are obviously meant to represent the legs. The arms are fre-
quently missing, or come out of the head next to the legs. The torso and the neck
are very badly treated" (pp. 110–111).

Bühler observed that when children chose to draw animals, they generally chose
to draw familiar pets or farm animals. "The animal is drawn from the very begin-
ning in profile, head and body often in closed outline, legs and tail stuck to them"
(Bühler, 1918/1930, p. 111). Trees were also a popular theme that presented the
child with difficulty in developing the figure. It proceeded much as the body did
with "a gradual differentiation into trunk, branches with more and more twigs,
leaves and fruit takes place, or the outline becomes gradually more tree-like, as this
is easier to draw" (p. 112). The subject of a house was another common theme in
children's drawings. It was usually presented as a rectangle with windows and a
door and a triangular roof with a chimney drawn as a rectangle on the triangle of
the roof.

In his final analysis, Bühler asked:

Why does the child draw such curious outlines of things? Surely it sees them differently, or,
more correctly, its retinal images are quite different. . . . There can be no doubt that, from
the point of view of the art of drawing this childish schematism is an abortion, which runs
counter to the spirit of pictorial art in many respects. . . . Indeed, we know that it is the bane
of drawing masters, to get the child to see properly. They are quite right in saying that the
child has been badly brought up, that it is in a rut out of which they can only drag it with the
greatest difficulty. But it is no use complaining, and it would be a serious error to suppose
that a radical change can be brought about by the "back to nature" method. (Bühler,
1918/1930, pp. 113–114)

This suggested the belief that children's drawing was inferior to that of adults. He also did not believe that young children could benefit from drawing lessons. This was the prevailing view of children's drawing during the first quarter of the 20th century.

Bühler blamed humans' use of language that shapes the way the mind stores knowledge: "Conceptual knowledge, which is formulated in language, dominates the memory of the child. . . . As a rule the concrete images fade, but as far as the facts are capable of being expressed in language, we remember them. The child draws from its knowledge, that is how its schematic drawings come about. Here, then, we have the key to the understanding of children's drawings" (Bühler, 1918/1930, p. 114).

Bühler drew four conclusions about children's schema:

First: The child draws almost entirely from memory. "Out of its head" as we say. . . . Secondly: The portrayed objects only receive their constant and essential attributes. . . . Thirdly: . . . Its drawings are, in a sense, graphic accounts. . . . The fault lies not so much in a chaotic mind, as in errors of translating from knowledge—formulated by language—to the spatial order of pictorial representation. Fourthly: The child adds part after part, it draws synthetically, as it remembers one thing after another. Many of its impossible creations can be understood if we remember this. They are errors of composition. (Bühler, 1918/1930, pp. 114–116)

Bühler concluded that drawing is important for children because it can lead to four lines of development. The first is handwriting, the second is aesthetics, the third is geographical maps, and the fourth is the realistic picture according to the principles of photography. (Bühler, 1918/1930, pp. 117–119)

Bühler commented on the maturation of children and how it stifles their interest in drawing:

As a rule, the desire for graphic expression fades at the level of the schema, unless there be special talent or school training. About the age at which the child outgrows fairy tales, it also gives up its spontaneous efforts at drawing. We can say that it discards schematic drawing just as it discards many other things of which later it almost seems to be ashamed, without being able to put something more mature in their place. . . . The whole graphic ability lies in writing, and since this belongs to language, we may say: Language has first spoilt drawing, and then swallowed it up completely. (Bühler, 1918/1930, pp. 119–120)

Bühler stated that some people have a natural ability in drawing and music and that lessons are wasted on those who do not have talent in these areas. Only the more talented children will benefit by good instruction and will be able to free themselves from the "shackles of the schema" (Bühler 1918/1930, p. 120).

Bühler expressed interest in what he called "wonder children" a special group of mentally incompetent children who had extraordinary ability in drawing. He noted:

From early childhood their drawing is effortless and realistic, although they have never had any instruction. . . . These children are particularly fond of making copies of heads and the like, (lion, human etc.) from pictures, and later even from life. They can reproduce them to the minutest detail, but without the least expression, and they fail in the simplest task to be done from memory or imagination. The most interesting psychological problem is presented by those talented children who draw entirely from memory. (Bühler, 1918/1930, p. 120)

Bühler used an example from Kerchensteiner's study for his analysis in this area. It opened the way for future investigations that continued well into the 20th century and today. He wrote: "Unheard of achievements by children, which to the lay mind seem miraculous, lose some of their romantic halo and gain much in scientific interest, when psychology begins to lay the foundation for their explanation. At the age at which such wonder-children are discovered, their first attempts with a pencil have usually been lost to science" (Bühler, 1918/1930, p. 121).

Finally, Bühler was interested in the connection of children's drawing to so-called primitive art of the Eskimos, Australian natives, and bushmen of South Africa. In common with scientists, the cave drawings found in France, Spain, and Germany held a fascination for Bühler, and the similarities between these images and children's drawing demanded an explanation. In conclusion, he proposed two additional lines of inquiry. He was primarily interested in language, and so he inserted this topic squarely into the psychological Mirror paradigm. He encouraged the investigation of the language of the primitive tribes and of their connection to the cave drawing images. Also, he raised this question for further research: "Why does language have no influence on the drawings of the wonder-children?" (Bühler 1918/1930, p. 124).

FLORENCE L. GOODENOUGH

In 1926 with the publication of Florence L. Goodenough's *Measurement of Intelligence by Drawings*, a major American contribution to the psychological Mirror paradigm was introduced, and Sully's earlier prediction of using children's drawing as a measurement of intelligence came true. The notion that children's drawing could be used as an instrument to assess children's cognitive aptitude shaped a tradition in the research that was continued for some thirty years, as evidenced by the publication of *Children's Drawings as Measures of Intellectual Maturity* by Dale B. Harris in 1963. Goodenough, a professor of psychology at the University of Minnesota, was thoroughly informed in her study of children's drawing by the preceding researchers in the psychological Mirror paradigm. Her bibliography and initial historical review of the literature were the most comprehensive available at the date of her publication in 1926.

From this framework, Goodenough was convinced that "the nature and content of children's drawings are dependent primarily upon intellectual development. Previous attempts to classify these drawings had, however, been very crude"

(Goodenough, 1926, p. 14). From this starting point she devised the "Draw-a-Man" test that was widely accepted by the practitioners of the psychological Mirror paradigm as a point-scale method where each feature of the figure was scored and the result, or Goodenough Intelligence Quotient, was determined. It was very clear that she was eliminating any aesthetic considerations in her scale: "Artistic standards have been entirely disregarded," she wrote. There was a great deal of consideration in selecting a figure that had universal understanding and that could be simply recognized and appreciated. The experiment was conducted in Perth Amboy, New Jersey, with the assistance of just under 4,000 drawings offered by children in the kindergarten through fourth grade: "The characteristics noted were defined as objectively as possible, and on the basis of these pooled observations a rough scale of about forty separate points was devised. . . . It was based chiefly upon presence or absence of various parts of the body, and the relationship of these parts to each other" (p. 17).

As Goodenough examined the development of cognition, she looked at early infancy: "The first associations and recognitions are perhaps more clearly related to the conditioned reflex than to the conscious reasoning of later life; yet in them we can trace the beginnings of analysis, of differentiation and comparison" (Goodenough, 1926, p. 67). To Goodenough, the evidence was clear that higher thought processes were responsible for the child's drawings. To her it was not just eye-hand coordination or visual imagery:

It has been said that the ability to recognize objects in pictures, an ability which must obviously precede any real attempt to represent objects by means of pictures, is dependent upon the ability to form associations by the similarity of certain elements which are common both to the picture and to the object, in spite of the dissimilarity of other elements. Analysis and abstraction are clearly involved, but only the final result is present in consciousness. (Goodenough, 1926, p. 73)

The ability to understand relationships is also important, as Goodenough wrote:

In general it may be said that the brighter the child, the more closely is his analysis of a figure followed by an appreciation of the relationships prevailing between the elements which are brought out by his analysis. . . . It is this inability to analyze, to form abstract ideas, to relate facts, that is largely responsible for the bizarre effects so frequently found among the drawings of backward children the—"*Zusammenhangenlosigkeit*" to which Kerschensteiner has called attention. (Goodenough, 1926, p. 75)

Goodenough hoped that her investigation would assist both psychologists and teachers in their attempts to support students in their schools and to better understand the conceptual framework of childhood mental functions. She wrote:

It is felt that the present experiment, which has dealt chiefly with the intellectual side has by no means exhausted the possibilities that these drawings possess for the study of child development. On the contrary, it is the writer's opinion that, if properly understood, they

would contribute much to our knowledge of child interests and personality traits. It is hoped that the experiment which has been described will point the way to further research into this very fundamental type of childish expression. (Goodenough, 1926, p. 80)

The "Draw-a-Man" test is no longer used as a measurement for intelligence, though for years it was used as a school readiness test.

HELGA ENG

A somewhat different methodology was followed by Helga Eng (1931), who systematically recounted the drawings of her niece Margaret from infancy to the age of eight. This is the first available study of its kind that could actually follow a single child through early childhood from her first scribble at one year, nine months, ten days, to her eighth year and colored drawings. Eng followed her niece through various stages of pictorial development. She explained these as follows:

1. scribbling
2. the transition from scribbling to formalized drawing [usually a human figure]
3. automatism
4. orientation [incorrect relationship of parts, i.e., eyes below mouth]
5. perspective
6. proportion
7. movement [stiff and expressionless at first]
8. colour
9. ornament [narrative drawings occur before decorative].

(Eng, 1954, pp. 101–180)

Eng informed her readers that she used the investigations of Kerschensteiner, Rouma, Luquet, and Buhler, among others. Her goal was to "deepen and widen our knowledge of the psychology of drawing and of the child" (pp. vii-viii).

JEAN PIAGET

With the dominance of Piaget beginning in the mid-1930s in developmental and cognitive theory, the study of drawing/art virtually came to an end. For Piaget, children's drawings were interesting only as a support to his own stage theory of child development. He wrote: "It has seemed advantageous to . . . investigate the elementary relationships operative in representational space through the study of children's drawings, or more accurately, the study of their pictorial space" (Inhelder & Piaget, 1958, p. 45).

Piaget and Luquet both held that the representations of children were intentionally realistic, and, utilizing the stages put forth by Luquet, Piaget presented a developmental theory of organizational and graphic skills:

Children's drawings were never an important aspect of Piaget's system of child development so by the 1970s this topic was hardly mentioned by practitioners who were so greatly influenced by Piaget, nor was it a subject in the textbooks that were educating the future generations of cognitive and child psychologists. Drawing theory was ancillary to his developmental theories relegated to a status somewhere between symbolic play and mental images. (Thomas & Silk, 1990, p. 29)

Piaget's stages of cognitive development are based upon maturation and, consequently, age. Experience plays an insignificant role in this theory. The outer world of the child is received by either assimilation or accommodation. Through assimilation, the preconceptions of the child are used to understand the new stimuli and accommodation requires an adjustment to these new stimuli (Thomas & Silk, 1990, p. 62). Play provides the main vehicle that allows for assimilation for the child, and Piaget locates drawing in this process of assimilation. It is from this notion that art therapy developed. Art therapy provides children and adults with assimilation experiences by re-creating images of important concerns or events.

Piaget believed that drawing was an attempt to visualize the external world, and because of this it was framed around mental images and the understanding of space. Because of his evolutionary theories of cognition, he examined children's drawings as a guide to developing spatial geometrical recognition. Piaget adopted from Luquet the proposition that a drawing is an attempt to represent the real world and is based on a mental image (Piaget & Inhelder, 1967). What Piaget's theory does not adequately address are the organizational and procedural problems faced by the child in trying to make a drawing. The cognitive psychologists have taken up this interest in children's drawings. They have investigated the processes involved in the planning of drawings by children. Freeman (1980) has presented many examples of the substantial effects that performance biases and planning difficulties can have on the final form of a finished drawing. He is interested in the strategies children use to execute their renderings:

The shift from viewing drawings as a "print-out" of mental contents to considering them as constructions whose final form depends crucially on the procedures used to produce them has been one of the most important recent developments in the study of children's drawings. Indeed, so fundamental is this change in our approach to children's drawing that its consequences may yet restore children's art to a central position in child cognitive psychology. (Thomas & Silk, 1990, pp. 31–32)

ROBERT COLES

Robert Coles, one of our final influential practitioners in the psychological Mirror paradigm, is from a Freudian tradition of psychoanalysis. During the 1950s, Coles was a medical student preparing for a career in pediatrics. Early in his career he met William Carlos Williams, an elderly physician and famous poet whose bedside manner included candies and crayons. Williams was receptive to the visual language of his patients and encouraged Coles to "look at them, looking, . . . their

eyes meeting the world," as they drew their images (Coles, 1992, p. 1). Williams appreciated the seriousness of the children's drawing and did not understand why the schools and parents did not appreciate it. "A youngster drawing is a youngster thinking, a youngster telling you a hell of a lot. When will we know that? . . . Let them flower as artists, . . . so they can display all their beauty—rather than be cut down to size in drill after drill!" (Coles, 1992, p. 1)

This early influence shaped the career of Coles, who became acquainted with Anna Freud, daughter of Sigmund Freud. Eventually, he became a pediatrician and then a child psychiatrist. In order to better understand his young patients, he began to ask them to draw for him in order to get to know them better. For over thirty years he has collected drawings of young children from all over the world. He has learned that "what is significant in the life of the child comes across again and again in the drawings or paintings that child makes—more so, in my experience, than is the case with much of what passes for (verbal) communication or an interview" (Coles, 1992, p. 7).

Coles' career has taken him around the United States as well as the world to examine what he calls *Children in Crisis*, the title of his five-volume series (1967). Coles found drawing a medium that allows him to reach the children in a way that spoken language could not. As a practitioner of the psychological Mirror paradigm, Coles has shown that the drawings of children can benefit the field of psychoanalysis by providing insight into the child that is clear and sincere. For Coles, it is more difficult to hide thoughts in a drawing than it is in words; children's drawings provide another projective measure to understand the inner workings of the mind.

These theorists demonstrate that they had extensive interests, all within the psychological Mirror paradigm. They all heeded Sully's call for an examination of the earliest years of childhood and the steps children are taking both physically and mentally, to reveal the true child-nature. These practitioners sought to examine children's drawings as interpretive tools to extract information about the child's thinking processes and development. The science of psychology embraced the study of children's drawing to serve as a reflection, like a Mirror, on the inner workings of the child's mind and a reflection of their development.

The psychological Mirror paradigm is made up of practitioners whose interest is not of an aesthetic nature. These are scientists who do not recognize artistic relevance in the renderings of children. The work of Ricci, Kerschensteiner, Rouma, Luquet, Bühler, and Goodenough all continued the work begun by Sully in their classification and descriptive analysis of children's drawings. The investigation of intelligence through drawings was an important line of inquiry among the psychologists. Once this interest waned, it became a neglected theme for study among developmental psychologists. With the predominance of Piagetian theory, this oversight continued because children's drawings did not serve as a central theme to his broader theories. Piaget was satisfied to incorporate Luquet's earlier theories into his own cognitive development theory. Robert Coles continues the psychological Mirror paradigm in the tradition of Freudian analysis. He appreciates chil-

dren's drawings for their ability to delve into the inner thoughts of his patients. Coles considers drawings a language system that is more honest than words.

As we have seen, these influences have also penetrated the aesthetic Window paradigm, especially with the art educators, and particularly those latest practitioners who are interested in the association of drawing with writing and language theories. Finally, the aesthetic Window paradigm practitioners merge their symbolic generalizations, shared commitments, values, and exemplars, as shown by their articles published in both psychological and artistic journals. Ironically, it is a psychological Mirror paradigm practitioner who most challenges the artistic Window paradigm, Seymour B. Sarason, discussed in the next chapter. His challenge is to the art educators and other practitioners of the Window paradigm to continue with their message of the importance of the arts to improve the human condition. His is a defense that artistic activity is something that everyone is universally capable of doing. He is challenging the artistic Window paradigm practitioners to overcome society's insistence that "objective" thinking is required for a successful life. It is a challenge to uncover the artistic self that is buried by the many years of school that promote reading, writing, mathematics, and science.

SECOND-GENERATION PRACTITIONERS: THE WINDOW PARADIGM

As the psychological Mirror paradigm has developed in its own direction, the aesthetic Window paradigm has progressed as well. However, the boundaries between the Mirror and Window paradigms have been increasingly blurred. The vocabulary, the values and problems, or lines of inquiry have been melded into interconnected parts that have helped to create an interdisciplinary subject: children's drawing/art. This subject has become increasingly expanded due to the influences of the modern world with the cultural threads of physics, psychoanalysis, cognitive science, child development, and especially the modernist artistic movements of impressionism and expressionism. The awareness of cross-cultural factors has also opened up our senses to an acceptance of children's art that stands in opposition to the realistic representational models hitherto adhered to in the Western world.

Cizek was a part of the new "mood" in the arts that signified a reinterpretation of art with its departure from the shackles of realistic representation. He supported the continued movement toward impressionism and expressionism and all that these movements represented. The three most influential theorists or practitioners of this paradigm immigrated to the United States from the Weimar Republic after the Nazi invasion. All were informed by Cizek's work and sought to promote his pioneering effort. Henry Schaefer-Simmern, Viktor Lowenfeld, and Rudolf Arnheim have all been responsible for shaping and influencing the aesthetic Window paradigm for the last sixty years:

When we think of Weimar, we think of modernity in art, literature, and thought: we think of the rebellion of sons against fathers. . . . And we think, above all, of the exiles that exported Weimar culture all over the world. . . . When the Nazis seized control of Germany; the exiles Hitler made were the greatest collection of transplanted intellects, talent, and scholarship the world has ever seen. (Gay, 1968, pp. xiii–xiv)

In this chapter the theories of Schaefer-Simmern, Lowenfeld, and Arnheim are examined. These men are all practitioners of the aesthetic Window paradigm with the commonly held beliefs that children's art serves as their Window to the world. These practitioners are interested in visual clarity and material applications that allow for expression of children's depiction of their world. Some of these writers are more interested in how the child images fit into the accepted style of art and whether they possess the accepted beauty and taste of the time. Others explore the developmental concerns of the psychological Mirror paradigm and self-expression considerations above the aesthetic concerns. We have a wider range of interests within the aesthetic Window paradigm than we found in the psychological Mirror paradigm. In fact, it is notable that within the Window paradigm, Rudolf Arnheim crosses paradigms and captures the interest of both groups of practitioners, beginning what may be a new, synthetic approach. He merges their interests into a common paradigm while still maintaining the individuality of the two paradigms by writing and teaching a subject he has called the psychology of art.

HENRY SCHAEFER-SIMMERN (1898–1978)

Henry Schaefer-Simmern was born on December 11, 1898, in the town of Haan-on-the-Esels in the Northern Rhineland, Germany. He attended Teachers College in Mettman, was drafted into the German army for a short time, and eventually attended the State Academy of Arts in Düsseldorf, where he received a diploma for teaching art in the gymnasiums and teachers colleges. Schaefer-Simmern set up his studio in Wuppertal-Elberfeld and became a member of the Das Junge Rheinland, an expressionist art association, in 1919 and 1920. His first art exhibit was at Galerie Neue Kunst Frau Ey in Düsseldorf in 1922. He returned to the State Academy of Fine Arts and received an additional diploma to teach applied and industrial arts. Afterward, he continued to teach as well as exhibit his own work. Schaefer-Simmern's life was steeped in the traditions of Germany during the period 1926–1933: "He directed art programs at Frankfurt's prestigious Model School from 1926 until the Nazi takeover in 1933. Here he followed in the foot steps of several distinguished predecessors, Johann Pestalozzi had established this school in the late 18th century, Friedrich Froebel had taught there in 1805, and George Kerschensteiner had developed his psychological theories of child art there in the 1910s" (Berta, 1994, p. 124).

Schaefer-Simmern first learned of the Berlin School of Gestalt Psychology through the work of Max Wertheimer in 1927, and at this time Arnheim completed his Ph.D. under Wertheimer. In 1928 Schaefer-Simmern attended the Sixth International Congress on Art Education in Prague. At this conference he met Franz Cizek, who presented a paper (Berta, 1994, pp. 533–536). Also in 1928 he realized that his art was not his own. He wrote:

I tell you openly that I lost over thirty years of my life before I learned the meaning of genuine art, what I could do myself, and what was my own art. All my studies at Düsseldorf

and Kassel Art Academies were complete nonsense. I didn't learn anything except imitating nature, duplicating techniques, copying the styles of other artists, and reproducing the latest art vogues. Even though I had exhibited with DAS JUNGE RHEINLAND in Düsseldorf, Kassel, Frankfurt, Munich, Marburg, and Berlin, I was a complete fraud. My paintings were nothing but swindle. My work was non-artistic because it was not mine; it was not from my own convictions. So to forget all of that business, I burned all my Expressionist paintings on a Sunday morning in 1928. (Berta, 1994, p. 263)

As Schaefer-Simmern was moving toward his educator role, he found a new vision of art as a Gestalt product created by cognitive processing. His influences were Conrad Fielder, Gustaf Britsch, and Gestalt psychology. From Fielder he learned that "artistic activity begins when man, driven by an inner necessity, grasps with the power of his mind the entangled multiplicity of appearances and develops it into configurated visual existence." He continued: "This is common knowledge to all genuine artists, from their daily experience; yet in official art education it has been almost unknown and very seldom applied" (Schaefer-Simmern, 1948, p. xi).

But it was more from Gustaf Britsch, who applied Fielder's theory, that he felt inspired:

He [Britsch] demonstrates the existence of definite evolutionary stages by which artistic configuration develops gradually from simple to more complex relationships of form. Thus he indicates a way toward the foundation of an art education which will encourage the natural unfolding of artistic activity as an inherent quality of man. My work in art education has been decisively stimulated by Britsch's theory. For twenty years I have tested his principles in practice, with children and adults, persons of different nationalities and of different mental, educational, and economic backgrounds. I have extended his theory and added to his findings. Out of this experience a doctrine of art education has emerged which may serve as a stimulus for new educational procedures and may activate later, hitherto unconsidered, potentialities in artistic as well as other fields of human functioning. Moreover, such broadening of the layman's capabilities has definite social and cultural implications." (Schaefer-Simmern, 1948, p. xi)

Schaefer-Simmern emigrated with untold thousands after the Nazi invasion of Weimar, and he settled in May 1937 in New York City, where he was accepted immediately into the art community, as evidenced by his German student art exhibit at Karl Nierendorf's Gallery in June of that year. Shortly after this, Lowenfeld also emigrated from Vienna. Arnheim, who emigrated in 1930, and both Schaefer-Simmern and Lowenfeld were all working in New York City at the same time. In 1942 Schaefer-Simmern met Arnheim during an air-raid blackout drill at the International House in New York City (Berta, 1994, pp. 539–540). They became close friends for the rest of Schaefer-Simmern's life. Their work within the aesthetic Window paradigm was supportive and complementary to one another, but Lowenfeld was at odds with Schaefer-Simmern's philosophy, as will be shown.

Schaefer-Simmern continued to make inroads in the art world with support he garnered while initially practicing in Weimar. In 1942 he was offered a position to

teach mentally retarded children and adults through the Russell Sage Foundation at the Southbury Training School in Connecticut, and he remained there until 1944. Through this research that his seminal theories were set down in *The Unfolding of Artistic Activity, Its Basis, Processes, and Implications*, published in 1948.

Schaefer-Simmern began his book with the prefatory statement: "[M]an is only partly educated and only partly a functioning entity. Because the harmonious development of his sensuous, emotional, intellectual, and physical powers is neglected, his creative capacities cannot unfold" (Schaefer-Simmern, 1948, p. 3). He criticized the then-current art education practices that evinced a preference for self-expression. He explained:

To the psychologist and psychiatrist this kind of self-expression offers insight into various important psychological processes—a fact which explains why such investigators are less interested in the artistic quality of the child's work than in drawing and painting as a "projective technique." . . . Hence, the educational method which aims at self-expression, though it may have psychological values, does not forward the growth of the child's artistic abilities. (Schaefer-Simmern, 1948, p. 5)

He argued that since external achievement is encouraged, there is "no organic unfolding of the student's own artistic ability; he becomes, in any field of pictorial production, a victim of unrelated specialization. . . . He becomes divided within himself" (Schaefer-Simmern, 1948, p. 6). Schaefer-Simmern objected to the 19th century pedagogy that attempted to reach and over-evaluate and isolate details to gain understanding. It achieved specialized knowledge in various fields but also lost the understanding of relationships that led to further closure and added to a disassociation to an accepted way of life. "The unfolding of artistic activity cannot be separated from the nature of man; it must grow out of him as a unified process" (Schaefer-Simmern, 1948, p. 7).

Schaefer-Simmern explained to his reader that his viewpoint of art will be judged on "pictorial data only" (Schaefer-Simmern, 1948, p. 8). He insisted that artistic form could be seen not only in sophisticated artworks but also in the simpler works of children. His theory "attempts to reveal the nature of artistic activity in its organic development and growth, and further, to establish the fact that artistic activity is a function of general human activity, and to indicate its relation to ordinary experience" (Schaefer-Simmern, 1948, p. 9). He explained that individuals needed to be led to their own stage of visual conceiving and that from here, they moved to a higher stage of visual conceiving based on their own visual judgment and understanding of their drawing as a formed whole (Schaefer-Simmern, 1948, p. 191).

Schaefer-Simmern reported that he worked with four populations—mental defectives, delinquents, refugees, and professionals—in proving his thesis that *everyone* is capable of unfolding her or his creative activity. His conclusions elucidate this proposition:

The entire experience reveals that from the beginning, artistic activity is an autonomous operation . . . based upon sensuous creation and "visual thinking" of relationships of form . . . artistic activity should also be considered as a part of nature. Its growth can only take place in accordance with natural laws of unfolding and development; simple structures precede complicated ones . . . according to the evolutionary laws of visual conceiving.

Through this process the stages are successive and naturally lead to the next stage. Art education that is built on this natural foundation is able to achieve successful results by everyone. "The experiment reveals further that the natural unfolding of inherent artistic activity can take place only if its execution is suited to the individual's specific mental capacities and interests; that is to say, if it starts at the student's unadulterated stage of his visual conceiving" (Schaefer-Simmern, 1948, p. 198).

Schaefer-Simmern's work at Southbury drew the attention of the art community, and in 1945 he was offered a position on the faculty at the University of California at Berkeley in 1945 and remained until 1948. His appointment was established to set up an art education program, but abstract expressionism drew a formidable following in the Berkeley area at this time. So with the publication of his book, it was clear that Schaefer-Simmern was out of touch with the times at Berkeley, as demonstrated by his rejection of expressionism in 1928.

Schaefer-Simmern was slipping into obscurity, and the final thrust of his ouster occurred in 1951, when he attended the National Art Education Association (NAEA) conference in New York City. Viktor Lowenfeld, as president of the association, gave the closing address supporting his theories of art education and his self-expression teachings of art in the elementary schools. "During the question period immediately following Lowenfeld's address Schaefer-Simmern goes to the podium and delivers an unscheduled, uninvited, and unappreciated lecture contradicting Lowenfeld's "creative self-expression" rationale and refuting his psychological theory of visual and haptic personalities" (Berta, 1994, p. 547). Lowenfeld was in favor with the majority of the NAEA members, who were sympathetic to the concerns of the expressionist school of art. These artists/teachers emphasized the displays of the inner feelings and motivations of their students, with liberal usage of forms and color that were highly individualized, and they placed major emphasis on response rather than form. While Schaefer-Simmern emphasized an art education whose primary focus should be directed to the artistic product, Viktor Lowenfeld emphasized the psychological process as his primary focus.

Following this altercation Schaefer-Simmern slipped out of national favor and attention, and by 1955 he disassociated himself from the NAEA. Berta wrote: "During the same period that his public career declined, his private career as teacher, art connoisseur and researcher flourished in ironic contrast. He taught children, adolescents, and adults at his Berkeley Institute from 1949–1971, at St. Mary's College from 1961 to 1978, and at various other places and institutions throughout the Bay Area" (Berta, 1994, p. 8). Berta noted that his influence on his passionate followers and students never waned, though his work with them would,

however, hinder their academic degree aspirations because his institute had no accreditation of academic affiliation. For the majority of his students this made little difference, but those who desired to become K-12 teachers or collegiate academics had to leave. Several of his students went on to become established and well-known artists, and one especially, Sylvia Fein, is an artist and writer practitioner in the aesthetic Window paradigm. Her most recent book, *First Drawings, Genesis of Visual Thinking*, was published in 1993 by Exelrod Press.

Schaefer-Simmern met Seymour B. Sarason, a psychologist who was assigned to work with him during his Southbury days. This was early in both of their American careers. Sarason says of Schaefer-Simmern that he was "a man who influenced and altered my thinking in countless ways. . . . He was the most extraordinary person I have ever known (Sarason, 1988, p. 30). His viewpoints were very much in opposition to the cognitive model established by Bühler and others but remained unaltered throughout his life.

Schafer-Simmern taught his students to use only visual data to analyze art. Berta recounts an incident that illustrates the pedagogic style of Schaefer-Simmern:

During the late 1950s with a group of prominent Bay area women in the Atherton home of Elise Stern Haas, Arnheim recalls a woman new to the group presenting her first painting to Schaefer-Simmern for analysis. She began, "Professor Schaefer-Simmern, there is a great deal behind my painting." Arnheim, knowing full well Schaefer-Simmern's pristine dedication to "visual facts only" and his aversion to any type of psychological reading into art, enjoyed watching Schaefer-Simmern carefully lift her painting, turn it over and with great flourish, study the blank back side meticulously, and then dramatically announce: "Oh? Is there something behind your painting? Madame, I do not see anything behind but raw canvas and a wood frame. In order to understand art, we don't have to wonder what's behind it. Everything is there in front on the canvas, not behind the canvas. Please remember there is nothing more factual than a work of art. We have only to open our eyes and see the visual relationships. These visual facts constitute artistic form, nothing else. Please do not believe a single word I say about artistic form unless I can prove it to you with visual facts only." (Sarason, 1990, pp. 36–37)

Schaefer-Simmern was a structuralist/formalist like many of the European émigrés in his theory of aesthetic theory. Berta recounts a lecture he gave in 1968 at University of California at Berkeley: "I can only show structural laws in the realm of visual conceiving as they develop in the child and in related epochs of mankind. To understand children, help them unfold their artistic abilities, and build their minds, we must know these laws of visualization. This is why I stress the development of artistic form." He then explained that the artistic form in child art "begins with scribbles, proceeds to spirals, simplifies into circles, advances with horizontal-vertical, moves with diagonals, heightens into overlapping, climaxes with elaboration, and finalizes through borderless transition from parts with figural meaning to parts with ground meaning" (Berta, 1994, p. 457). This resembled the evolutionary model but was characteristically focused on the form. The past stages were not as detailed with regard to the figures or images that are found in each stage

but were primarily focused on the age of children and their physical development as well as their cognitive state of mind. Schaefer-Simmern was informed of what had been researched before and applied the stages of the previous investigators to develop his Gestalt structural approach.

Schaefer-Simmern stressed a style of direct inquiry of students to help them find their own personal artistic form and solve any problems they were having with their work. This demonstrated the influence of Cizek as he assisted the children with their art projects. Cizek also believed that students should be able to develop according to their individual tendencies. He taught not by teaching but by drawing out from the children their personal artistic development.

Henry Schaefer-Simmern died in 1978, but his legacy lives on in the people he touched both personally and professionally. At this time in history, his name has been all but forgotten, but there is currently a resurgence in his legacy. Beta's dissertation is but one example. The language he used in his only published book, such as "artistic unfolding," is seen throughout the art education Window literature, but it is not clear if practitioners know of its genesis. Schaefer-Simmern's wife is currently in the process of publishing his last piece posthumously. This may rekindle the interest that was so prevalent in his early years before his split with Lowenfeld. Schaefer-Simmern's legacy also lives on in the work of Seymour B. Sarason, the psychologist from his Southbury days, and with Rudolf Arnheim.

VIKTOR LOWENFELD (1903–1960)

Viktor Lowenfeld and Schaefer-Simmern were both practitioners within the aesthetic Window paradigm and although their theories ran parallel, they differed greatly from one another. Lowenfeld was born in Linz-on-the-Danube in Austria on March 21, 1903, and was an observer and one of Franz Cizek's assistants in his children's art school (Smith, P. 1985, p. 219). Both Schaefer-Simmern and Lowenfeld came from Weimar; both were educated in traditional art schools. Lowenfeld studied in Vienna, but, like Schaefer-Simmern, he rejected this early tradition in favor of the new expressionism in his art. They both began their professional work in a milieu for nonartists, Schaefer-Simmern with adult nonartists and Lowenfeld with the blind to develop their haptic aptitudes in art production. This early experience led Lowenfeld to develop his particular self-expression theory (Berta, 1994, p. 433). Lowenfeld's brand of self-expression differed from the visual expression of Schaefer-Simmern because of Lowenfeld's extensive work with the blind, which led him to examine various aptitudes of expression besides visual.

Fleeing from the Nazi regime, Lowenfeld immigrated to the United States, where he first lived in New York City. He then settled in Pennsylvania when he was appointed professor of art education at Pennsylvania State in 1946. He was the first full-time tenured professor in the Art Education Department. "By 1960, Viktor Lowenfeld had established the largest art educational program in America with 9 faculty members teaching 25 courses to over 200 full and part-time students at the

B.S., M.S., M.Ed., Ed.D., and Ph.D. levels within the Art Education Department of the College of Education at Pennsylvania State University" (Berta, 1994, p. 435).

During the 1950s Lowenfeld shared his dominance of the profession with Edwin Ziegfeld of Columbia Teachers College (Berta, 1994, p. 12). Lowenfeld approached his theory of children's art from a psychological viewpoint. Although a practitioner from the aesthetic Window paradigm, he was greatly influenced by the interests of the psychological Mirror paradigm practitioners; that is, he was interested in the feelings that motivated the art of children. From this point, the natural progression was Freudian interpretation of children's art from those who were influenced by his theories and the art therapy field that began in the 1960s:

Much of Lowenfeld's work as an art educator was scientific, and he was one of the few who published in psychological journals. Furthermore in his position as chairman of one of the largest graduate programs in art education, he was in a position to influence future art educators who themselves would be responsible for the education of teachers of art. In short, Lowenfeld not only wrote two of the most significant books in the field of art education and provided a model for scholarly inquiry into the field, but also worked directly with those who were later to become professors of art education in the colleges and universities in the U. S. and Europe. (Eisner & Ecker, 1966, p. 1)

Published in 1947, Lowenfeld's *Creative and Mental Growth* was the most widely used textbook in the field of art education. Lowenfeld, like other psychological Mirror practitioners, was interested in developing a stage theory of drawing development. That theory and his visual-haptic theory were explained in this textbook. James Sully first examined visual-haptic theory as he searched for a connection between visual and haptic perception. "Sully suggests that visual and haptic perception are not separate developments but interdependent—'visual perception has thus in a manner grown out of tactual perception,' concluded Sully" (Macdonald, 1970, p. 325). Sully wrote on this subject in *The Human Mind*, published in 1892. His influence is far-reaching and prescient not only in the psychological Mirror paradigm but with Lowenfeld in the aesthetic Window paradigm as well.

Lowenfeld's textbook remained in print for decades in eight separate editions, the last five coauthored by a former doctoral student, W. Lambert Brittain, 1982. This text offered teachers not only an outline of the various stages of development but suitable applications for art activities in each stage of personality growth. It could even be used by teachers who had little formal training in art as a pragmatic guide to learning and teaching. Therefore, Lowenfeld's theories were more accessible to the general population of art educators than Schaefer-Simmern's *The Unfolding of Artistic Activity, Its Basis, Processes and Implications*—a volume that offered no guidelines to apply the author's idiosyncratic research findings. Thus, a well-developed sense of aesthetic hypothesis and research was methodologically necessary to use his theory. Most art teachers continue to be resistant to theoretical studies, as indicated by the dearth of such articles published in the journal *School Art*.

In his text *Creative and Mental Growth*, Lowenfeld outlined the stages of drawing development as:

Scribbling (2 to 4 years)

Pre schematic (4 to 7 years)

Schematic (7 to 9 years)

Dawning Realism in the Gang Age (9 to 12 years)

Pseudo-Naturalistic stage (12 to 14 years)

Period of Decision (14 to 17 years).

<div align="right">(Lowenfeld & Brittain, 1982, pp. 36–40)</div>

Within each of these stages Lowenfeld attempted to insert his personal theories of personality and motivation to find what is "behind" the children's drawings. Brittain wrote of his efforts: "It is not the product that concerns us, it is not the picture or the properly executed clay piece or the construction made from wood that should concern us. Rather it is the value of these experiences to the child that is important. If the youngster has increased in awareness of the environment, has found joy in developing skills, has had the opportunity to express feelings and emotions, then we have succeeded" (Lowenfeld & Brittain, 1982, preface).

Another important aspect of Lowenfeld's research is his visual-haptic expressive types theory, which developed out of his work with the blind early in his career:

At about the age of twelve or so it is possible to see examples of two types of expression. One is called the visual type, and the other is usually referred to as haptic (from the Greek word haptos, meaning "to lay hold of"). Theoretically at opposite ends of a continuum, these types refer to the mode of perceptual organization and the conceptual categorization of the external environment. The visually minded person is one who acquaints himself with his environment primarily through the eyes or feels like a spectator. A person with haptic tendencies, on the other hand, is concerned primarily with his own body sensations and subjective experiences, which he feels emotionally. (Lowenfeld & Brittain, 1982, p. 326)

It is more usual to find some traits of both visual and haptic types in a single person than it is to see only visual or only haptic tendencies in a single person. As Lowenfeld believed that the origins of artistic activity were in the polar visual and haptic types, Schaefer-Simmern argued that the origins of artistic activity came from an intuitive visual activity.

Viktor Lowenfeld retained his enormous influence when he died suddenly while addressing the Penn State senate faculty on June 12, 1960. He died while working vigorously toward his goal of installing art education certification standards for all teachers in such programs. Schaefer-Simmern sent the following eulogy for Lowenfeld:

With a sadness in my heart do I hear of Viktor Lowenfeld's passing away. He was in our home last Christmas and we discussed the New York situation in art education. . . . He has

actually finished a definite stage in the development of art education in the USA—the psychological approach—for this he has earned his niche. Above all, he was an honest, kind man and believed with all his being in his work. Unfortunately, he did not see the artistic insight and because of this, he created an epoch of art education that saw the child as a "psychological thing." (Berta, 1994, p. 464)

Thus, for Schaefer-Simmern, it seemed as if the emerging consensus of the aesthetic Window paradigm, especially among the European prewar émigrés who came to dominate the field of art education in the United States, was nearly derailed by the efforts of the widely popular Viktor Lowenfeld. But by the 1960s, the time was ripe for the emergence of another Weimar émigré, Rudolf Arnheim, who was able to merge the aesthetic Gestalt formalism of Schaefer-Simmern with the psychological art expressions of Lowenfeld to a more balanced middle ground. He was able to unify the two paradigms of psychological Mirror and aesthetic Window.

RUDOLF ARNHEIM(1904–)

Rudolf Arnheim was born in Berlin on July 15, 1904, studied at the city's university, and received his Ph.D. in visual expression, philosophy, and the history of art and music in 1928. He studied under Max Wertheimer, Wolfgang Köhler, and Kurt Lewin, all Gestalt psychologists. By all accounts, Arnheim was educated in both the fine arts and psychological theory. He fled the Nazis in Weimar for Rome, London, and finally New York City in 1933. He met Schaefer-Simmern in 1942, when Arnheim introduced him to the theories of Britsch, and thus began their lifelong friendship. Arnheim was awarded Rockefeller and Guggenheim Fellowships and taught at the New School of Social Research and at Sarah Lawrence from 1943 to 1968 as a professor of psychology of art. Afterward he joined Harvard University from 1968 to 1974, where he taught at the Carpenter Center for the Visual Arts, and then was appointed a visiting professor at the University of Michigan in Ann Arbor from 1974 to 1984. In 1976 he received the Distinguished Service Award of the National Art Education Association (Arnheim, 1989, p. 61). To this day he still resides in Michigan and continues his work.

Arnheim struggled for years to have his landmark *Art and Visual Perception*, published, but his work met only rejection. Through the intercession of Henry Schaefer-Simmern, who introduced Arnheim to August Fruge, editor at the University of California Press, *Art and Visual Perception* was finally published in 1954 (Berta, 1994, p. 548). Despite his varied publications translated into English, this was Arnheim's initial English entry, one that he found necessary to completely rewrite in 1974, because, as he noted: "Such a revision may come more naturally to a teacher than to other others, for a teacher is accustomed to being given another chance every year; to formulate his ideas more clearly, to drop dead weight, and add a few facts and insights, to improve the arrangement of his material, and in general to profit from the reception his presentation has received" (Arnheim, 1974a, Preface).

It is generally agreed that this book has provided the very best application of Gestalt perceptual psychology to children's art and to art in general. Arnheim's Gestalt theory is a comprehensive system that surpasses any previous attempts to systematize a formalist theory of art. In his Introduction, Arnheim postulated his formal and structural approach: "Finally, there was a wholesome lesson in the discovery that a vision is not a mechanical recording of elements but rather the apprehension of significant structural patterns. If this was true for the simple act of perceiving an object, it was all the more likely to hold also for the artistic approach to reality" (Arnheim, 1974a, p. 6).

Arnheim attributed his formal structural precepts of art to both Schaefer-Simmern and Gustaf Britsch:

It was encouraging to me to discover that similar conclusions had been reached independently in the field of art education. In particular Gustaf Britsch, with whose work I had become acquainted through Henry Schaefer-Simmern, asserted that the mind in its struggle for an orderly conception of reality proceeds in a lawful and logical way from the perceptually simplest patterns to patterns of increasing complexity. There was evidence, then, that the principles revealed in the Gestalt experiments were also active genetically. (Arnheim, 1974a, p. 7)

Arnheim's fulsome praise for Schaefer-Simmern's pioneering theories revived the memory of his mentor and brought him back from the brink of obscurity:

The psychological interpretation of the growth process advanced in Chapter IV of the present book relies heavily on Schaefer-Simmern's theoretical formulations and lifelong experience as an educator. His work, *The Unfolding of Artistic Activity*, has demonstrated that the capacity to deal with life artistically is not the privilege of a few gifted specialists, but is available to every sane person whom nature has favored with a pair of eyes. To the psychologist this means that the study of art is an indispensable part of the study of man. (Arnheim, 1974a, p. 7)

He continued to explain that the book had been written for anyone with an interest, not just the specialists. Arnheim not only defended the maligned Schaefer-Simmern, but also demonstratively defended art as an everyday experience for the common man, not just the connoisseur or aesthete: "The book deals with what can be seen by everybody. . . . One of my reasons for writing this book is that I believe many people to be tired of the dazzling obscurity of arty talk. . . . Art is the most concrete thing in the world, and there is no justification for confusing the mind of anybody who wants to know more about it" (Arnheim, 1974a, p. 7). He is effectively opening up the aesthetic Window paradigm wider by including a larger number of people who can partake of the art world by making it more comprehensible.

Arnheim decried the various dry and academic responses to art. He deplored the attention to the primacy of the subject matter, as well as the identification of particular formal relations and motifs, rather than more rewarding study of the rela-

tionship of all these elements to the meaning of whole composition. All these transcendental approaches were just a way of avoiding art. He wrote:

> If one wishes to be admitted to the presence of a work of art, one must, first of all, face it as a whole. What is it that comes across? What is the mood of the colors, the dynamics of the shapes? Before we identify any one element the total composition makes a statement that we must not lose. We look for a theme, a key to which everything relates. If there is a subject matter, we learn as much about it as we can, for nothing an artist puts in his work can be neglected by the viewer with impunity, Safely guided by the structure of the whole, we then try to recognize the principal features and explore their dominion over dependent details. Gradually, the entire wealth of the work reveals itself and falls into place, and as we perceive it correctly, it begins to engage all the powers of the mind with its message. (Arnheim, 1974a, p. 8)

Arnheim raised the age-old question: "Why do children draw that way?" in his chapter on "Growth," and he poked holes into the theories of immature motor control and lack of observational skills. He explained:

> The oldest—even now most widespread—explanation of children's drawings is that since children do not depict what one assumes they see, some mental activity other than perception must intervene. It is evident that children limit themselves to representing the overall qualities of objects, such as the straightness of legs, the roundness of the head, the symmetry of the human body. These are facts of generalized knowledge; hence the famous theory which holds that "the child draws what he knows rather than what he sees." (Arnheim, 1974a, p. 164)

Arnheim agreed that the child, in fact, draws from a synthesis of knowledge attained over time, but with significant modifications. "This process can indeed be described as drawing from knowledge, but it is a knowledge that cannot be taken to be an alternative to seeing" (Arnheim, 1974a, p. 165). He quoted child psychologist Arnold Gesell's research to indicate his assent to the primacy of sight over knowledge in the earliest development: "Nature has given top priority to the sense of sight. Six months before birth the eyes of the fetus move sketchily and independently beneath their sealed lids. . . . The infant takes hold of the world with his eyes long before he does so with his hands—an extremely significant fact" (Arnheim, 1974a, p. 166). Arnheim synthesized these earlier approaches from both aesthetics and psychology and proposed a radical new theory under the subtitle "They Draw What They See." He clarified:

> A theory so palpably in conflict with the facts could never have been widely accepted had an alternative been available. None was, so long as it was believed that percepts can refer only to particular, individual instances: a particular person, a particular dog, a particular tree. Any general notion about persons, dogs, or trees as kinds of things had to derive necessarily from a nonperceptual source. This artificial distinction between perception and conception has been superseded by evidence that perception does not start from particulars, secondarily processed into abstractions by the intellect, but from generalities. . . . Doggishness is

perceived earlier than the particular character of any one dog. If this is true we can expect artistic representations, based on naive observation, to be concerned with generalities—that is, with simple, overall structural features. Which is exactly what we find. (Arnheim, 1974a, p. 167)

Arnheim believed without doubt that children see more than they draw and was the first to argue that children do not draw what they know but what they see. This was a formalist statement as opposed to an expressive response that children draw what they know: "Therefore, when a child portrays himself as a simple pattern of circles, ovals, and straight lines, he may do so not because this is all he sees when he looks in a Mirror, and not because he is incapable of producing a more faithful picture, but because his simple drawing fulfills all the conditions he expects a picture to meet" (Arnheim, 1974a, p. 168).

He discussed artists and nonartists and concluded that there is no reason to believe they experience the world differently:

To be sure, he must be deeply concerned with—and impressed by—his experiences. He must also have the wisdom to find significance in individual occurrences by understanding them as symbols of universal truths. These qualities are indispensable, but they are not limited to artists. The artist's privilege is the capacity to apprehend the nature of meaning of an experience in the terms of a given medium, and thus to make it tangible. The non-artist is left "speechless" by the fruits of his sensitive wisdom. He cannot give them adequate material form. He can express himself, more or less articulately, but not his experience. During the moments in which a human being is an artist, he finds shape for the bodiless structure of what he has felt. (Arnheim, 1974a, p. 169)

Arnheim explained that children's drawing images occur in stages as he criticized Jungian/Freudian art therapists in this quote. He observed:

The circle is the first organized shape to emerge from the more or less uncontrolled scribbles. It has been maintained that the child receives the inspiration for his earliest shapes from various round objects observed in the environment. The Freudian psychologist derives them from the mother's breasts, the Jungian from the mandala; others point to the sun and the moon. . . . Actually, the fundamental tendency towards simplest shape in motor and visual behavior is quite sufficient to explain the priority of circular shapes. The circle is the simplest shape available in the pictorial medium because it is centrically symmetrical in all directions. (Arnheim, 1974a, pp. 175–176)

From this stage the child begins to elaborate the circle shape to include combinations of circles and lines leading out of the circles like a sun image. Once these patterns have been placed in the child's visual vocabulary, they have multiple referents such as a flower, tree, hand, and head with hair. As Spencer wrote in his *First Principles* in 1862, child development proceeds from simple to complex, following evolutionary theory. Arnheim likewise applied Gestalt theory and concluded: "Perceiving and conceiving proceed from general to specific" (Arnheim, 1974a, p.

181). The vertical and horizontal lines are next added, then obliqueness, and eventually a combination of parts into defined forms. He noted: "It should be mentioned that there is no fixed relation between the age of a child and the stage of his drawings. Just as children of the same chronological age vary in their so called mental age, so their drawings reflect individual variations in their rate of artistic growth" (Arnheim, 1974a, p. 182). Arnheim disagreed with Lowenfeld and his growth of personality and expression theory in art education at the time and, in fact, thought it threatening to the child's welfare:

> The emphasis on personality factors has induced some art educators to regard techniques that favor precision of form with suspicion. . . . Spontaneous expression is certainly desirable, but expression becomes chaotic when it interferes with visual organization. . . . But there is . . . danger in preventing the child from using his pictorial work for clarifying his observation of reality and for learning to concentrate and create order. Shapeless emotion is not the desirable end result of education and therefore cannot be used as its means. (Arnheim, 1974a, pp. 207–208)

Thoughts on Education (1989) was published by the Getty Center for Education in the Arts. This publication presents a summary of the bulk of Arnheim's career that has spanned over forty years. Arnheim recapitulates his career with the following passage in the "Instead of an Introduction" at the beginning of his book:

> As a trained psychologist, I knew what the experiments on visual perception had revealed about formation of visual images. There were rules about the organization of shape and the way in which colors influence each other's appearance. Much was known about the effect of spatial depth created on a surface and about the influences of light on works of sculpture and architecture. . . . Composition turned out to do more than just organize the structure of the work externally. Each of the elements conveyed meaning, but that meaning made sense only in the context of the whole, and the context of the whole came across through the formal relations of the parts. The organization of the whole pattern was not just a more or less pleasant ornament but also a symbolic image of how the artist saw the world. (Arnheim, 1989, pp. 9–10)

Arnheim is known primarily for his wide-ranging interests in the fine arts, including an early and prescient volume on the art of cinema, Gestalt psychology, and philosophy, but through it all Arnheim returned to the earliest manifestations of the artistic vision in childhood to spearhead and bolster his aesthetic theories. These constant reminders of the integrity of childhood artistry to his readers appear frequently in the initial pages of his various volumes, but these writings appear to have been largely ignored or even dismissed by many of his disciples. In his most recent work, Arnheim again remonstrated with his readers to return to children's art images to refine further these visual perception and formalist theories:

> Context . . . connected artworks in time and space. . . . Such development could be studied in its least distracted manifestations by looking at the drawings, paintings, and sculpture of

children. An almost biological growth from the simplest original shape to highly complex patterns revealed the underlying theme of mental evolution—a history overlaid with a multiplicity of psychological and social agents in the work of the child and the adult artist. (Arnheim, 1989, p. 10)

Arnheim concluded this work with the realization that art can be understood only as it connects and relates to the workings of the mind,; they are inextricably bound to one another. This became his life's legacy:

Those were some of the way stations of my journey as a teacher. But actually they were only the external manifestations of the basic experience from which they all derived, namely, a growing awareness of the nature of the human mind and of the nature of art. I realized at an early age that the study of the mind in its relation to the arts would be the subject of my life's work. To this end, scientific psychology had to be supplemented by what philosophers and novelists had observed about human motivation and cognition. There was no other access, I thought, to a theoretical understanding of art and art making. . . . I was not meant to invent and create great images myself but rather to contemplate them in the work of others and to think about them. (Arnheim 1989, pp. 10–11)

It must have been with some frustration that Arnheim reiterated these thoughts to successive generations of those engaged in the practice and theory of art, since many of his avowed contemporary disciples patently ignored his most insistent creative touchstone—the childhood art impulse. While art historians remember Rudolf Arnheim as perhaps the single most influential art theorist, he has also left an indelible imprint on psychologists. These psychological followers—trained more specifically in experimental psychology than in aesthetics and thus most influenced by the psychological Mirror paradigm—have nonetheless repeatedly credited Arnheim and his theories of visual perception in their own work. Arnheim's special genius was his ability to cross-reference these two disparate focal points into a comprehensive interdisciplinary subject that incorporated both the psychological Mirror viewpoint and the artistic Window paradigm. Arnheim unquestionably left a strong and vital legacy for his "Psychology of Art" that continues to challenge the narrowly hermetic and constrained definitions of the adherents of each exclusive paradigm.

Only through a more cooperative attitude have the practitioners of these two seemingly disparate paradigms been able to begin to raise the status of children's drawing to its now growing position of importance in both art and science. In a contemporary culture that values logical-scientific thinking and measurements over the mysterious and infinitely less quantitative aspects of childhood "scrawling," this collaboration has figured importantly in recent research efforts that seek to bridge this chasm. The basic tenet that creativity is lost with age has been challenged, and the redress of this "theory" has become a goal for teachers in their redesign of outmoded curriculum goals: "What is at issue here . . . is what it means for people to come to regard themselves, and to be regarded by others, as incapable of any form of artistic expression that puts their distinctive stamp on something.

Most people carry this attitude with them throughout their lives. It is not an attitude with which they entered the world. Rather, it is an accommodation to long-standing cultural views and educational practices (Sarason, 1988, p. 77).

Our society does not place as high a value on artistic activity as it does on scientific activity. Sarason concluded his book *The Challenge of Art to Psychology* (1988), which is dedicated to his former colleague from Southbury, Henry Schaefer-Simmern, with the following observation:

> Artistic activity is not on the social agenda. It is not seen as a "social problem." It does not call for action. It is an activity that our psychologies regard as special in special people. And yet, these psychologies, by their focus on the individual psyche, distract us from examining how the early manifestations of artistic activity in all young people are aborted by the culture, thus robbing people of satisfaction from a unique feature of the human mind. We can no longer afford to regard the manifestations, development, and extinguishing of this feature only in terms of art, rather, we must see it as a symptom whose explanation will shed light on changes taking place in a world our society hardly understands. (Sarason, 1988 p. 184)

Here we have a psychologist challenging the aesthetic Window paradigm practitioners to continue to spread their message. He encouraged them to influence others so that there will continue to be an appreciation of the charm and intrinsic beauty in children's art. The Window practitioners of art—educators, artists, and theorists—see and understand the genesis of creative expression in children's art. This realization was begun by Cizek and continued by Schaefer-Simmern, Lowenfeld, and Arnheim. Each added his own layer of discourse to the texture of discussion that is now part of the inquiry of the aesthetic Window paradigm. This history has traced the genesis and evolution of the study of children's drawing/art through a purely pedagogical approach to a split into psychological and aesthetic paradigms and, via Arnheim and some later theorists, to a synthesis that is again in the service of pedagogy. It is clear that the subject of children's drawing/art has enjoyed a resurrection in the last two decades as practitioners of both paradigms have opened up new avenues of inquiry but also have returned to earlier avenues of explanation of children's drawing/art. This investigation has also demonstrated that it is a subject about both art and psychology. It is not only multidisciplinary but interdisciplinary as well.

BIBLIOGRAPHY

Abramson, R. E. (1985). Henry Schaefer-Simmern's research and theory: Implications for art education, art therapy, and art for special education. In B. Wilson & H. Hoffa (Eds.), The *history of art education: Proceedings from the Penn State conference* (pp. 247–254). Pennsylvania State University. University Park, PA: National Endowment of the Arts.

Allan, J. (1988). *Inscapes of the child's world.* Dallas: Spring.

Anderson, L. F. (1931). *Pestalozzi.* New York: McGraw-Hill.

Aries, P. (1962). *Centuries of childhood: A social history of family life* (Robert Baldick, Trans.). New York: Alfred A. Knopf.

Arnheim, R. (1989). *Thoughts on art education.* Los Angeles: Getty Center for the Arts.

Arnheim, R. (1986). *New essays on the psychology of art.* Berkeley: University of California. Press

Arnheim, R. (1974a). *Art and visual perception: A psychology of the creative eye. The new version.* Berkeley: University of California Press.

Arnheim, R. (1974b). *Visual thinking.* Berkeley: University of California Press.

Ault, R. L., & Vinsel, A. (1980). Piaget's theory of cognitive development. In R. L. Ault (Ed.), *Developmental perspectives* (pp. 1–47). Santa Monica, CA: Goodyear.

Aumont, J., Bergala, A., Marie, M., & Vernet, M. (1994). *Aesthetics of film* (R. Neupert, Trans.). Austin: University of Texas Press.

Baker, D. W. (1982). *Rousseau's children: An historical analysis of the romantic paradigm in art education.* Unpublished doctoral dissertation, Pennsylvania State University, University Park, PA.

Barkan, M. (1994). *Through art to creativity.* Boston: Allyn & Bacon.

Berta, R. C. (1994). *His figure and his ground: An art educational biography of Henry Schaefer-Simmern.* (Vols. 1, 2). Unpublished doctoral dissertation, Stanford University.

Bloch, M. (1959). *The historian's craft.* New York: Alfred A. Knopf.

Boring, E. G. (1950). *A history of experimental psychology.* New York: Appleton-Century-Crofts.

Bühler, K. (1930). *The mental development of the child* (Oscar Oeser, Trans.). London: Kegan Paul, Trench, Trubner. (Original work published in 1918)

Burton, J. M. (1981, February). With three dimensions in view. *School Arts*, pp. 76–80.

Burton, J. M. (1981, January). Representing experiences: Ideas in search of forms. *School Arts*, pp. 58–64.

Burton, J. M. (1980, December). Beginnings of artistic language. *School Arts*, pp. 6–12.

Burton, J. M. (1980, December). Representing experience from imagination and observation. *School Arts*, pp. 26–30.

Burton, J. M. (1980, November). Visual events. *School Arts*, pp. 58–64.

Burton, J. M. (1980, October). The first visual symbols. *School Arts*, pp. 60–65.Burton, J., Lederman, A., & London, P. (Eds.). (1988). *Beyond DBAE: The case for multiple visions of art education*. North Dartmouth, MA: University Council on Art Education.

Carline, R. (1968). *Draw they must*. London: Edward Arnold.

Chambers, M., Grew, R., Herlihy, D., Rabb, T. K., & Woloch, I. (1991). *The Western experience*. New York: McGraw-Hill.

Clark, G. A., Day, M. D., & Greer, W. D. (1987, Summer). Discipline-based art education: Becoming students of art. *Journal of Aesthetic Education, 21*, 129–193.

Coles, R. (1992). *Their eyes meeting the world*. Boston: Houghton Mifflin.

Coles, R. (1990). *The spiritual life of children*. Boston: Houghton Mifflin.

Coles, R. (1967). *Children in crisis: A study of courage*. Boston: Little, Brown.

Collingwood, W. G. (1893). *The life and work of John Ruskin* (Vols. 1, 2). Boston: Houghton Mifflin.

Compayre, G. (1910). *The history of pedagogy* (W. H. Payne, Trans.). Boston: D. C. Heath.

Compayre, G. (1907). *Jean Jacques Rousseau and education from nature* (R. P. Jago, Trans.). New York: Burt Franklin.

Compayre, G. (1898). *Lectures on pedagogy theoretical and practical* (W. H. Payne, Trans.). Boston: D. C. Heath.

Cook, E. T. (1912). *The life of John Ruskin* (Vols. 1, 2). London: George Allen.

Cook, E. T., & Wedderburn, Alexander (Eds.). (1908). *The works of John Ruskin* (Vol. 35). London: George Allen.

Cooke, E. (1886, January). Art teaching and child nature. *Journal of Education*, 12–15.

Cooke, E. (1885, December). Art teaching and child nature. *Journal of Education*, 462–465.

Cowper, R. (Ed.). (1884). *Proceedings of the international conference on education* (Vol. 2). London: William Clower.

Crain, William C. (1985). *Theories of development: concepts and applications*. Engelwood Cliffs, NJ: Prentice-Hall.

Crocker, L. G. (1973). *Jean Jacques Rousseau: The prophetic voice (1758–1778)* (Vol. 2). New York: Macmillan.

Denvir, B. (1989a). Impressionism. In D. Britt (Ed.), *Modern art: Impressionism to post-modernism* (pp. 11–58). London: Thames & Hudson.

Denvir, B. (1989b). Fauvism and expressionism. In D. Britt (Ed.), *Modern art: Impressionism to post-modernism* (pp. 109–157). London: Thames & Hudson.

Dewey, J. (1934). *Art as experience*. New York: Minton, Balch.

Dewey, J., Barnes, A. C., Buermeyer, L., Mullen M., & DeMazia, V. (1943). *Art and education, a collection of essays*. Merion, PA: Barnes Foundation.

Downs, R. B. (1975). *Heinrich Pestalozzi: Father of modern pedagogy*. Boston: Twayne.

Dray, William H. (1964). *Philosophy of history*. Engelwood Cliffs, NJ: Prentice-Hall.

Duncan, D. (1908). *Life and letters of Herbert Spencer* (Vol. 1, 2). New York: D. Appleton.

Efland, A. D. (1990). *A history of art education: Intellectual and social currents in teaching the visual arts.* New York: Teachers College, Columbia University.

Eisner, E. W., & Ecker, D. W. (Eds.). (1966). *Readings in art education.* Worcester, MA: Blaisdell.

Elliot, H. (1917). *Herbert Spencer.* New York: Henry Holt.

Eng, H. (1954). *The psychology of children's drawings* (2nd ed.). London: Routledge & Kegan Paul.

Eng, H. (1931). The psychology of children's drawing. (H. S. Hatfield, Trans.). London: Routledge & Kegan Paul.

Erikson, E. H. (1950). *Childhood and society.* New York: W. W. Norton.

Evans, J. (1954). *John Ruskin.* New York: Oxford University Press.

Feldman, E. B. (1981). *Varieties of visual experience* (2nd ed.). New York: Harry N. Abrams.

Freeman, N. H. (1980). *Strategies of representation in young children: analysis of spatial skills and drawing processes.* London: Academic Press.

Freud, S. (1965a). A general introduction to psychoanalysis. (J. Riviere, Trans.). New York: Washington Square Press.

Freud, S. (1965b). *New introductory lectures on psychoanalysis.* (J. Strachey, Trans.). New York: W. W. Norton.

Froebel, F. (1977). *The education of man* (W. N. Hailmann, Trans.). In D. N. Robinson (Ed.), *Significant contributions to the history of psychology 1750–1920: Series B, psychometrics and educational psychology* (Vol. 1), (pp. xxii–332). Washington, DC: University Publications of America. (Reprinted from 1887, New York: D. Appleton)

Froebel, F. (1889). *Autobiography of Friedrich Froebel* (W. N. Hailmann, Trans.). New York: D. Appleton.

Gaitskell, C. D., Hurwitz, A., & Day, M. (1982). *Children and their art* (4th ed.). New York: Harcourt Brace Jovanovich.

Gardner, H. (1985). *The mind's new science.* New York: Basic Books.

Gardner, H. (1980). *Artful scribbles.* New York: Basic Books.

Gay, P. (1968). *Weimar culture: The outsider as insider.* New York: Harper & Row.

Getty Center for Education in the Arts. (1985). *Beyond creating: The place for art in America's schools.* Santa Monica, CA: J. Paul Getty Trust.

Giorgi, A. (1970). *Psychology as a human science.* New York: Harper & Row.

Golomb, C. (1992). *The child's creation of a pictorial world.* Berkeley: University of California Press.

Goodenough, F. L. (1926). *Measurement of intelligence by drawings.* New York: Harcourt, Brace & World.

Green, F. C. (1955). *Jean-Jacques Rousseau; a critical study of his life and writings.* Cambridge, UK: University Press.

Grotberg, E. H. (Ed.). (1976). *200 years of children.* Washington, DC: Office of Human Development, Office of Child Development. U.S. Department of Health, Education, and Welfare, Office of Human Development, Office of Child Development.

de Guimps, R. (1909). *Pestalozzi: His life and work* (J. Russell, Trans.). New York: D. Appleton.

Gutek, G. L. (1968). *Pestalozzi & education.* New York: Random House.

Haftmann, W. (1965). *Painting in the twentieth century.* New York: Frederick A. Praeger.

Harris, D. B. (1963). *Children's drawings as measures of intellectual maturity.* New York: Harcourt, Brace, & World.

Harrison, F. (1925). *John Ruskin.* London: Macmillan.

Hawes, J. M., & Hiner, N. R. (Eds.). (1985). *American childhood*. Westport, CT: Greenwood Press.

Hudson, W. H. (1903). *Rousseau and naturalism in life and thought*. Edinburgh: T., & T. Clark.

Inhelder, B., & Piaget, J. (1958). *The growth of logical thinking from childhood to adolescence* (F. J. Langdon, & J. L. Lunzer, Trans.). New York: Basic Books.

International Congress for Art Education, Drawing and Art Applied to Industry. (1931). Prague: Report of the congress.

International Congress for Art Education, Drawing and Art Applied to Industry. (1928). Prague: Preliminary report of the congress.

Kazamias, A. M. (1966). *Herbert Spencer on education*. New York: Teachers College Press, Columbia University Press.

Kellog, R. (1970). *Analyzing children's art*. Palo Alto, CA: National Press.

Kellog, R. (1967). *The psychology of children's art*. New York: CRM-Random House.

Kerschensteiner, G. (1905). *Die entwicklung der zeicherischen begabung*. Munich: Druck and Verlag von Carl Gerber.

Kessel, F. S. Bornstein, M. H., & Sameroff, A. J. (1991). *Contemporary constructions of the child. Essays in honor of William Kessen*. Hillsdale, NJ: Lawrence Erlbaum.

Kessel, F. S., & Siegel, A. W. (Eds.). (1981). *The child and other cultural inventions*. New York: Praeger.

Krampen, M. (1991). *Children's drawings*. New York: Plenum Press.

Kuhn, T. S. (1962, 1970). *The structure of scientific revolutions*. Chicago: University of Chicago Press.

Leon, D. (1949). *Ruskin, the great Victorian*. London: Routledge & Kegan Paul.

Liebert, R. M., Poulos, R. W., & Strauss, G. D. (1974). *Developmental psychology*. Englewood Cliffs, NJ: Prentice-Hall.

Lilley, I. M. (Ed.). (1967). *Friedrich Froebel*. Cambridge, UK: University Press.

London International Health exhibition. (1884). *Proceedings of the international conference on education* (Vol. 2). London: William Clowes.

Lotman, J. (1976). *Structure of the artistic text* (M. E. Suino, Trans.). Ann Arbor: University of Michigan Press.

Lowenfeld, V., & Brittain, W. L. (1982). *Creative and mental growth* (7th ed.). New York: Macmillan.

Lowenfeld, V. (1974). *Creative and mental growth* (7th ed.). New York: Macmillan.

Lowenfeld, V. (1966). Tests for visual and haptical aptitudes. In E. Eisner, & D. Ecker (Eds.), *Readings in art education*. Waltham, MA: Blaisdell.

Lowenfeld, V. (1954). *Your child and his art*. New York: Macmillan.

Luquet, G. H. (1913, 1927). *Les dessins d'un enfant* [The drawings of a child]. Paris: Alcan.

Macdonald, S. (1970). *The history and philosophy of art education*. London: University of London Press.

MacKintosh, A. (1989). Symbolism and art nouveau. In David Britt (Ed.), *Modern art: Impressionism to post modernism* (pp. 59–107). London: Thames & Hudson.

Morley, J. V. (1923). *Rousseau and his era*. London: Macmillan.

Mosse, G. L. (1988). *The culture of Western Europe: The nineteenth and twentieth centuries*. Boulder, CO: Westview Press.

Mukarovsky, J. (1970). *Aesthetic function, norm and value as social facts* (M. E. Suino, Trans.). Ann Arbor: The University of Michigan Press.

Murphy, G., & Kovach, J. K. (1972). *Historical introduction to modern psychology.* New York: Harcourt Brace Jovanovich.

Olson, J. L. (1992). *Envisioning writing: Toward an integration of drawing and writing.* Portsmouth, NH: Heinemann.

Olson, Janet W. (1998). Encouraging visual storytelling. In Judith W. Simpson et al,. *Creating meaning through art: Teacher as a choice maker* (pp. 163–205). Upper Saddle River, NJ: Prentice-Hall.

Perez, B. (1975). *The first three years of childhood.* New York: Arno Press.

Perry, M., Chase, M., Jacob, J. R., Jacob, M. G., & Von Laue, Theodore. (1996). *Western civilization: Ideas, politics & society.* Boston: Houghton Mifflin.

Pestalozzi, J. H. (1977a). *How Gertrude teaches her children* (L. E. Holland and F. C. Turner, Trans.) (E. Cooke, Ed.). In D. N. Robinson (Ed.), Significant *contributions to the history of psychology 1750–1920. Series B, psychometrics ands educational psychology* (Vol. 2) (pp. 1–391). Washington, DC: University Publications of America (Reprinted from 1889, Syracuse NY: C. W. Bardeen)

Pestalozzi, J. H. (1977b). *Pestalozzi's educational writings* (J. A. Green, Trans.). In D. N. Robinson (Ed.), *Significant contributions to the history of psychology 1750–1920. Series B, psychometrics and educational psychology* (Vol. 2) (pp. v–322). Washington, DC: University Publications of America. (Reprinted from 1912, New York: Longmans, Green)

Pestalozzi, J. H. (1912). Letters to Greaves (J. A. Green, Trans.). In *Pestalozzi's educational writings.* New York: Longmans, Green. (Original work published 1827)

Peters, R. S. (1965). *Brett's history of psychology.* Cambridge: MIT Press.

Piaget, J. (1972). Some aspects of operations. In M. W. Piers (Ed.), Play *and development* (pp. 15–27). New York: W. W. Norton.

Piaget, J. & Inhelder, B. (1967). *The child's conception of space* (F. J. Langdon, & J. L. Lunzer, Trans.). New York: W. W. Norton.

Read, H. (1958). *Education through art* (3rd ed.). London: Faber & Faber.

Read, H. (1953). *The philosophy of modern art.* New York: Horizon Press.

Ricci, C. (1894). L'Arte dei bambini [The art of little children] (L. Maitland, Trans.). *The Pedagogical Seminary* (Vol. 3). Worcester, MA: J. H. Orpha. (Original work published 1887)

Ricci, C. (1887). *L'Arte dei bambini* [The art of little children]. Bologna: Nicola Zanichelli.

Richardson, S. (1914). *Pamela.* London: J. M. Dent.

Richardson, S. (1902). *The history of Clarissa Harlowe with an introduction by William Phelps.* New York: AMS Press.

Robertson, P. (1974). Home as a nest: Middle class childhood in nineteenth century Europe. In L. deMause (Ed.), *The History of Childhood* (pp. 407–431). New York: Psychohistory Press.

Rouma, G. (1913). *Le langage graphique de l'enfant* [The graphic language of the child] (2nd ed.). Brussels: Misch et Thron.

Rousseau, J. J. (1989). *Eloisa, or a series of original letters* (W. Kenrick Trans.). Oxford: Woodstock Books. (Original work published 1803)

Rousseau, J. J. (1911). *Emile* (B. Foxley, Trans.). London: Aldine Press.

Royce, J. (1904). *Spencer: An estimate and review.* New York: Fox, Duffield.

Ruskin, J. (1907a). *The elements of drawing.* London: J. M. Dent.

Ruskin, J. (1907b). *The elements of perspective.* London: J. M. Dent.

Ruskin, J. (1905?). *The works of John Ruskin.* London: The Chesterfield Society.

Sahakian, M. L., & Sahakian, W. S. (1874). *Rousseau as educator.* New York: Twayne.

Sarason, S. B. (1988). *The challenge of art to psychology.* New Haven, CT: Yale University Press.

Savage, L. (1985). The history of art education and social history: Test and context in a British case of art school history. In B. Wilson & H. Hoffa (Eds.), *The history of art education. Proceedings from the Penn State conference* (pp. 94–98). Pennsylvania State University. College Park, PA: National Endowment of the Arts.

Schaefer-Simmern, H. (1948). *The unfolding of artistic activity: Its basis, processes, and implications.* Berkeley: University of California Press.

Siegler, R. S. (1991). *Children's thinking.* Englewood Cliffs, NJ: Prentice-Hall.

Silber, K. (1965*). Pestalozzi: The man and his work.* London: Routledge and Kegan Paul.

Smith, P. (1985). Franz Cizek: Problems of interpretation. In B. Wilson & H. Hoffa (Eds.), *The history of art education. Proceedings from the Penn State conference* (pp. 219–223). Pennsylvania State University, College Park, PA: National Endowment of the Arts.

Smith, R. A. (1986). *Excellence in art education.* Reston, VA: National Art Education Association.

Spencer, H. (1911). *Essays on education and kindred subjects.* London: J. M. Dent.

Spencer, H. (1904). *An autobiography* (Vols. 1, 2). New York: D. Appleton.

Stromberg, R. N. (1966). *An intellectual history of modern Europe.* New York: Appelton-Century-Crofts.

Sully, J. (1977). Studies of childhood. In D. N. Robinson (Ed.), *Significant contributions to the history of psychology 1750–1920. Series B, psychometrics and educational psychology* (Vol. 3). Washington, DC: University Publications of America. (Reprinted from 1896, New York: D. Appleton)

Sully, J. (1888). *Outlines of psychology.* New York: D. Appleton.

Thistlewood, D. (1985). National systems and standards in art and design in higher education in Britain. In B. Wilson & H. Hoffa (Eds.). (1985). *The history of art education. Proceedings from the Penn State Conference* (pp. 80–86). Pennsylvania State University. College Park, PA: National Endowment of the Arts.

Thomas, G. V. & Silk, A. M. J. (1990). *An introduction to the psychology of children's drawings.* New York: New York University Press.

Viola, W. (1944). *Child art.* London: University of London Press.

Viola, W. (1936). *Child art and Franz Cizek.* London: Simpkin Marshall.

Vygotsky, L. S. (1971). *The psychology of art.* Cambridge, MA: MIT Press.

Wells, G. (1986). *The meaning makers.* Portsmouth, NH: Heinemann.

Wilenski, R. H. (1933). *John Ruskin and an introduction to further study of his life and work.* London: Faber & Faber.

Wilson, B., & Wilson, M. (1979, June). Of graphic vocabularies and grammars: Teaching drawing skills for worldmaking. *School Arts*, pp. 36–41.

Wilson, B., & Wilson, M. (1979, May). Drawing realities: The themes of children's story drawings. *School Arts*, pp. 12–17.

W ilson, B., & Wilson, M. (1979, April). Children's story drawings: Reinventing worlds. *School Arts*, pp. 6–11.

Wilson, F. (1921a). *The child as artist.* London: Children's Art Exhibition Fund.

Wilson, F. (1921b). *A lecture by Professor Cizek.* London: Children's Art Exhibiton Fund.

Wilson, F. (1921c). *A class at Professor Cizek's.* London: Children's Art Exhibition Fund.

Wilson, M. & Wilson, B. (1982). *Teaching children to draw: A guide for teachers & parents.* Englewood Cliffs, NJ: Prentice-Hall.

Wingfield-Stratford, E. (1930). *Those Earnest Victorians.* New York: William Morrow.

Winner, E. (1982). *Invented worlds. The psychology of the arts.* Cambridge: Harvard University Press.

INDEX

ABOUT THE AUTHOR

DONNA DARLING KELLY is Associate Professor and Art Education Program Coordinator in the Department of Art at Rhode Island College.